THE BIGGER PICTURE

30 YEARS OF PORTRAITS
BY DIANA WALKER

NATIONAL GEOGRAPHIC
Washington, D.C.

This book is for Mallory and for our grandchildren:
Charlie, Jack, Wyatt, and Zoe

CONTENTS

FOREWORD BY ANNE TYLER

WARNING

She's not at all scary to look at. She has a rangy, casual style to her and an easy laugh. She comes sauntering in with her cameras and you think, Where's the harm? Let her snap a photo or two.

For what it's worth.

She travels around the room repositioning a lamp here and assessing the lighting there. Meanwhile, she's talking. Oh, this and that, la-la-la, and what do you think? It's not difficult to answer her, since she hardly seems to be listening. She peers down into some instrument and makes a minute adjustment. She says, "Mmhmm." Her eyes flicker briefly in your direction.

Watch out.

Watch out, Ms. Smith! (Or Senator. Or Mr. President.)

Those eyes are two of the keenest in the business.

Like a novelist or a poet, she gives full value to the significance of detail. Notice how she photographs not just the man but his office, taking in the clutter or the lack of clutter, the spread of papers on a desk, the books helter-skelter on the shelves. Or how she registers a royal wife's slantwise glance at her husband, or a diplomat's tensed hands.

Oh, she's very good with hands.

Still, if you have nothing to hide then you have nothing to fear. Just look at the young Ugandan boy on page 193—his serene and peaceful face. Look at the South African AIDS patient on page 196. "I think of this picture as hopeful," she says as she studies her photo of the South African. She says she can't explain why. The bright colors, maybe? His careful placement of his belongings? She says she views him with respect. She says she views all of her subjects with respect.

The South African knows that, you can tell from his posture. All of us know that.

Relax, Ms. Smith.

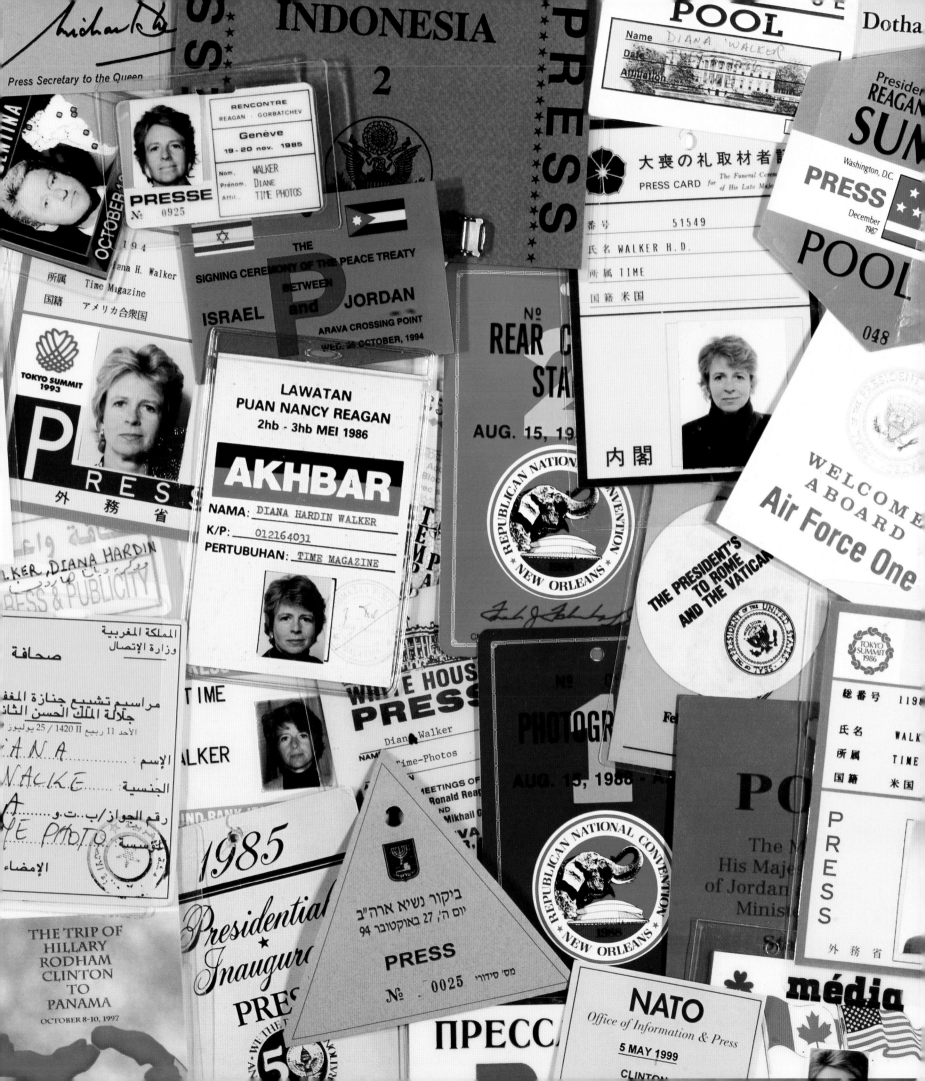

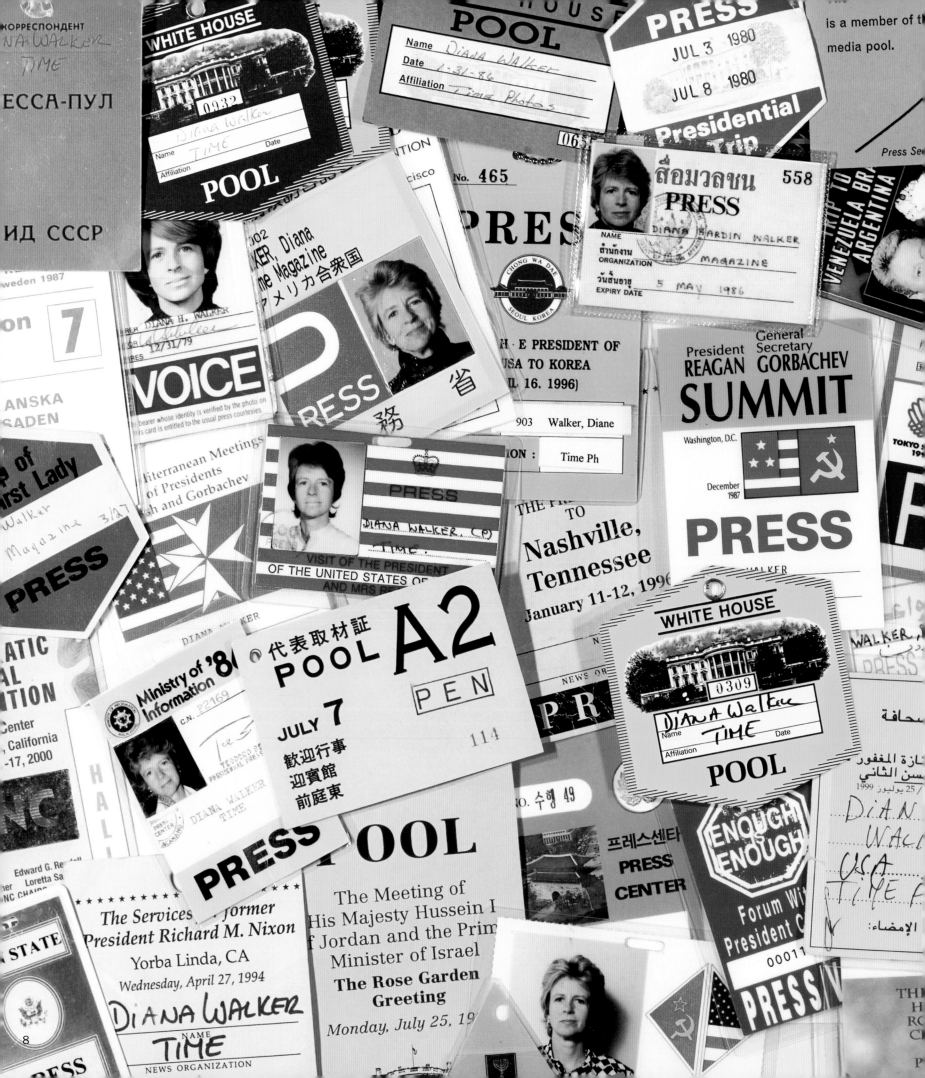

INTRODUCTION

Every man's work,
whether it be literature or music or pictures or architecture or anything else,
is always a portrait of himself.
—SAMUEL BUTLER, 1835–1902

I can argue long into the night about what a portrait is, about how much of what we photographers see is truly real, and how much of it is the subject playing to the camera. I can talk technique, I can wonder whether all my chatter to bring out the sitter is worthwhile, or muse about how it is that I ask all these questions but don't really hear the answers since I'm busy framing the picture and adjusting the f-stops. A portrait is a complicated thing, and it seems, by the look of this volume, that I take a very broad interpretation of the word.

Because I work in Washington, there are necessarily lots of photographs of well-known people in this book. However, very little effort has been made to include this famous person or that influential statesman. My editor and my book designer chose these pictures just because they liked them, not because of who was in them. Missing persons can probably be found in the next book, as my archive is large.

I interviewed five individuals for this book, and their words are featured in special sections. They are: Madeleine Albright, Steve Jobs, Karenna Gore Schiff (for her father), Jamie Lee Curtis, and Hillary Rodham Clinton. I have photographed these people in depth over many years.

The different kinds of portraits in this book were taken in a variety of circumstances: There's the shot taken from the back of a riser, using a long lens aimed at a subject who is well aware we photographers and reporters are there; a portrait of a politician shot from the buffer zone below the stage, looking up at him and hoping that your angle beats that of your competition. Then there are the pictures made during the reporter's interview, with prob-

lems of light and the journalist's mike in the way, or the challenge to capture the author or actor's genius, hoping that his or her gifts indeed will show through. Or studio shots where at last you have control—but is the lighting good, the background neat? There's the excitement of following your subject from pillar to post, only to have the door closed when discretion reigns; or the panic of photographing the President of the United States from "behind the scenes" and suddenly realizing your camera batteries have died; or the disappointment of being poised to go into a fascinating tête-à-tête, and just as you step over the threshold, that perky press aide slips in between you and the door with a "thank you, Diana." "But…but…this is just what I need!" you protest as you are ushered into an empty room down the hall to dream of your lost exclusive moment. Or being assigned to photograph someone you know—which should be a sheer delight—but having to be aware of the minefields when you blur the lines between being a friend and being a journalist. All situations have their perils.

Over the years, as a photojournalist based in Washington, I have encountered all of the above, in spades. But we have chosen here a collection of portraits where mercifully I did have the right lens, the doors were not closed, my cameras had film, my colleagues were helpmates, and my subjects oftentimes seemed to forget I was there. My hope is that I have managed to tell you something about the people I have photographed, perhaps shedding light on aspects of their character you might not have noticed, or reinforcing opinions you already had. I hope you will have as good a time looking at the photographs as I had in taking them; it has been a great ride.

THE PRESS

Growing up in Washington, my mother and father had many friends who were members of the press. I was very familiar with columnists Arthur Krock, Rowland Evans, Charles Bartlett, and Philip Geyelin; I heard often the names of the Alsop brothers, Alfred Friendly, Scotty Reston, and Walter Lippmann. I grew up in the park alongside the children of Philip and Katharine Graham. So I came from a culture that admires the work of the fourth estate. And as someone who loves pictures, I was always looking in publications for the work of Eugene Smith, Gordon Parks, Tony Frissell, John Dominis, Stanley Tretick, George Tames, Alfred Eisenstaedt, and Carl Mydans. Though I had taken pictures all my life, my career came as something of a surprise. Charlie Peters of the *Washington Monthly* was encouraged by my pal Linda Smith, then on his staff, to give me a press pass and send me out, which, to my delight, he did. Eventually I was offered a contract by *TIME* magazine. That's the story.

What I have kept in my mind all these years is that the magazine I worked for was sending me to a place where you, the reader, couldn't be, and I was carrying a camera. This camera took me all over the world, and I never stopped believing, and still do today, that I was there to capture on film as much action, and as much nuance, as was possible. I became fascinated with trying to go as far as I could to unpeel the artichoke, find the subtleties that could help us understand better the subjects I was assigned to follow. Sometimes it worked, sometimes it didn't, but I had a great time trying.

So much about Washington—Capitol Hill and the White House—is staged; it's all about mikes and lights, sound bites and press releases. My editors wanted me not to settle for the surface; they also wanted me to run fast and carry long lenses. As I waited in the White House pressroom, rode with the "tight pool" in the back of a van, or flew to China with a huge press corps, my colleagues were the best. They were all trying to do the same thing: Remain objective, give it to you straight, follow any crooked roads, be smart, and be honorable. I know that when thinking about the press, words such as pesky, biased, pompous, inaccurate, or annoying can come to mind. But there are also words such as persevering, well informed, observant, insightful, and very, very necessary.

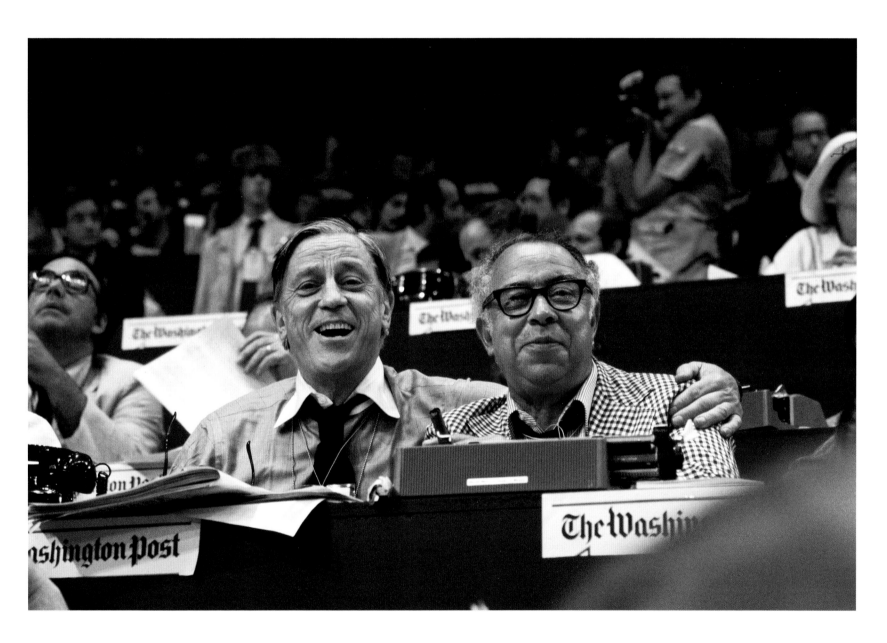

BEN BRADLEE AND ART BUCHWALD
The Executive Editor of the *Washington Post* and his great friend and mine the late columnist Art Buchwald (1925–2007)
at the Democratic Convention, August, 1980

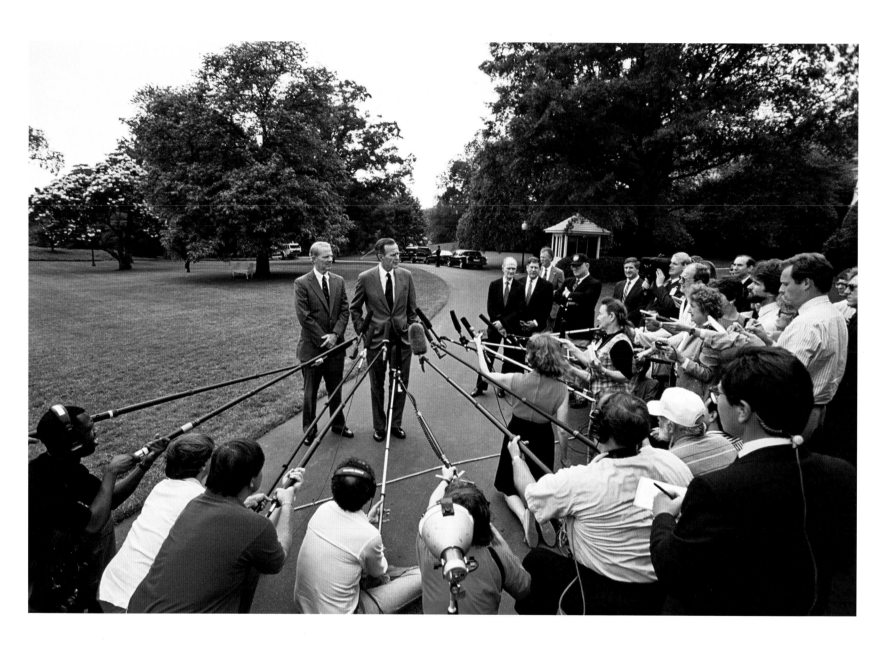

PRESIDENT GEORGE H.W. BUSH AND SECRETARY OF STATE JAMES A. BAKER III
Remarks and an exchange with reporters on Middle East peace talks, the South Lawn of the White House, May 17, 1991

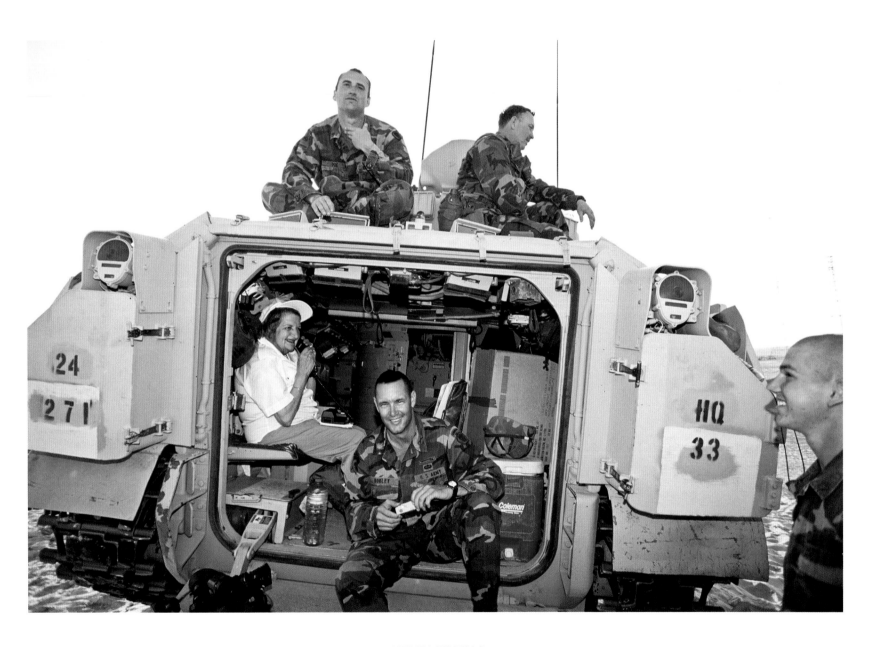

HELEN THOMAS

Longtime UPI reporter Thomas, in a Bradley infantry fighting vehicle, covering President's Clinton's trip to Kuwait, October 28, 1994

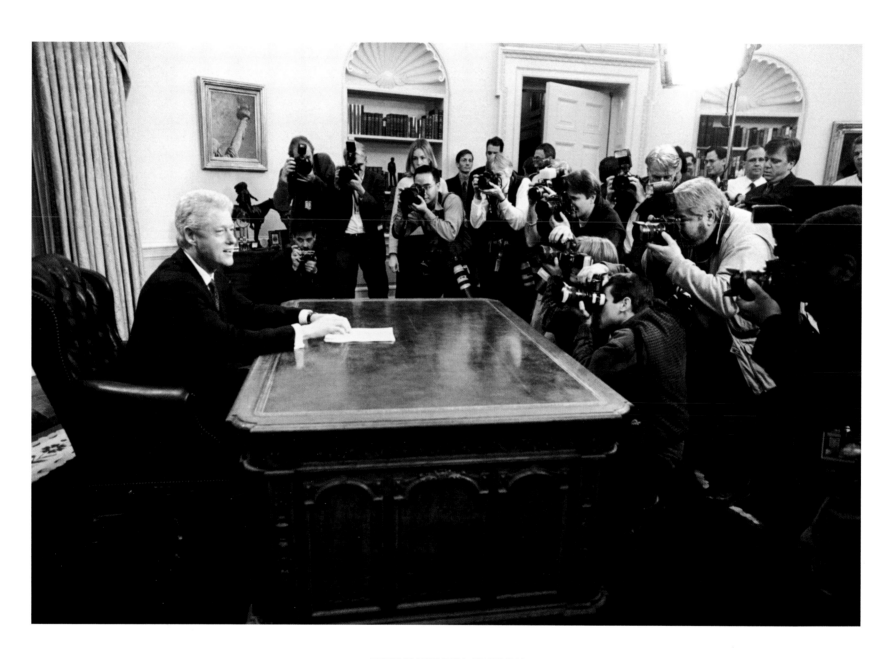

PRESIDENT BILL CLINTON

After the President delivers his farewell address to the nation from the Oval Office, in come the still photographers, January 18, 2001.

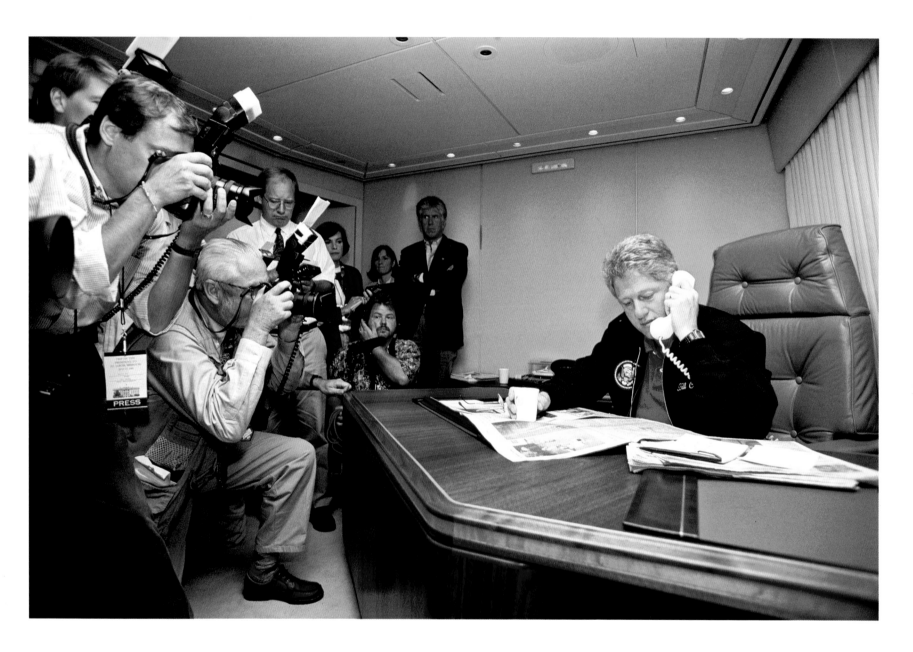

PRESIDENT BILL CLINTON

President Clinton is photographed by the traveling pool as he makes a call from his office on *Air Force One*,
on his way to Iowa to inspect flood damage, July 14, 1993.

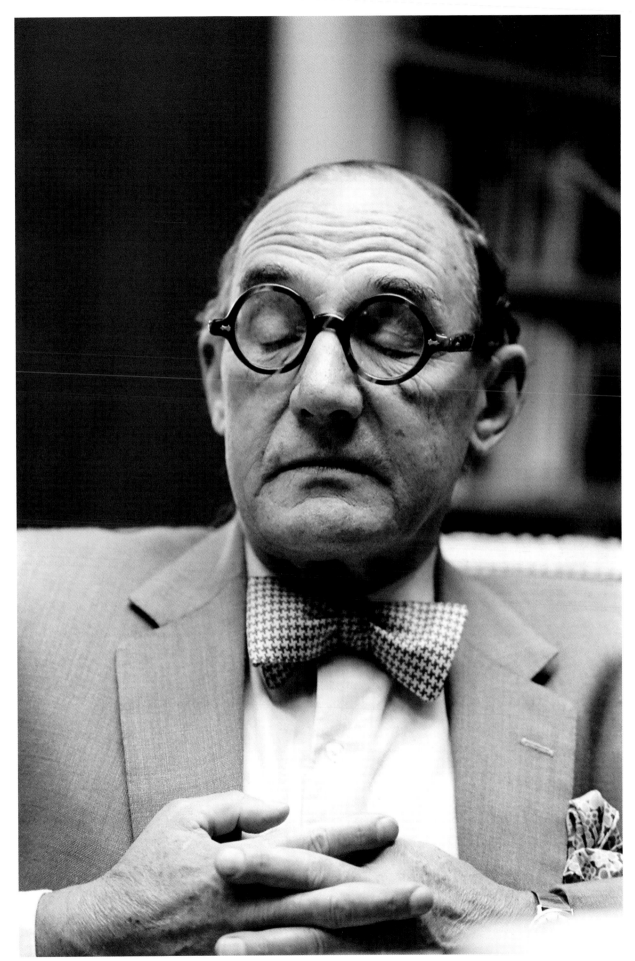

JOSEPH ALSOP
Columnist Alsop
(1910–1989)
photographed at
home in 1974

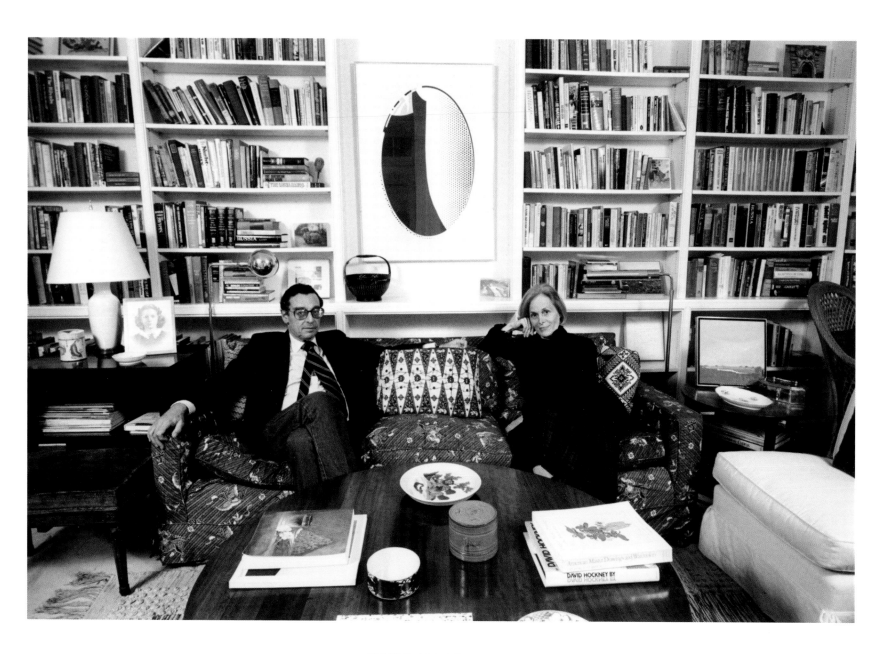

JOSEPH AND POLLY KRAFT
Columnist Joe Kraft (1924–1986) at home in Georgetown with his wife, artist Polly Kraft, Washington, D.C., October 27, 1981

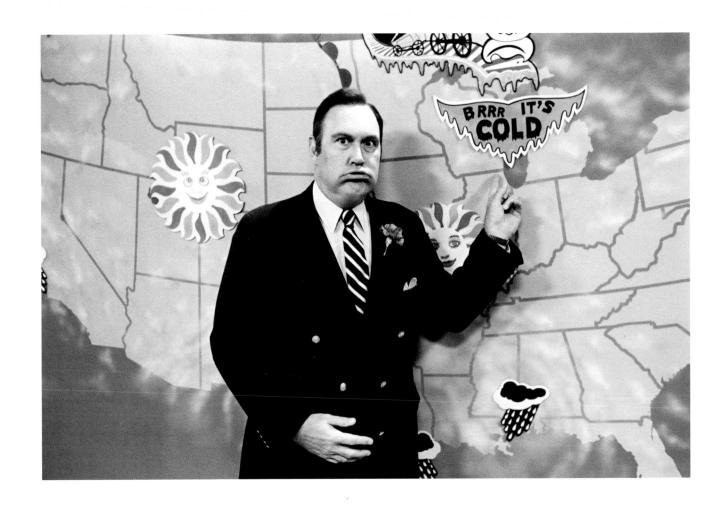

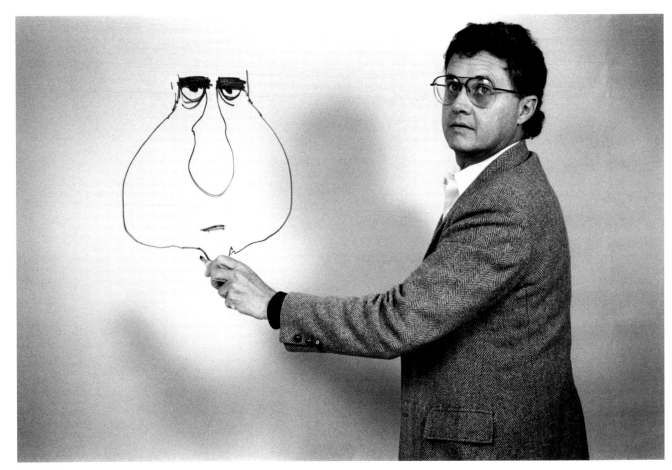

Top: **WILLARD SCOTT**
America's beloved
weatherman, on the *Today*
show, December 4, 1984

Bottom: **PAT OLIPHANT**
Political cartoonist and
artist, October 1982. "Years ago,
I photographed Pat for the cover
of *TIME*—his first cover,
and mine. Our story was killed,
but we became pals."—D.W.

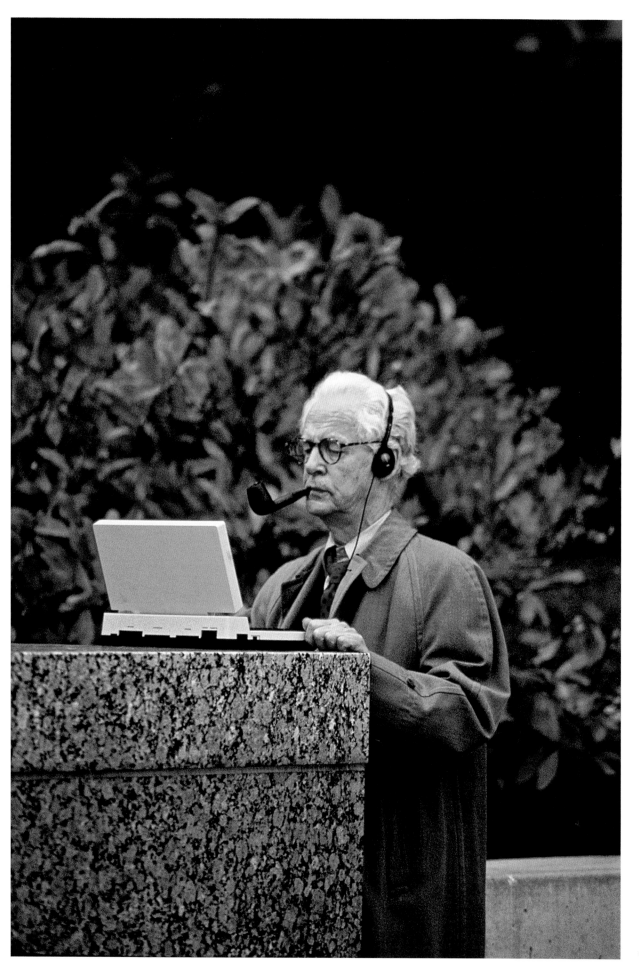

MURRAY KEMPTON
Pulitzer Prize-winning
columnist Murray Kempton
(1917–1997) on the
road covering a campaign
for *Newsday*, 1980s

HERBLOCK
"I was enchanted by
Herblock (1909–2001),
the late, great cartoonist for
the *Washington Post*.
His office gave me the
impression he lived there."
May 1985 —D.W.

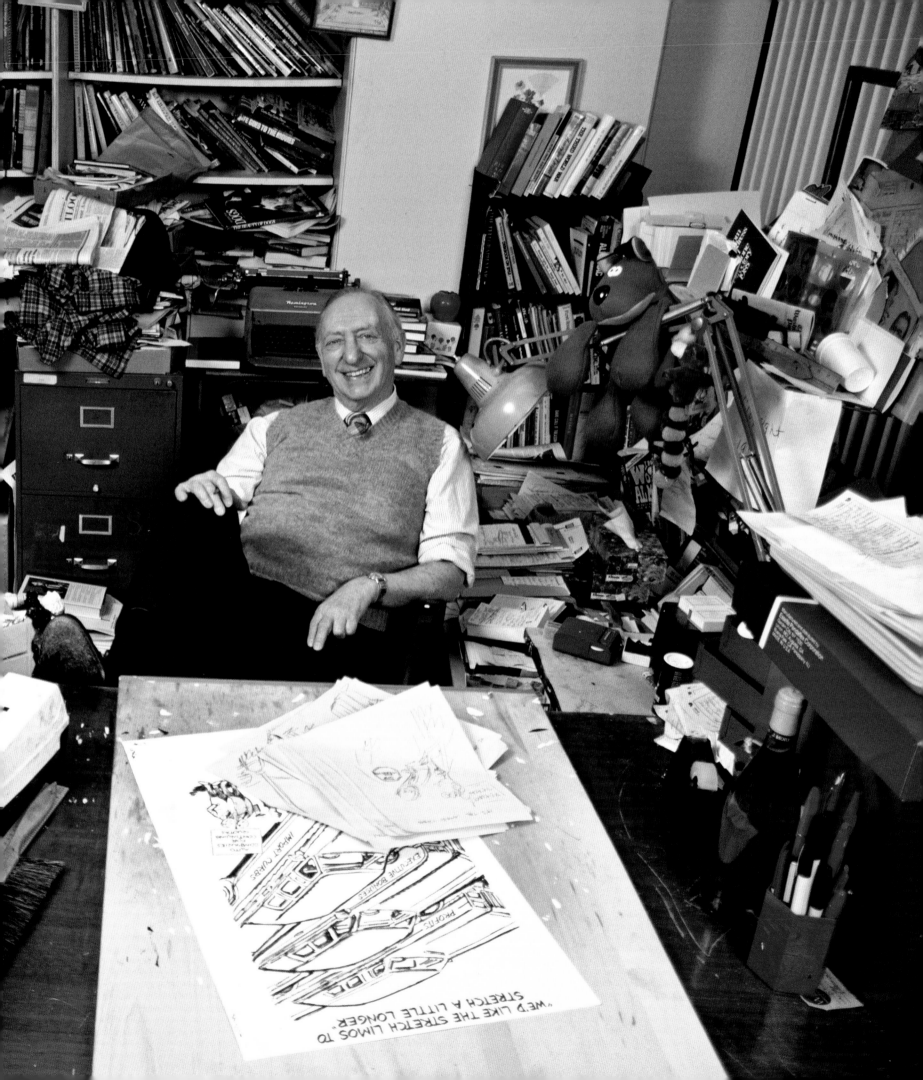

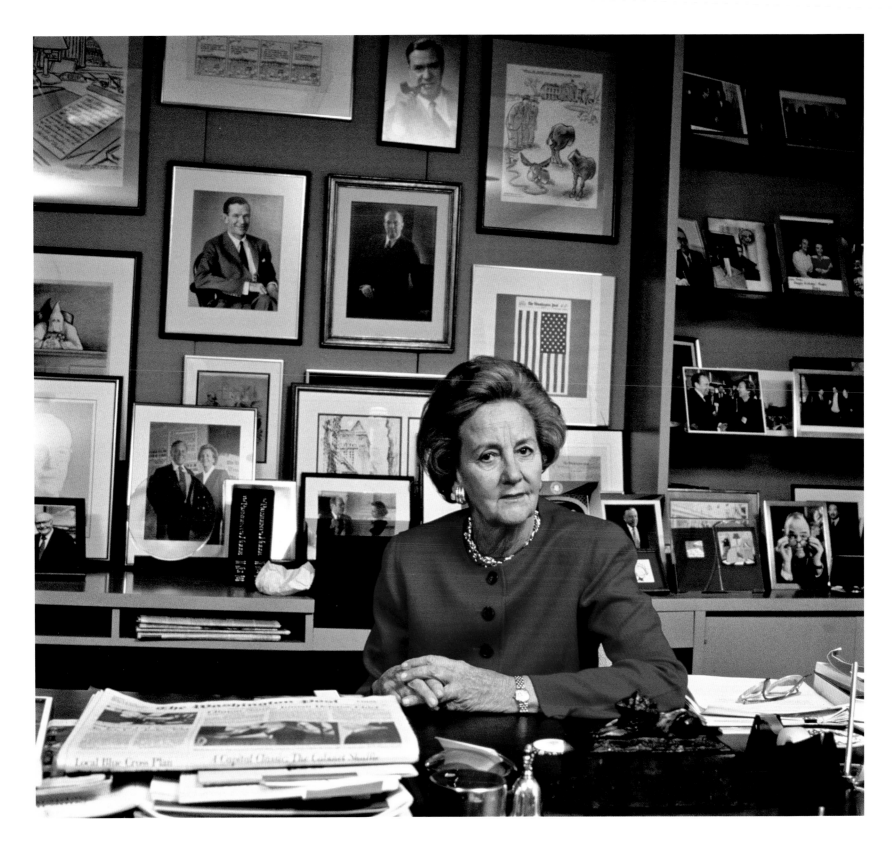

KATHARINE GRAHAM

"Katharine Graham (1917–2001) was simply a great lady. I loved that even though she was publisher of the *Washington Post* and *Newsweek*, she asked a *TIME* photographer to do her portrait. She made me laugh when she jokingly suggested I take the back stairs rather than be seen in the *Post*'s elevator." December 1993 —D.W.

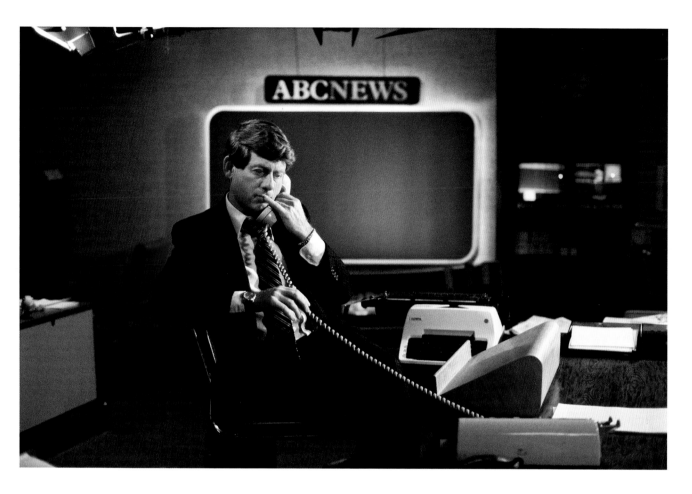

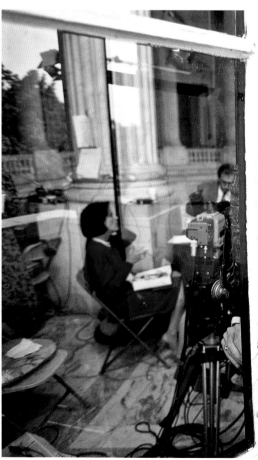

Top: **TED KOPPEL**
Anchor of ABC's *Nightline*,
January 29, 1985

Bottom: **NINA TOTENBERG**
The Legal Affairs correspondent
for National Public Radio covering
the hearings to confirm Clarence
Thomas as an Associate Justice
of the Supreme Court,
October 15, 1991

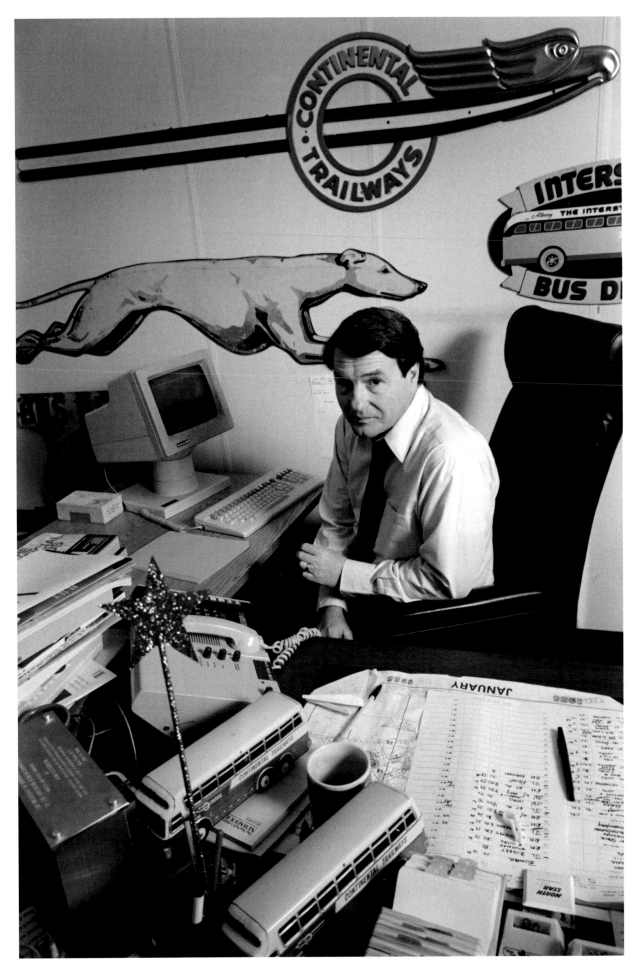

JIM LEHRER
WETA-TV's anchor of *The NewsHour with Jim Lehrer* in his office, surrounded by his collection of bus memorabilia, April 1985

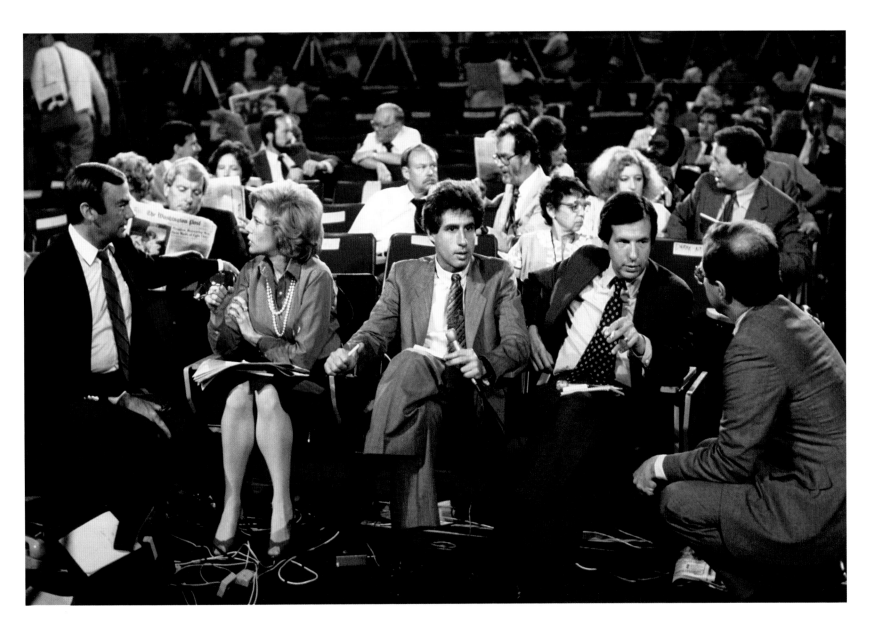

SAM DONALDSON, LESLEY STAHL, ROBERT BAZELL, AND CHRIS WALLACE
Correspondents await a briefing at Bethesda Naval Hospital following President Reagan's surgery for colon cancer, July 1985.

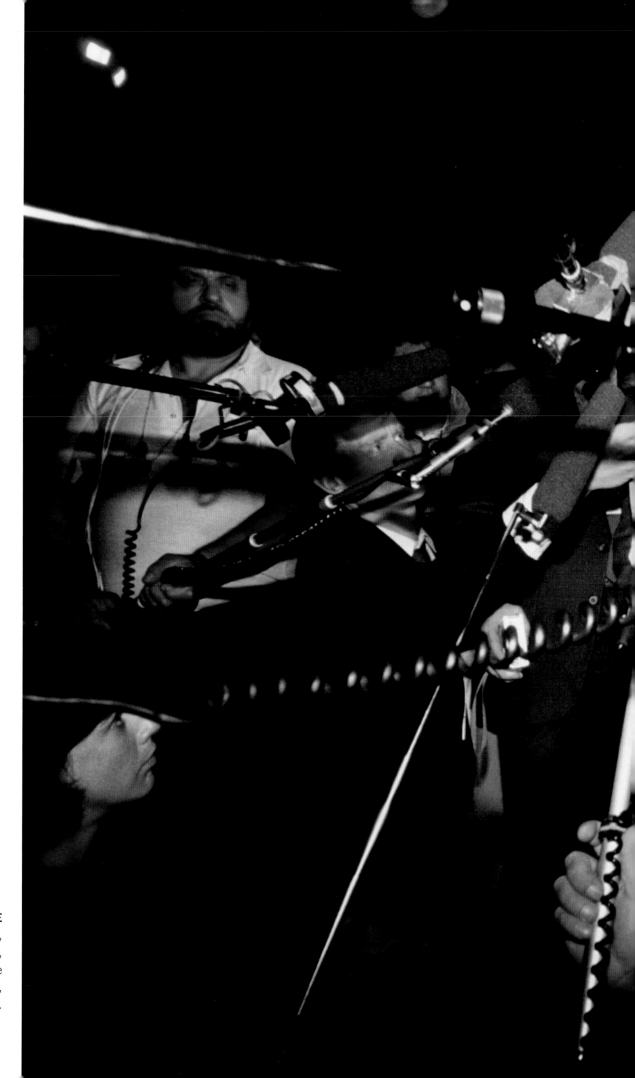

WALTER MONDALE
Vice President Mondale,
running for President,
meets the press on the
tarmac at the Seattle airport,
September 20, 1984.

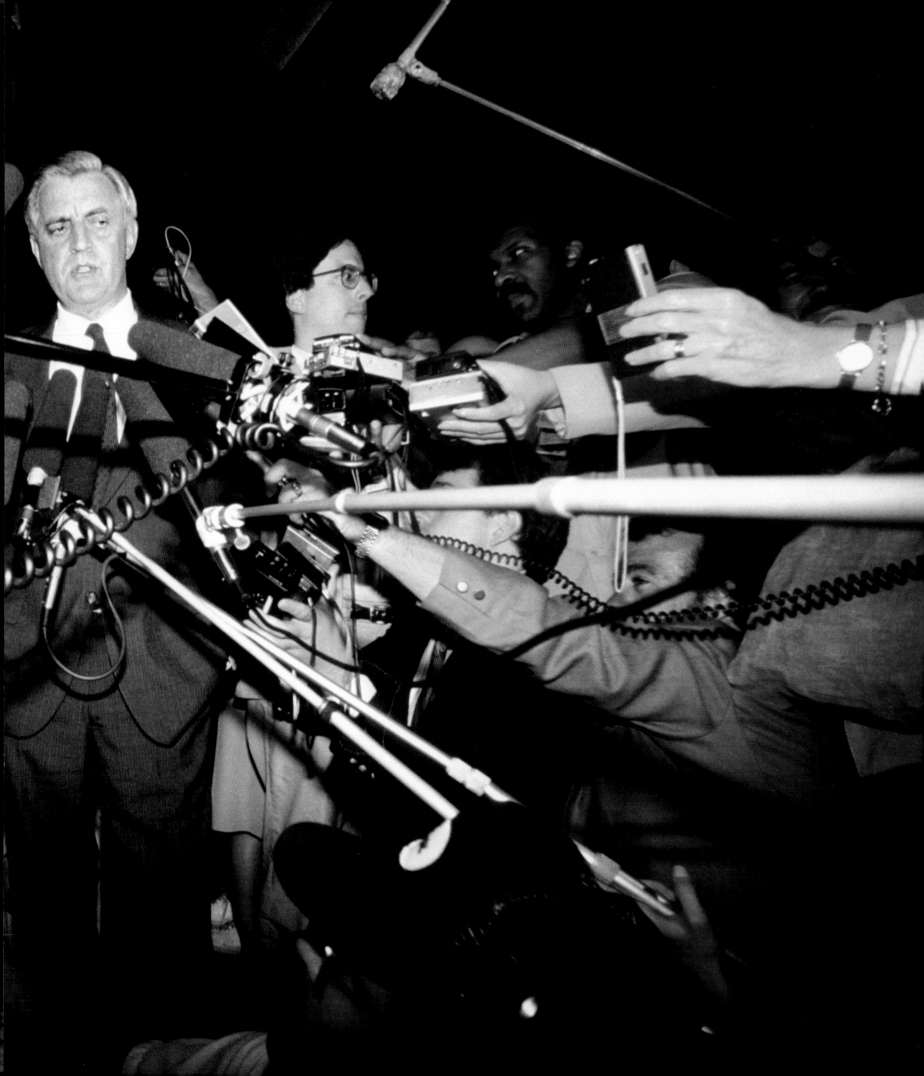

From my conversation with **MADELEINE ALBRIGHT**

"There are people who think that I had planned this from childhood, but it never occurred to me. Not that I wasn't ambitious about doing things, but there had never been a woman secretary of state. There was no reason to think that it would happen. I do think I spent a great deal of time trying to get Democrats elected, and I did want to be in the government.

"Being the first is always interesting because you are kind of setting the tone for things. And I think in many ways there are many advantages to being a woman in these jobs, because I think that we are better at relationships. Being a diplomat means that you have to try to put yourself in the other person's shoes—that's the essence of it. And I think that a lot of women have a very good sense about that—of empathy and of understanding—and I think that it's possible to have a good friendship, but at the same time be very direct in what you say. Probably there are some people who would say I would switch signals. I'd be very friendly, and then I'd say, 'I've come a long way, so I must be frank,' or something like that. But the disadvantage was, at least in my case, because I was the first, was whether a woman can do it at all. I don't think that's an issue for Condi Rice, for instance. People might disagree with her policies, but people aren't questioning as to whether she's capable of being secretary of state.

"You're never free of your job. You never are. But it was so energizing. I think that you learn to sleep in segments. Obviously, you're not doing stuff by yourself, either. I mean it's a team effort. And I think there were times, obviously, when I got discouraged. Because things aren't always the way you want them. But it's such an incredible job to represent the United States.

"You can't really have an activist diplomacy where you see America engaged if you aren't also thinking about what your different tools are as a diplomat. I think it is very important for people to understand the link between force and diplomacy. You obviously use diplomatic tools and economic tools, but ultimately you have to be prepared to use force. And what we were doing in Kosovo—we initially had used the threat of the use of force to move diplomacy forward. And then, when we were using force, we needed diplomacy to keep everybody together. And these pictures tell the story of force and diplomacy.

"Now, I do a lot of different things. First of all, my passion is democratization. I really do think that it's important that people all over the world be able to live within societies where they can make their own decisions. So everything that I'm doing now has something to do with that."

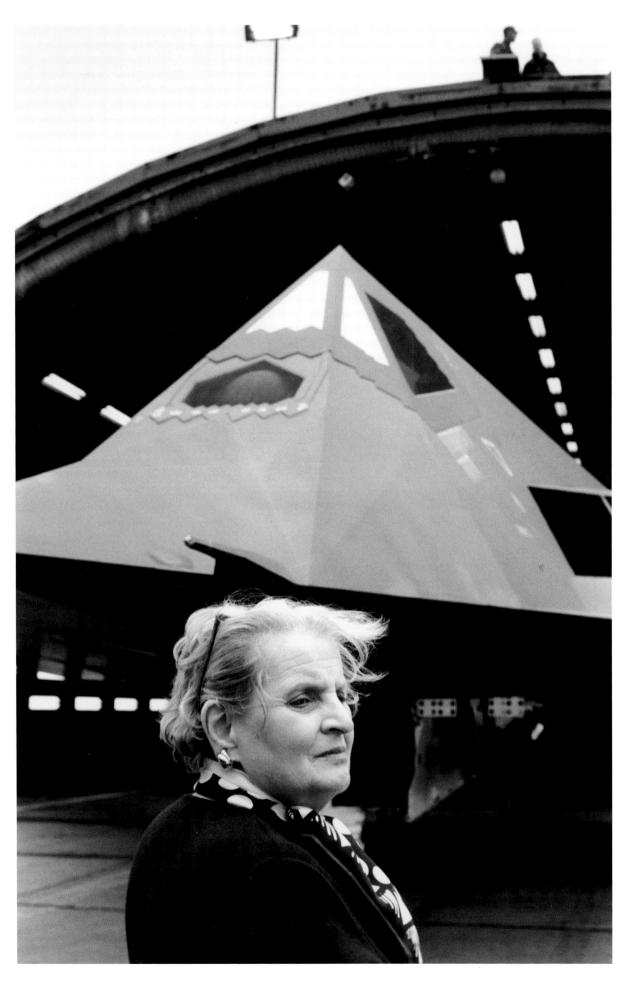

SECRETARY OF STATE ALBRIGHT in front of a Stealth bomber at Spangdahlem Air Base in Germany, May 5, 1999

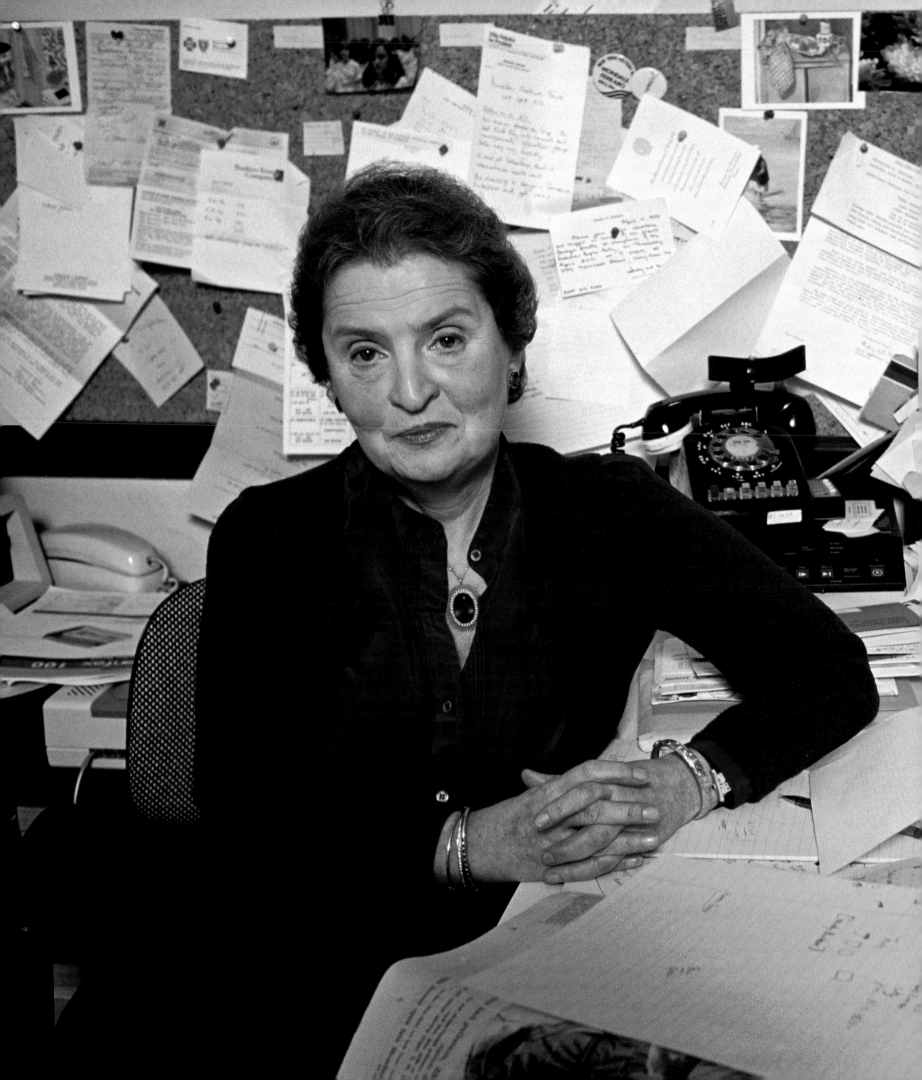

SECRETARY ALBRIGHT
in her office at home, June 21,
1988. "I was very young,
wasn't I? I was teaching at
Georgetown University then,
and doing things for the Dukakis
campaign."—M.A.

SECRETARY ALBRIGHT sitting at a makeshift communications center at Ramstein Air Base, Germany, May 5, 1999
"I love my bomber jacket. I still have it. It is one of my treasured possessions."—M.A.

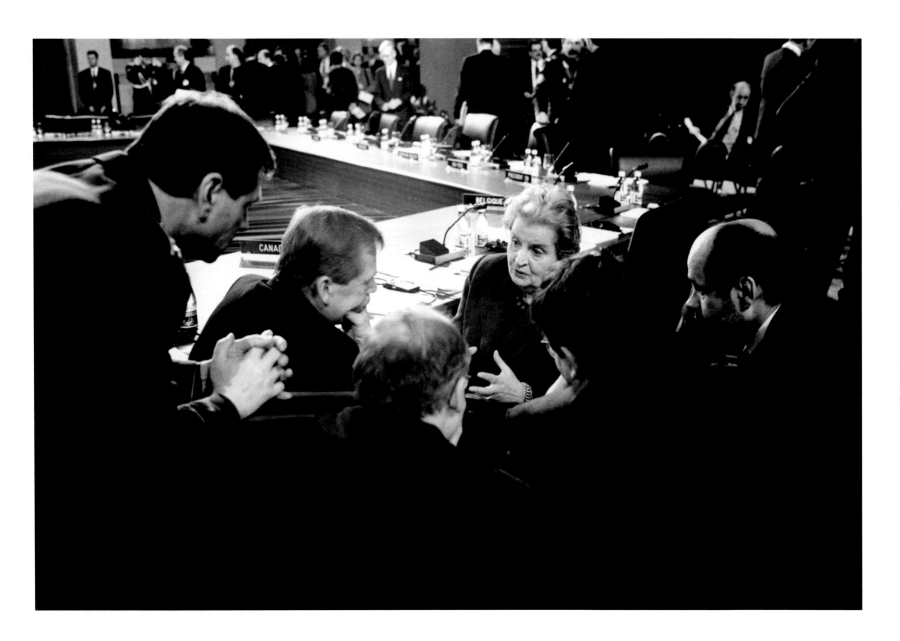

SECRETARY ALBRIGHT TALKING, in Czech, to Czech President Vaclav Havel, at a NATO meeting in Washington, D.C., April 24, 1999
"I didn't meet Havel until 1990. I gave him a copy of my father's book, *Twentieth-Century Czechoslovakia*. As I am handing him the book, he says 'So, Mrs. Fulbright,' and I say, 'No, I am Mrs. Albright.' We have been friends ever since."—M.A.

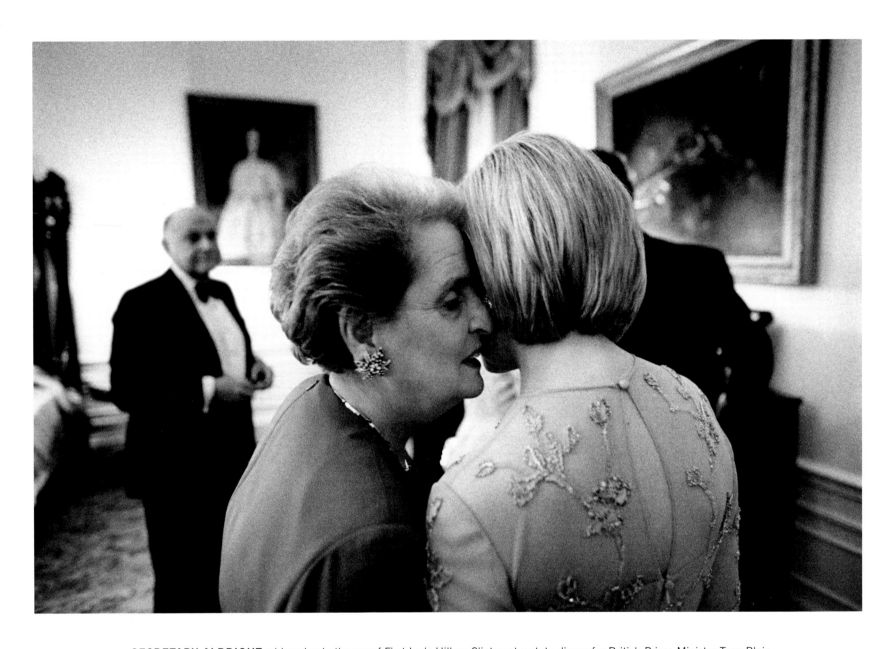

SECRETARY ALBRIGHT whispering in the ear of First Lady Hillary Clinton at a state dinner for British Prime Minister Tony Blair, February 5, 1998. "Since she'd be sitting next to the guest of honor, before most White House dinners, I would just quickly tell her about the most recent developments between our two countries. With Blair, for instance, we had a lot of issues to do with the Balkans."—M.A.

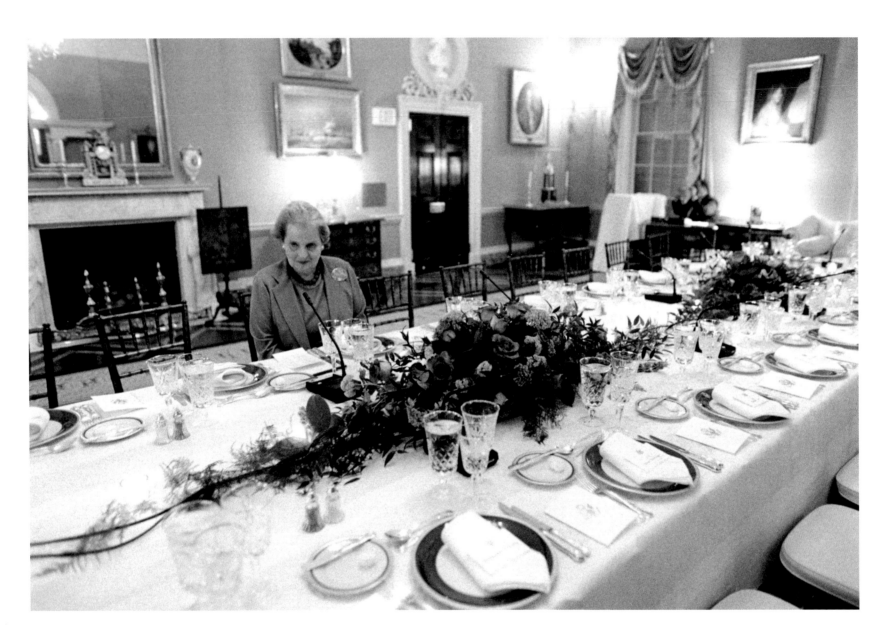

AT THE TABLE in the State Department's Jefferson Room before a dinner for foreign ministers, April 22, 1999

"It was an interesting problem, being a woman secretary of state, and also being a hostess. Here, I had clearly thought, okay, guys, let's go in to dinner, and meanwhile, they're out in the Franklin Room, not coming in."—M.A.

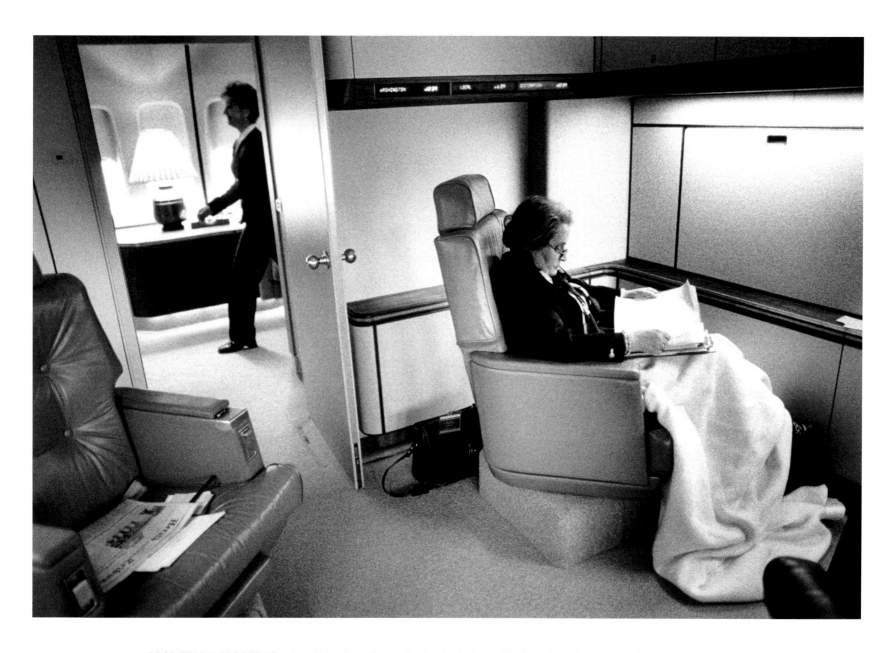

SECRETARY ALBRIGHT, aboard *Air Force One*, returning to Andrews Air Force Base from Bonn, Germany, May 6, 1999
"I traveled over a million miles as secretary of state, but not always in such comfort."—M.A.

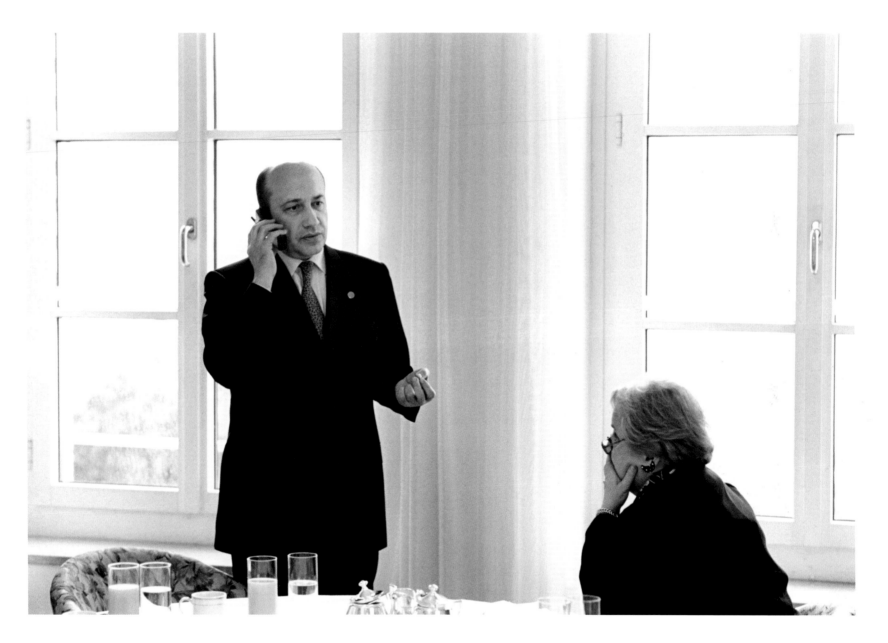

MADELEINE ALBRIGHT AND RUSSIAN FOREIGN MINISTER IGOR IVANOV at a private meeting during the G-8 meeting in Bonn, Germany, May 6, 1999. "As my going-away present, Ivanov gave me a tea set with pictures of several of the key foreign ministers that were involved in Kosovo. He called it 'Madeleine and her Dream Team.' Well, people ask about friendship. That's friendship."—M.A.

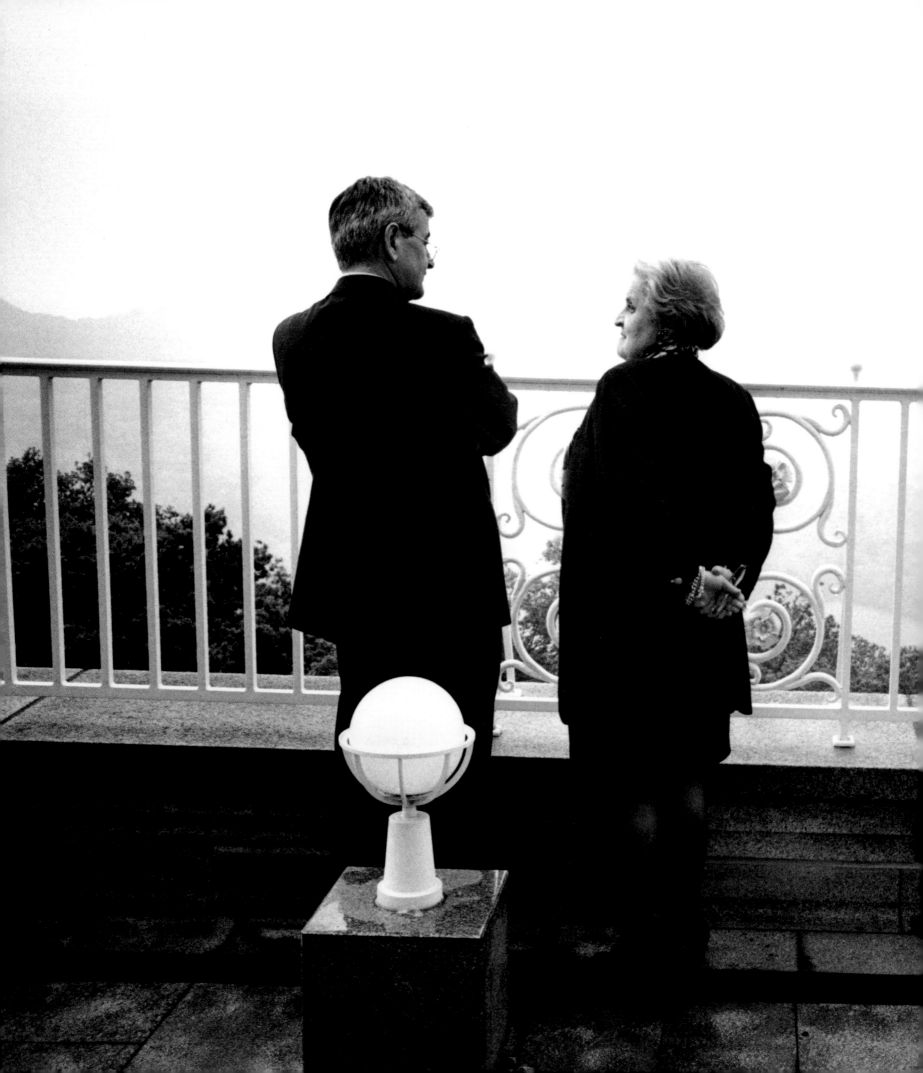

MADELEINE ALBRIGHT
on a balcony overlooking
Bonn with Joschka Fischer,
foreign minister of Germany,
May 6, 1999. "Joschka Fischer
and I got to be very, very good
friends, and a lot of it had to do
with Kosovo. One thing I've done is
to create a group of former foreign
ministers. We have meetings all
the time under the auspices of
the Aspen Institute. We take up
different foreign policy issues and
have very frank discussions without
our 'national positions.' Nobody
says, this is what the U.S. thinks,
or this is what Germany thinks.
So we're putting together a lot
of experience and have very good
discussions."—M.A.

POLITICS

Covering politics in Washington means that you shoot everything from presidential campaigns and debates to inaugural balls, from political appointees to White House staff, from members of Congress to members of the Cabinet. Speechwriters, bag carriers, administrative assistants, press secretaries; they all come under my political umbrella. In this section is a photograph of Henry Kissinger (page 44) from my earliest days as a photographer. It's of the back of Kissinger's head—clearly I was a novice, but I love this strange "grab shot" taken in the Ford White House.

On the following pages I start off with pictures of Pamela Harriman, who successfully raised money for the Democratic Party, helping Bill Clinton and Al Gore get to the White House in 1992. President Clinton appointed her U.S. ambassador to Paris. The pictures of Pam in this section show her when she first arrived in Washington and years later on the day she was appointed to Paris, looking proud and successful, at the top of her form. Later I was delighted to be assigned by *LIFE* magazine to photograph her in Paris, where she seemed to wow the French with her language skills and her charm.

I covered one campaign in its entirety. For 16 months straight, I followed Fritz Mondale, who ran for president in 1984. He had been a greatly respected senator from Minnesota and Vice President under Jimmy Carter. It was an amazing, fascinating experience, though a grueling one. Being so close to the campaign for that long, I could pretty much tell the moods of the staff, and that of Mondale himself. Coming upon Mondale and his friend John Reilly in quiet conversation (opposite), I thought they both looked shell-shocked. I quietly released the shutter, and moved on.

After being defeated by Gary Hart in the New Hampshire primary, Mondale used the phrase "Where's the Beef?", adapted from a TV slogan, to dispatch Senator Hart. Mondale became the Democratic nominee and ran against Ronald Reagan, who won reelection by a landslide. The entire Mondale family displayed heart, grace, and dignity through it all.

There are other places in this book where you will find politics. It permeates all of my work over the years. Certainly Hillary Clinton, Madeleine Albright, and Al Gore belong in this category, but they have sections of their own, since I photographed them extensively over the years. I first photographed Al Gore in 1976.

This is a chapter of political moments: my lifeblood for 30 years.

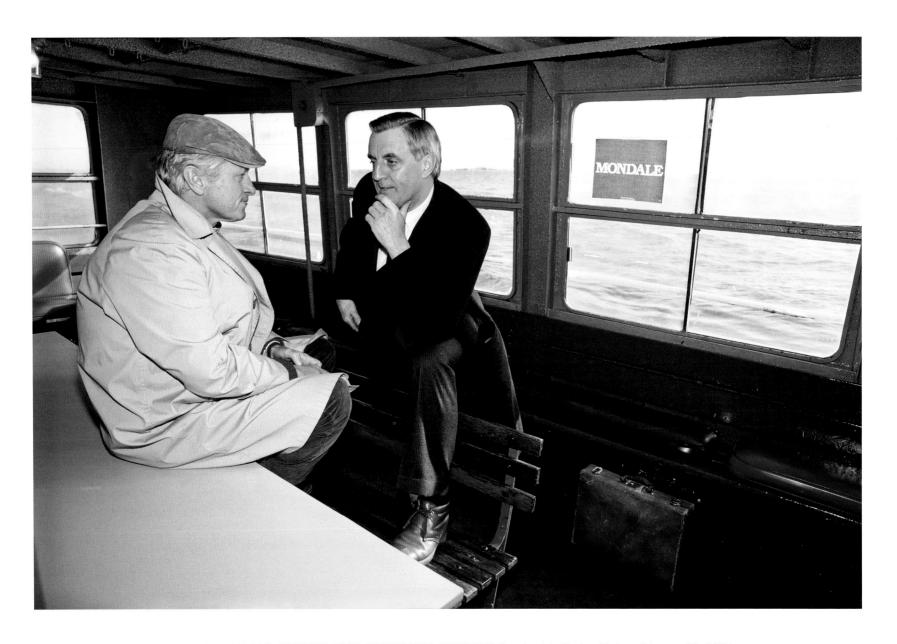

JOHN REILLY AND FORMER VICE PRESIDENT MONDALE On a boat in Boston Harbor, February 27, 1984
"I discovered later that this was the moment when senior campaign aide John Reilly delivered the tough news to Mondale that private poll projections had Senator Gary Hart winning the next day's all-important New Hampshire primary in a big upset."—D.W.

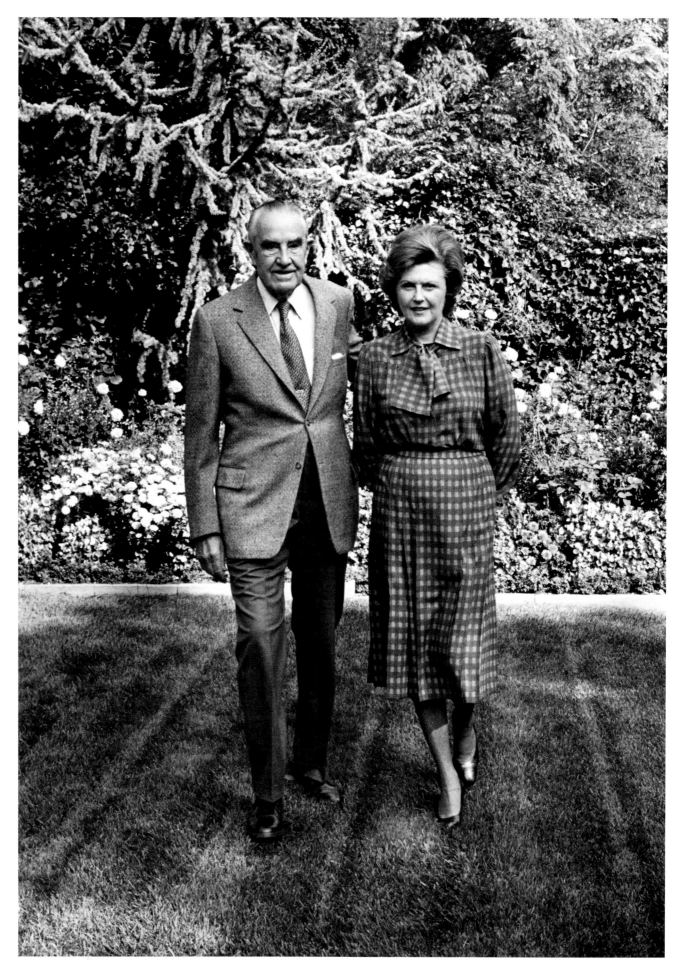

**W. AVERELL HARRIMAN
AND PAMELA HARRIMAN**
Governor Harriman (1891–1986)
walks with his wife, Pamela
(1920–1997), in their
Georgetown garden, not long
after their 1971 marriage.

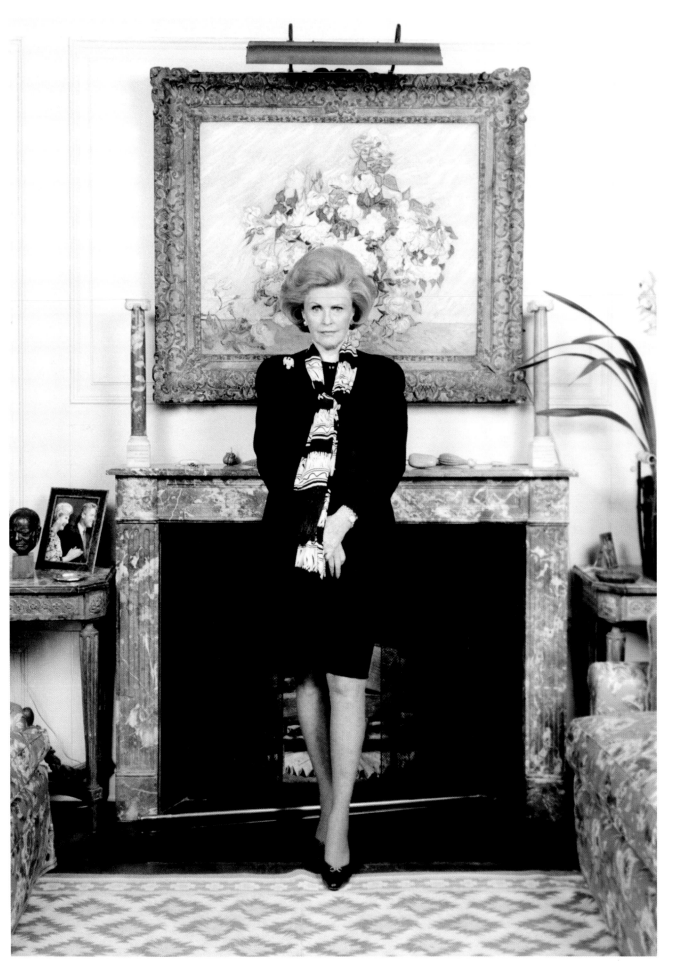

AMBASSADOR DESIGNATE PAMELA HARRIMAN

"Pam looks in this 1993 photograph just as I saw her that day, at the top of her form—about to go off to Paris where she served as U.S. ambassador from 1993 until her death in Paris in 1997."—D.W.

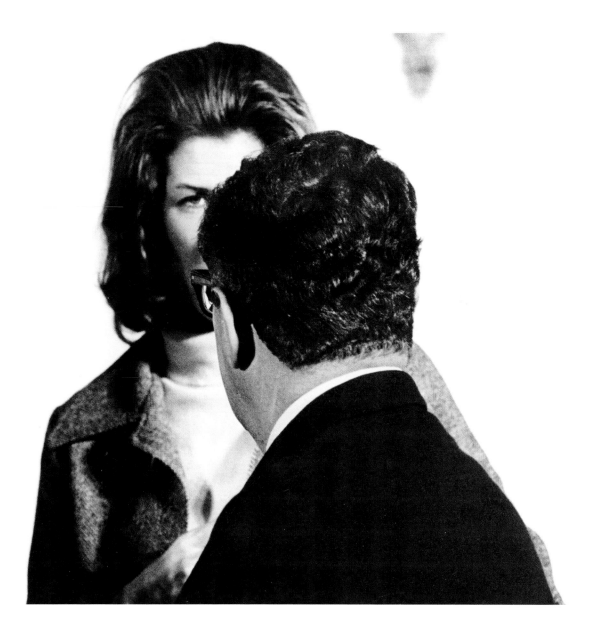

SECRETARY OF STATE HENRY KISSINGER AND NANCY KISSINGER
"I made this serendipitous shot on perhaps my second or third White House shoot, as the Kissingers attend an East Room arrival ceremony during the Ford Administration." November 12, 1974 —D.W.

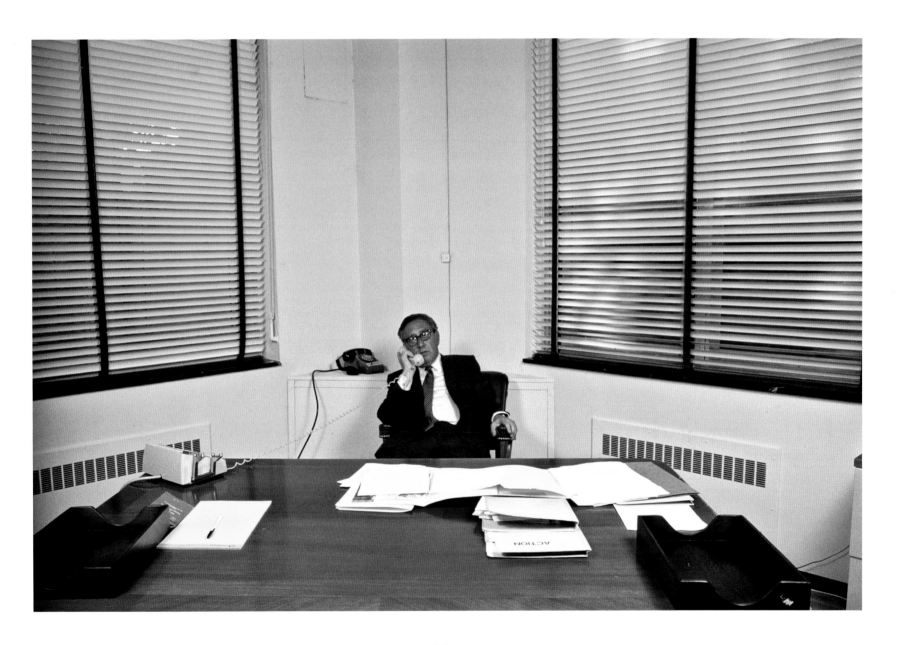

HENRY KISSINGER
No longer secretary of state, Kissinger occupies temporary offices at the State Department in his role as
chairman of the National Bipartisan Commission on Central America, August 1983.

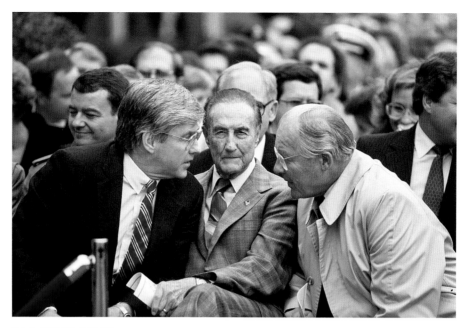

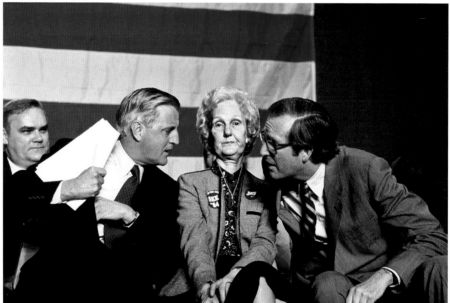

Top: **JACK KEMP,
STROM THURMOND, AND
ROBERT MICHAEL**
March 1989

Middle: **FRITZ MONDALE,
ERMA ORA BYRD, AND
JAY ROCKEFELLER**
November 1984

Bottom: **JOSEPH ALSOP,
NANCY KISSINGER, AND
ROBERT MCNAMARA**
October 15, 1979

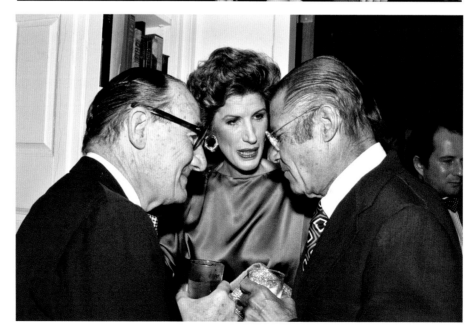

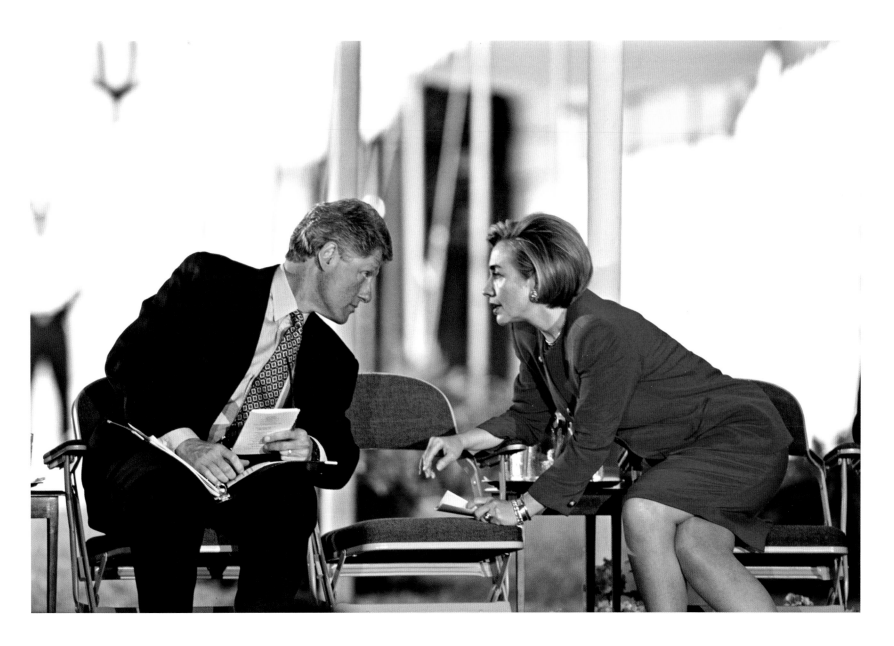

PRESIDENT BILL CLINTON AND HILLARY CLINTON
The Clintons at an event on the South Lawn of the White House, April 29, 1994

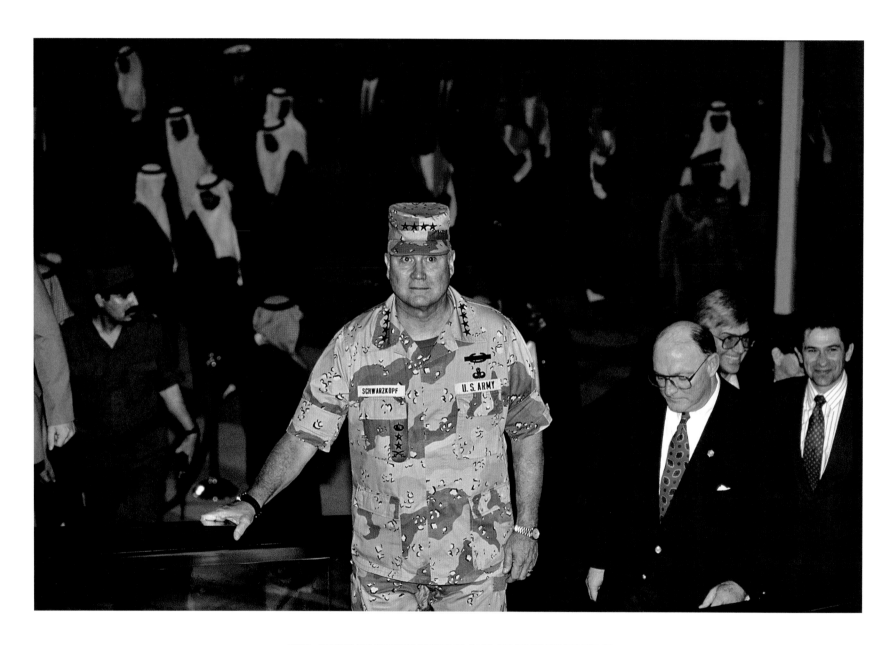

GEN. NORMAN SCHWARZKOPF AND MARLIN FITZWATER
General Schwarzkopf, after welcoming President George H.W. Bush to Saudi Arabia prior to the Desert Storm offensive, Thanksgiving, 1990

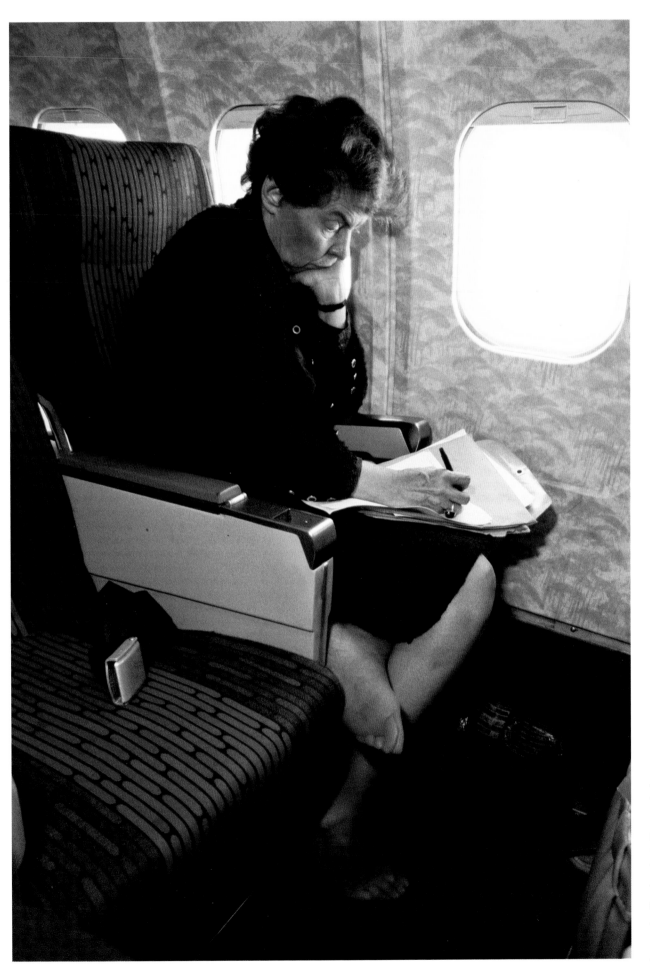

JEANE J. KIRKPATRICK
"I followed UN ambassador Kirkpatrick for several days as she traveled back and forth between Washington and New York on the shuttle. I had always thought her formidable, but she became more accessible after we discovered our mutual love of Siamese cats."
June 1983 —D.W.

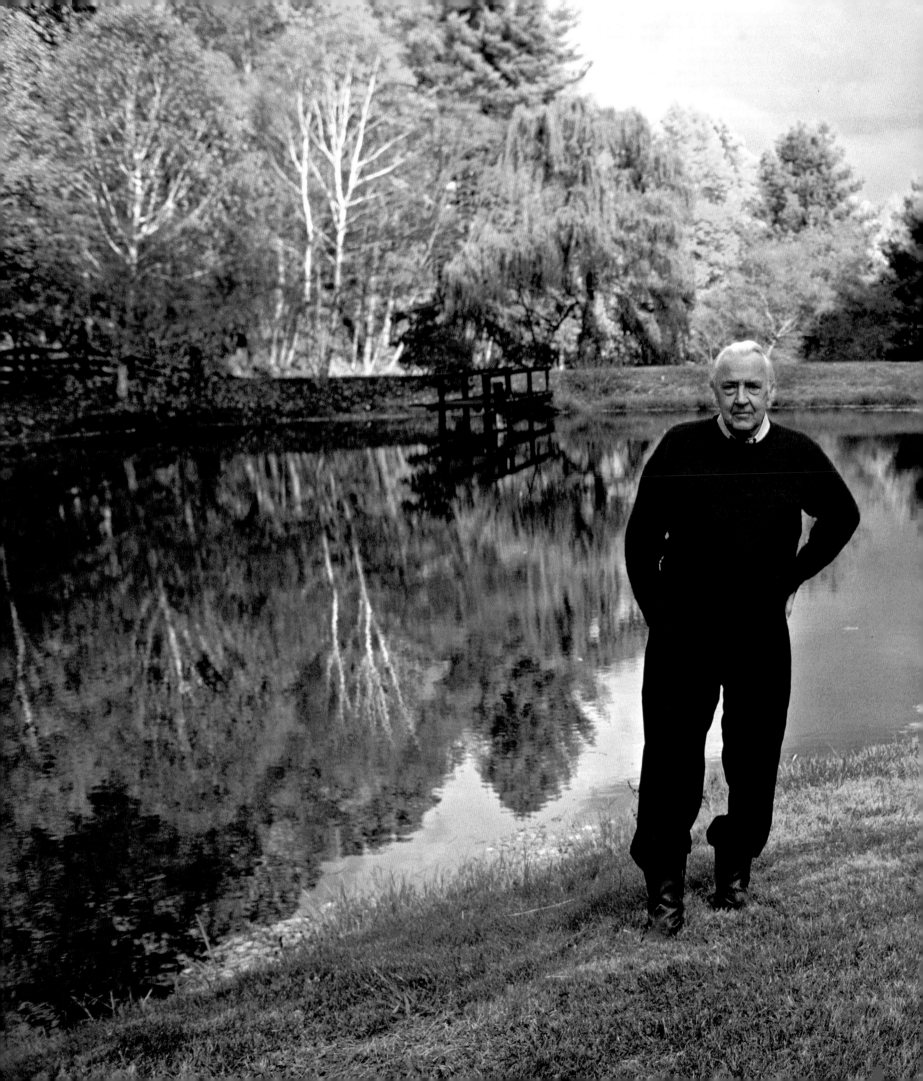

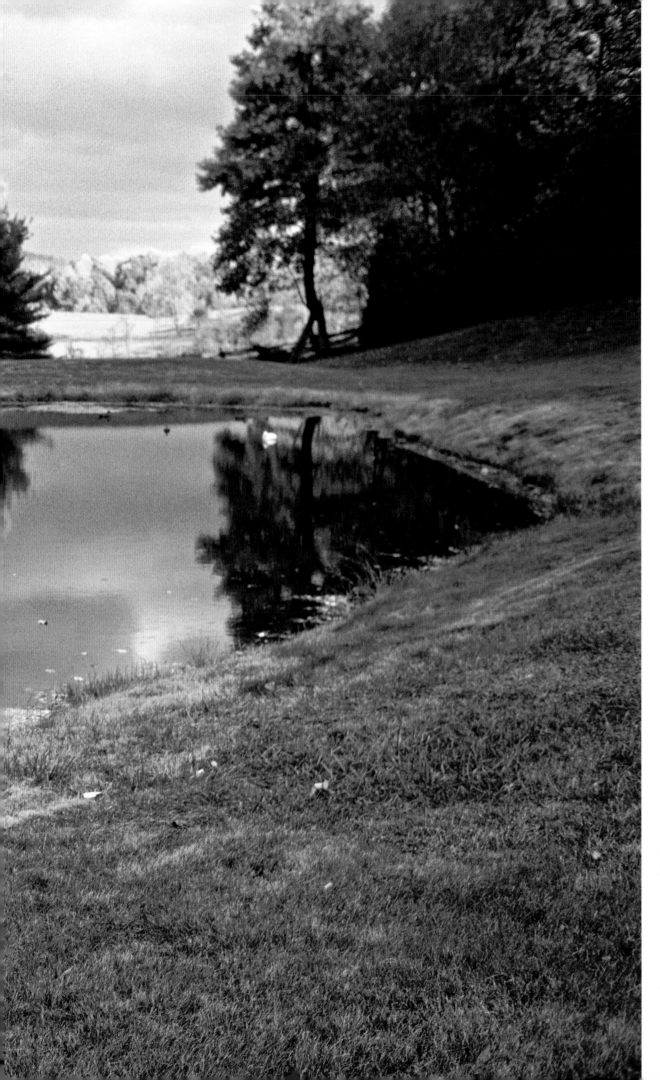

EUGENE MCCARTHY

"I vividly remember Senator McCarthy (1916–2005) as the anti-Vietnam War candidate in the turbulent year of 1968. Twenty years later, I photographed him at his home in this stunningly beautiful and tranquil place near Sperryville, Virginia, a polar opposite from the madness of the campaign trail and the hubbub of Capitol Hill."—D.W.

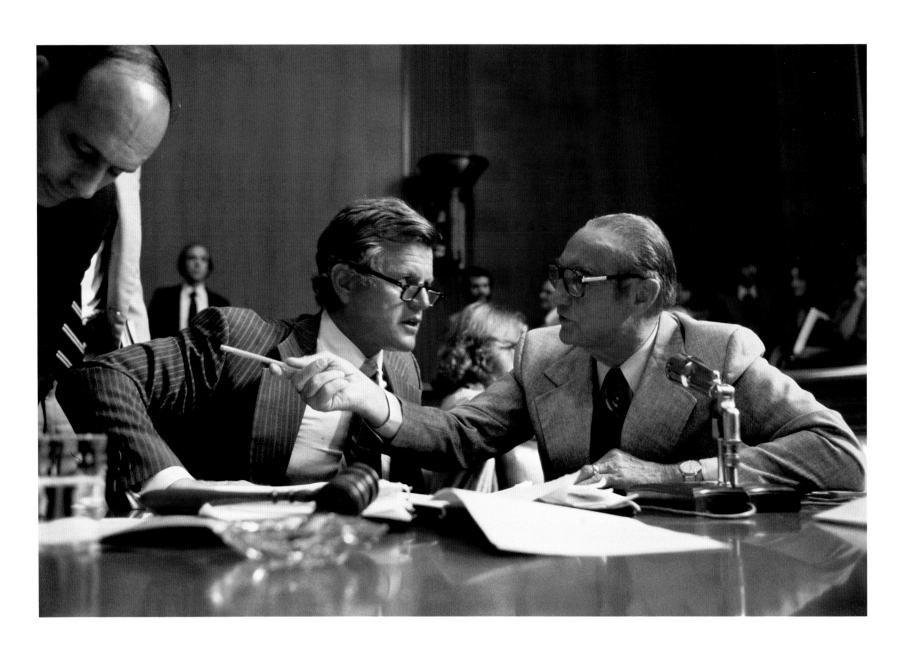

SENATORS EDWARD KENNEDY AND STROM THURMOND

Ted Kennedy and Strom Thurmond (1902–2003) voted together to confirm a federal appeals court judge, September 1979.

MILLICENT FENWICK

"My assignment was to photograph the congressman who was sitting next to Millicent Fenwick in this hearing room, but I was fascinated to see the congresswoman light up her pipe." April 4, 1978 —D.W.

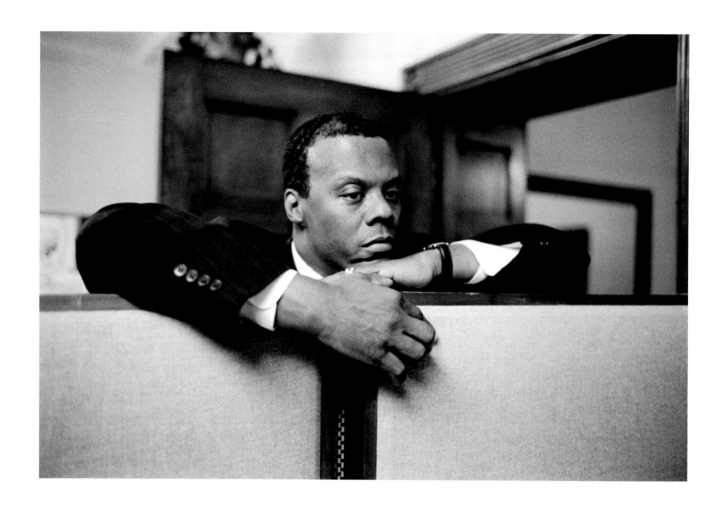

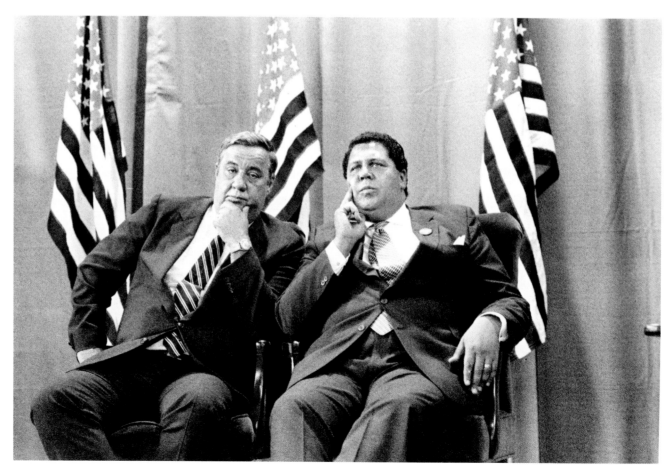

Top: **J.C WATTS**
Congressman Watts
in his Capitol Hill office,
March 1999

Bottom: **BERT LANCE
AND MAYNARD JACKSON**
Georgia Democratic
Chairperson Lance, and
two-time Atlanta mayor
Jackson, at a Mondale
campaign event, 1984

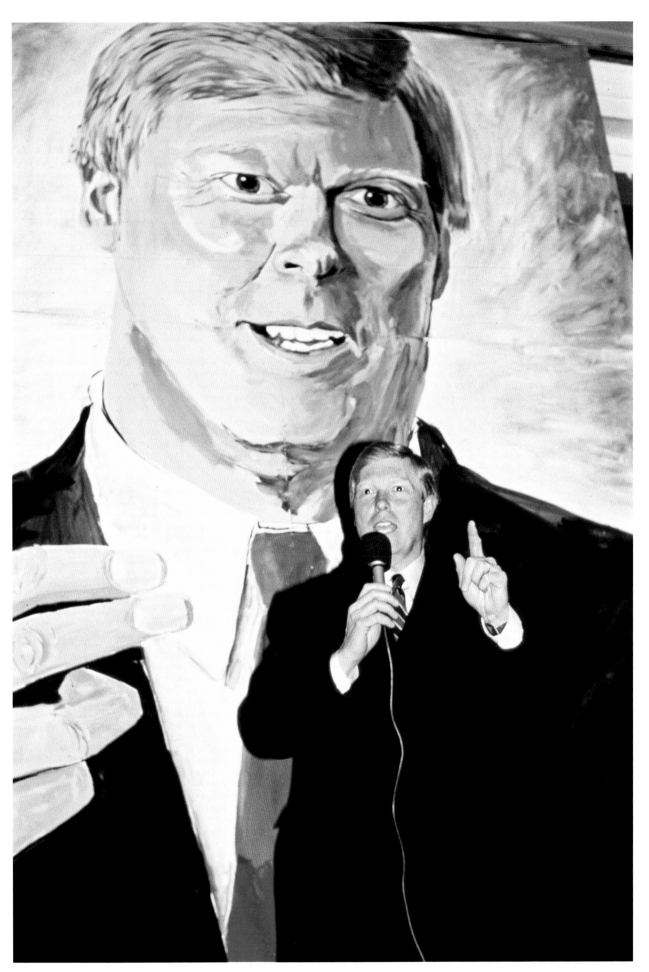

RICHARD GEPHARDT

"Sometimes the backdrops for candidates created by enthusiastic volunteers reach the absurd. This is Congressman Gephardt, larger than life, in New Hampshire, campaigning for the presidency in January 1988."—D.W.

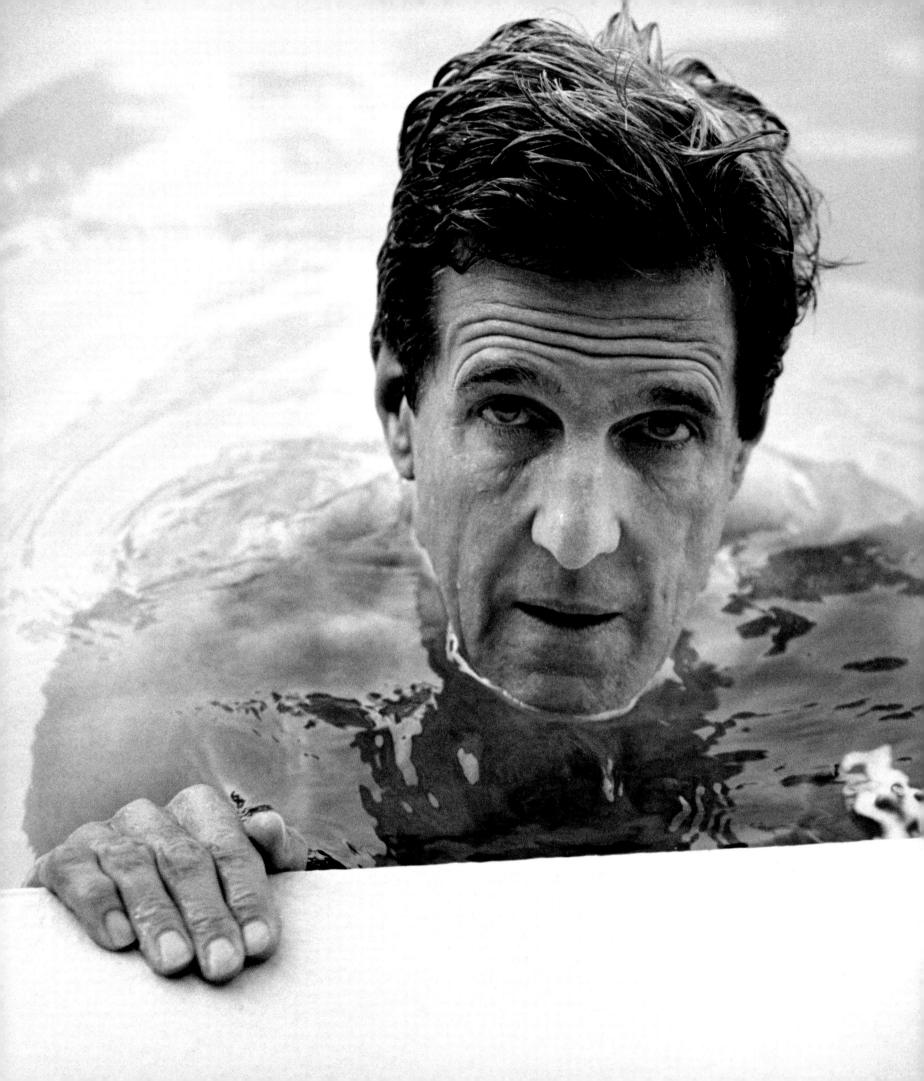

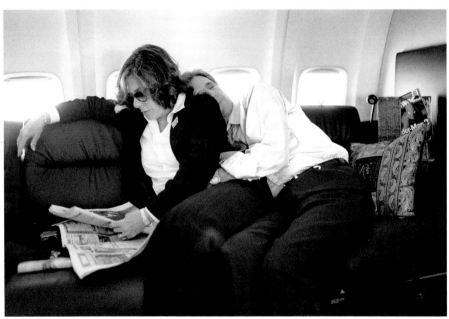

JOHN KERRY

Left: Senator Kerry takes a swimming break on the campaign trail.
Above, top: Senator Kerry and his wife, Teresa Heinz Kerry, campaign in Ohio.
Above, bottom: Exhaustion at the end of an intense week on the road, July 2004. "To me this picture is what behind-the-scenes photography is all about. It illustrates how tiring the campaign trail can be. A picture like this could never have been taken by a pool of photographers."—D.W.

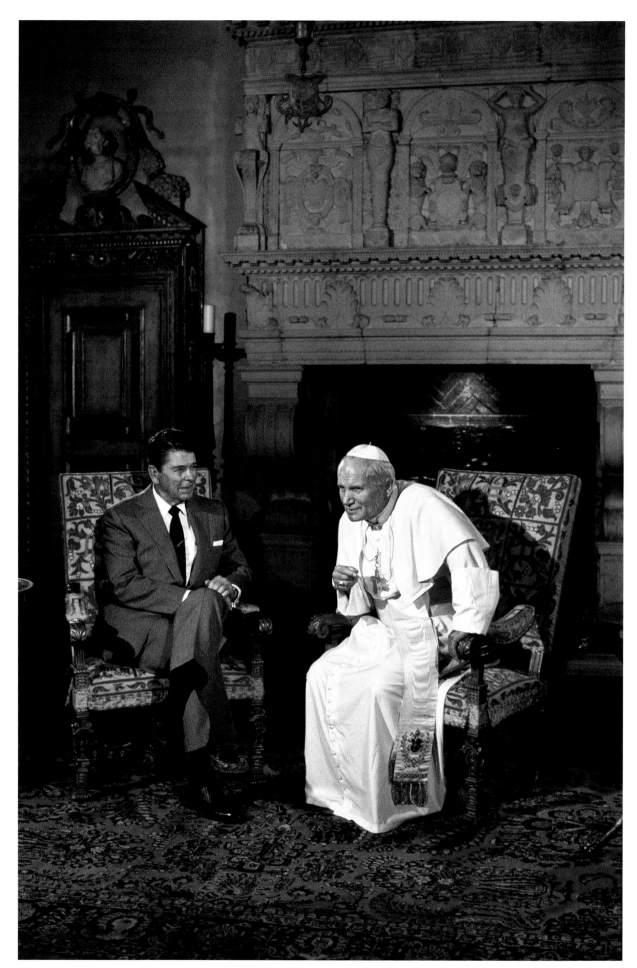

**PRESIDENT RONALD REAGAN
AND POPE JOHN PAUL II**
President Reagan (1911–2004)
and Pope John Paul (1920–2005)
meet in Miami, Florida, at the
Vizcaya Museum and Gardens,
September 10, 1987.

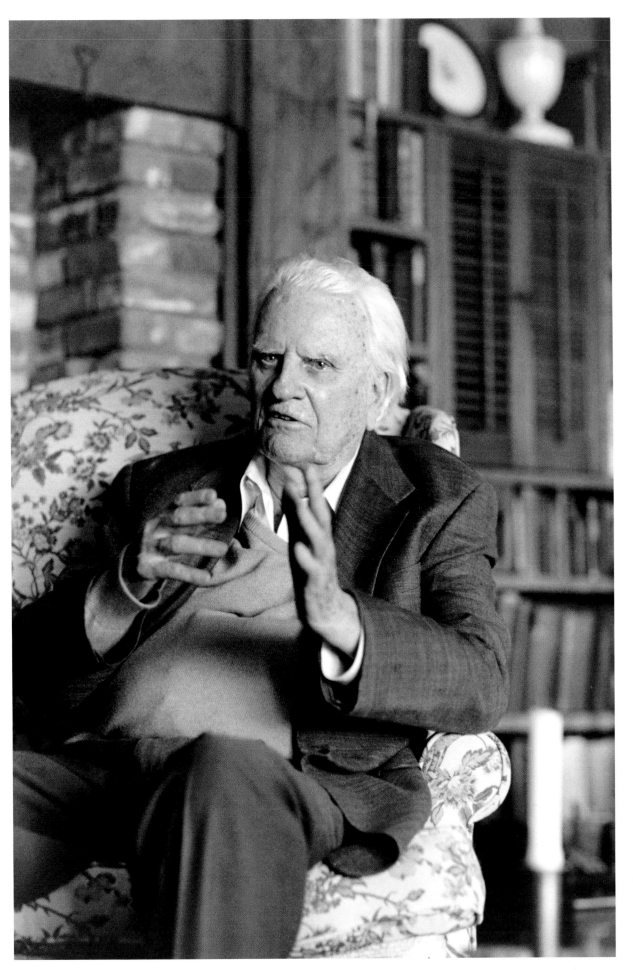

**THE REVEREND
BILLY GRAHAM**
At home near Montreat,
North Carolina,
January 18, 2006

From my conversation with **STEVE JOBS**

"In the 12 years I was away from Apple, I met Laurene, started a family, and started NeXT and Pixar. Pixar was like a big hill to climb for the first ten years, always uphill, no rest, no plateau, just always uphill. But then, with *Toy Story* it became a wonderful success, surprising everyone, and it's been nothing but fun since then.

"None of the computers we're shipping today will be used by anyone in 50 years. Creating technology is like laying down a sedimentary layer—layers of sediment that will support what others build above it, but that nobody will ever see again once they do. Pixar's work is very different. People will still be watching Pixar's films a hundred years from now, just as they watch *Snow White*, a 75-year-old movie, today. I guess that's the difference between art and technology.

"When I got back to Apple, the company was 90 days away from bankruptcy, so it was like trying to pull back on the stick of a plane that was diving right into the ground. Trying to miss the ground, get enough altitude to survive, and then fix it enough to stay airborne. It was tough, much more difficult than I thought it would be. I would get home at night and I literally couldn't speak. I was so drained I couldn't speak.

"Being able to return to Apple after 12 years and lead a great team of people to turn Apple around and bring it back to what it should have been has taken a tremendous amount of work by a lot of people, but it's also been a wonderful experience. And now the company is healthy, and we are turning out some really great products. When we introduced the Mac in 1984, we knew that someday every computer was going to work like the Mac. No knowledgeable person could really debate it; all computers would work that way. It was just a question of how long it would take. And I feel the same way about the iPhone."

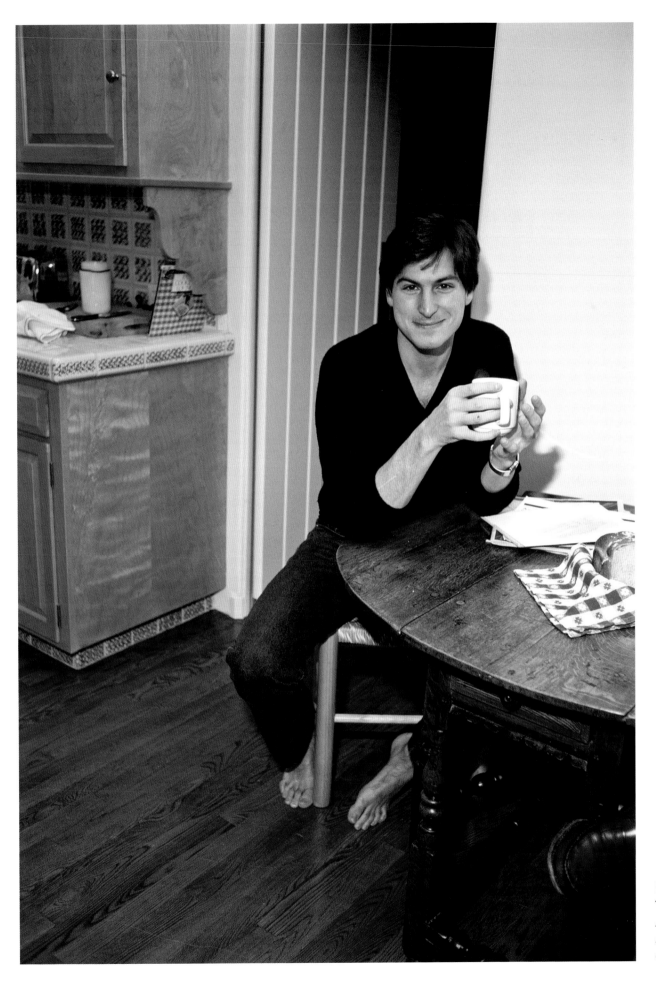

**MY FIRST TRIP
TO PHOTOGRAPH**
Apple's co-founder, Steve Jobs,
at his home in Los Gatos,
California, December 15, 1982

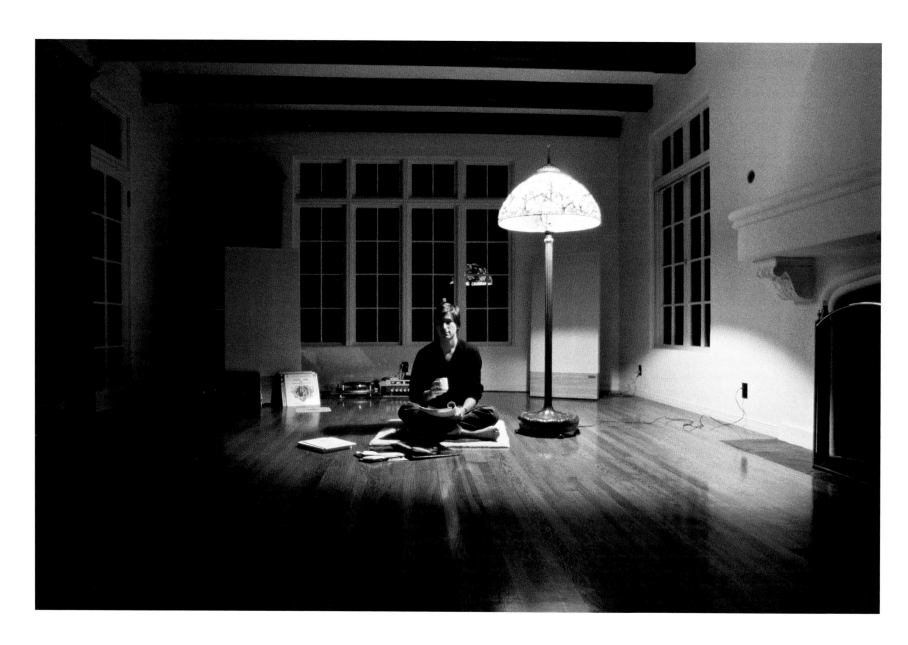

STEVE JOBS AT HOME IN 1982

"This was a very typical time. I was single. All you needed was a cup of tea, a light, and your stereo, you know, and that's what I had."—S.J.

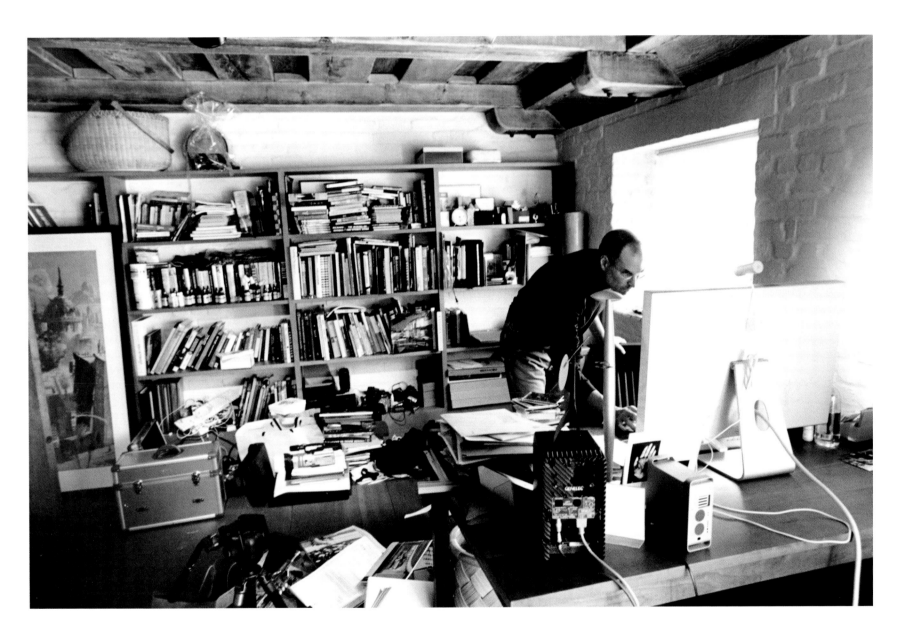

STEVE JOBS AT HOME IN 2004

"Well, you know, the physical plane gets cluttered, but the mind remains…empty."—S.J.

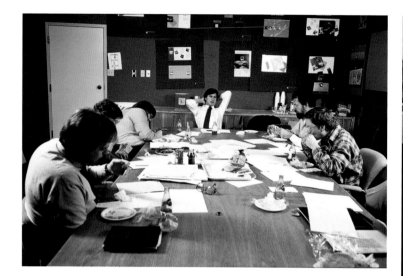

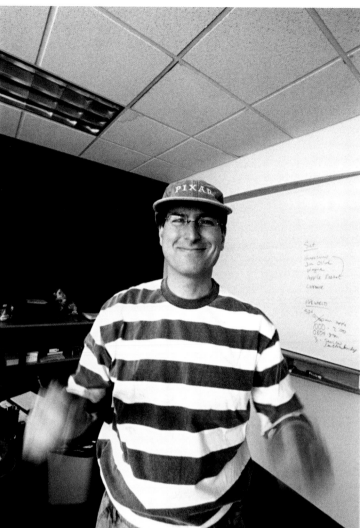

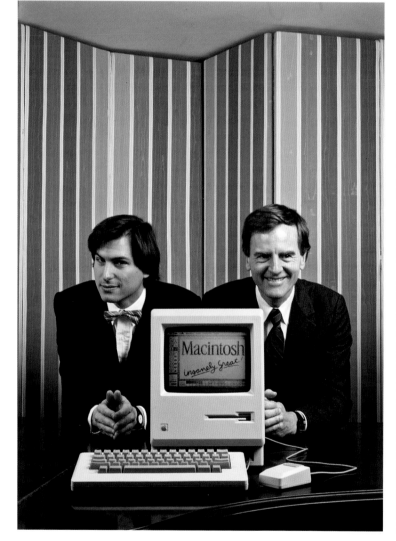

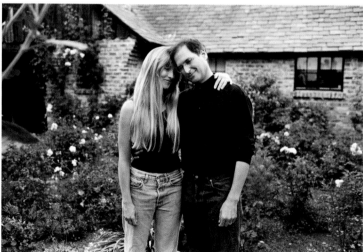

STEVE JOBS, OVER THE YEARS
Top left: Steve Jobs and employees of Apple around the conference table, working on the Macintosh, 1982;
Bottom left: Steve Jobs and new Apple CEO John Sculley presenting the Macintosh, Apple's new personal computer, in New York City,
January 30, 1984; Top right: The early days at Pixar, 1997; Bottom right: Laurene and Steve at home, August 1997

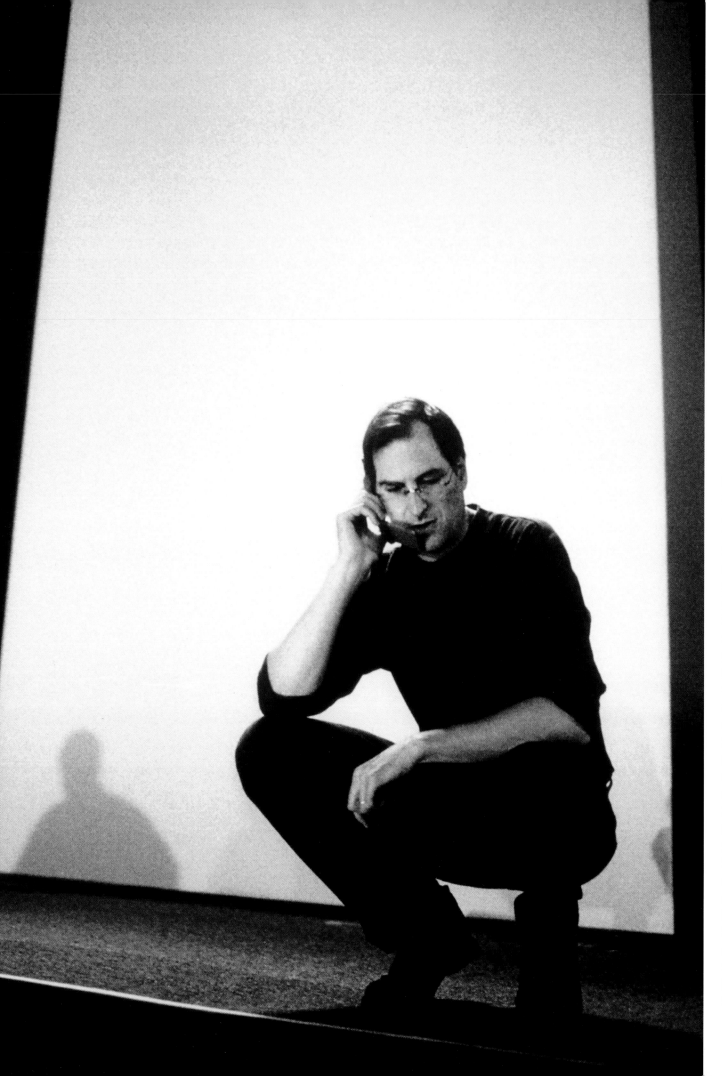

STEVE JOBS AT MACWORLD, AUGUST 6, 1997

"Because *TIME* expected some kind of announcement by Steve at MacWorld, I was assigned to follow him from California to Boston. While doing a run-through of his presentation the night before, Steve took a telephone call. Somehow the call seemed very important, and working quietly in the wings in a nearly dark auditorium, I kept shooting, holding my Leica, loaded with fast film, as steady as I could. It was not until the next morning that we found out that Steve and Bill Gates of Microsoft had formed a strategic alliance solving their intellectual property dispute, and Gates investing $150 million in Apple stock. My picture editor was able to tell our managing editor that I was the only photographer to shoot this extraordinary phone call between Gates and Jobs. We were very lucky; our reporter had scored, and with this image, I had the cover of *TIME*."—D.W.

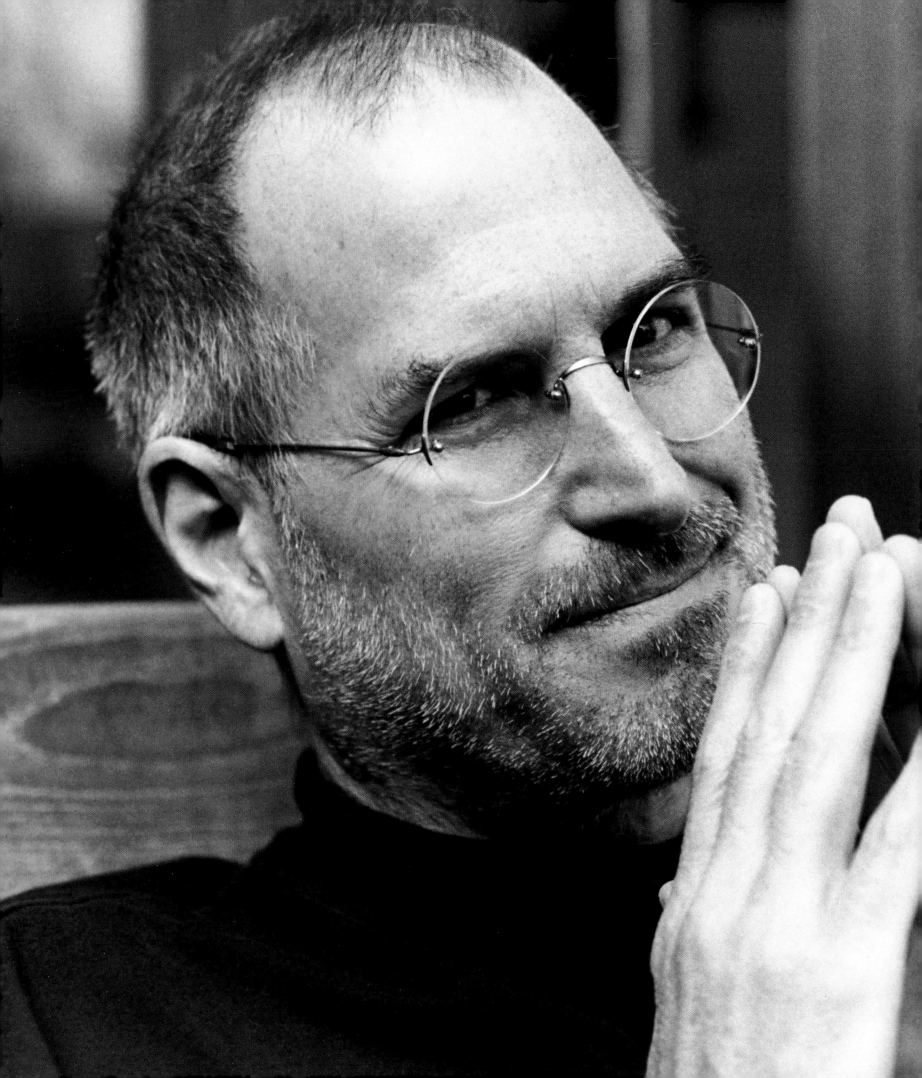

**STEVE AT HOME,
DECEMBER 7, 2004**

"The year of my surgery...
it definitely orders your priorities. My
son was 12 at the time. My father had
almost died when I was 12, so I know
what he was going through. It was
very tough, but it brought us all closer
together."—S. J.

PRESIDENTS

I got my feet wet on presidential travel with President Jimmy Carter. I was very green. Packing the right equipment was a huge problem for me. I carried too many cameras and lenses, and never enough film. I remember being so discouraged by the Secret Service agents surrounding the President, who never seemed to allow photographers a clean shot. As if that were their job! I had so much to learn. But a picturesque setting finally greeted us in California—all those American flags (opposite)!

On the next page, I give you pictures I shot in 1979 and 1981, each of a future President, though who would have guessed it back then. I covered the Reagan, Bush '41 and Clinton Administrations for *TIME* magazine, rotating in and out with colleagues on a monthly basis. I had many opportunities to go "behind the scenes"— being allowed quickly in and out of situations that were not open for press coverage. For these opportunities, I shot black-and-white film. The reason there are many more black-and-white pictures of President Clinton than of his predecessors is that my magazine had become increasingly interested in publishing this kind of work. We often asked for, and were granted, access to do it. I continued the behind-the-scenes photography in the Gore, Kerry, and Hillary Clinton campaigns.

Because I tried to be as unobtrusive as possible in these situations, I carried quiet Leicas, fast film, and wide lenses instead of the heavy equipment required for normal open-press work. I enjoy traveling light, and I also prefer black-and-white pictures. Therefore, I use black-and-white film when I have been given special access to photograph people such as Steve Jobs, the Reverend Billy Graham, Alan Greenspan, and Madeleine Albright.

You can understand how I recently jumped at the opportunity to photograph George H.W. Bush and Bill Clinton, two former Presidents, now good friends working together for the people of New Orleans (pages 96–97). Although the room was bare and the light poor, I was thrilled to see once again in my viewfinder these men I'd covered for so long—Bush for 12 years, Clinton for 8. I looked for a connection between them, evidence of their friendship, and there it was, just with a touch, clear as a bell.

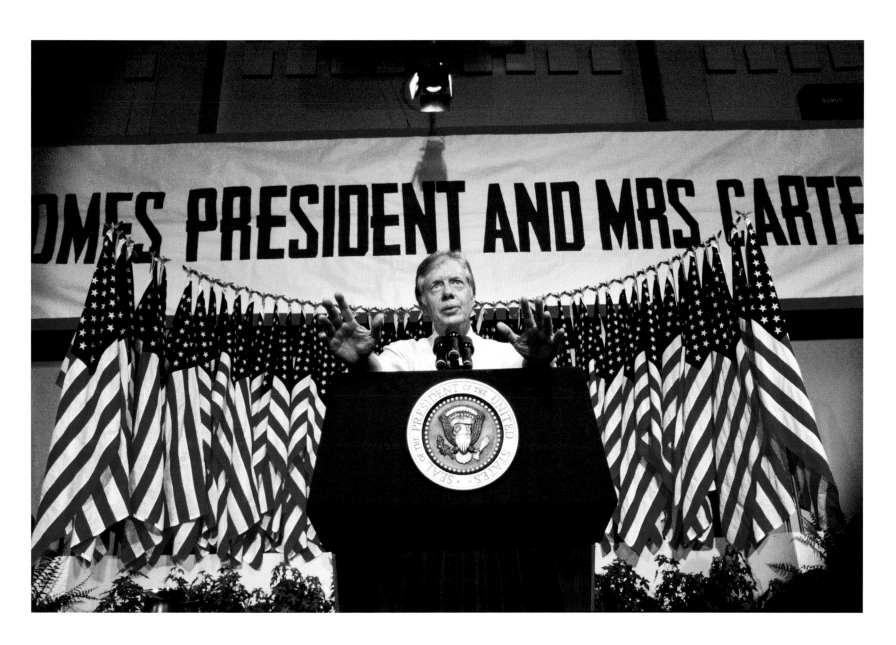

PRESIDENT JIMMY CARTER
My first presidential trip was with Jimmy Carter to Merced, California, July 4, 1980.

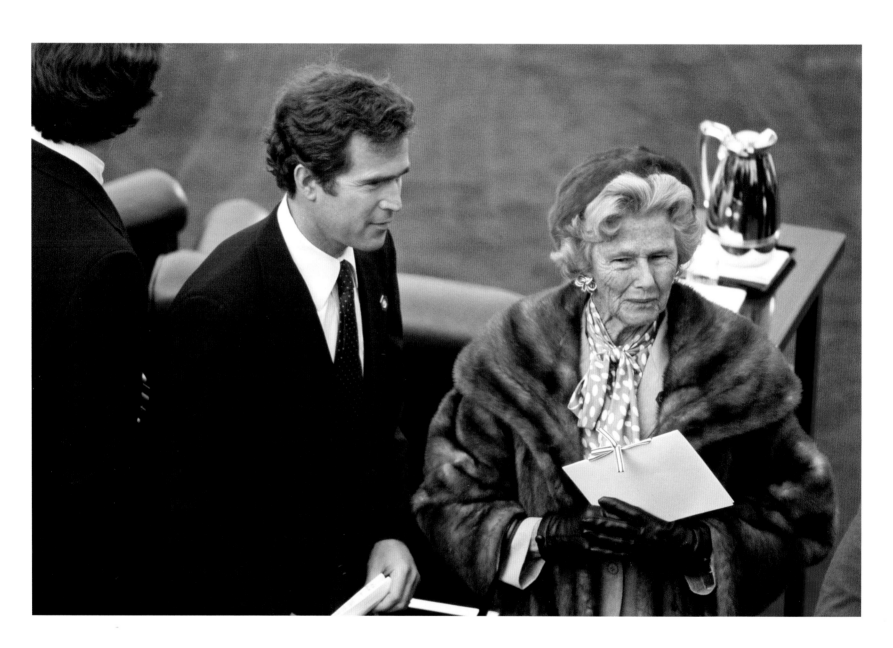

GEORGE W. BUSH AND MRS. PRESCOTT BUSH
"In this January 20, 1981, picture, Mrs. Bush (1901–1992) has just seen her son sworn in as Ronald Reagan's
Vice President. Who would have predicted that her grandson, escorting her to this ceremony,
would be sworn in as President exactly 20 years later."—D.W.

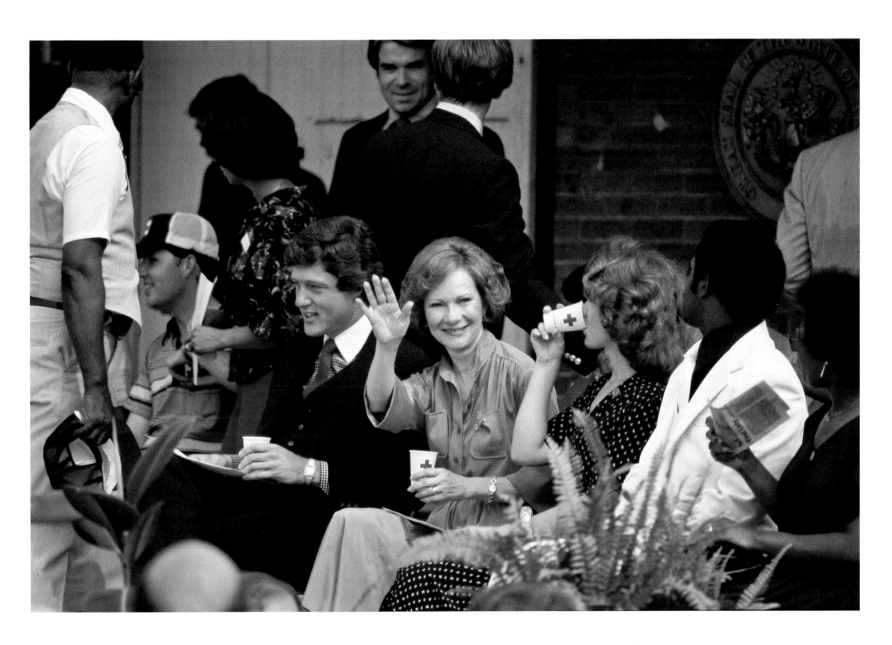

BILL CLINTON, ROSALYNN CARTER, AND HILLARY RODHAM CLINTON

In Pine Bluff, Arkansas, on a trip with First Lady Rosalynn Carter, July 23, 1979. "I photographed Mrs. Carter with the then-Governor of Arkansas and his wife. I sure didn't know I'd be seeing a lot more of the Clintons in years to come."—D.W.

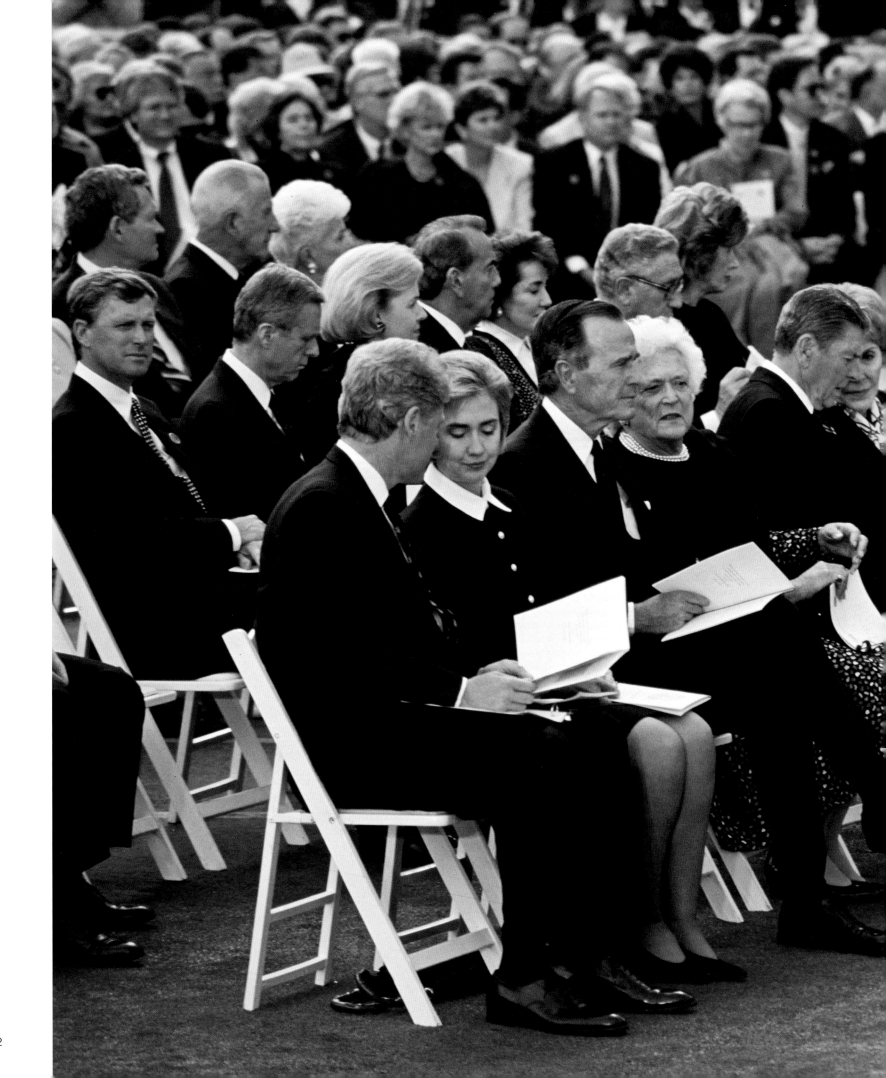

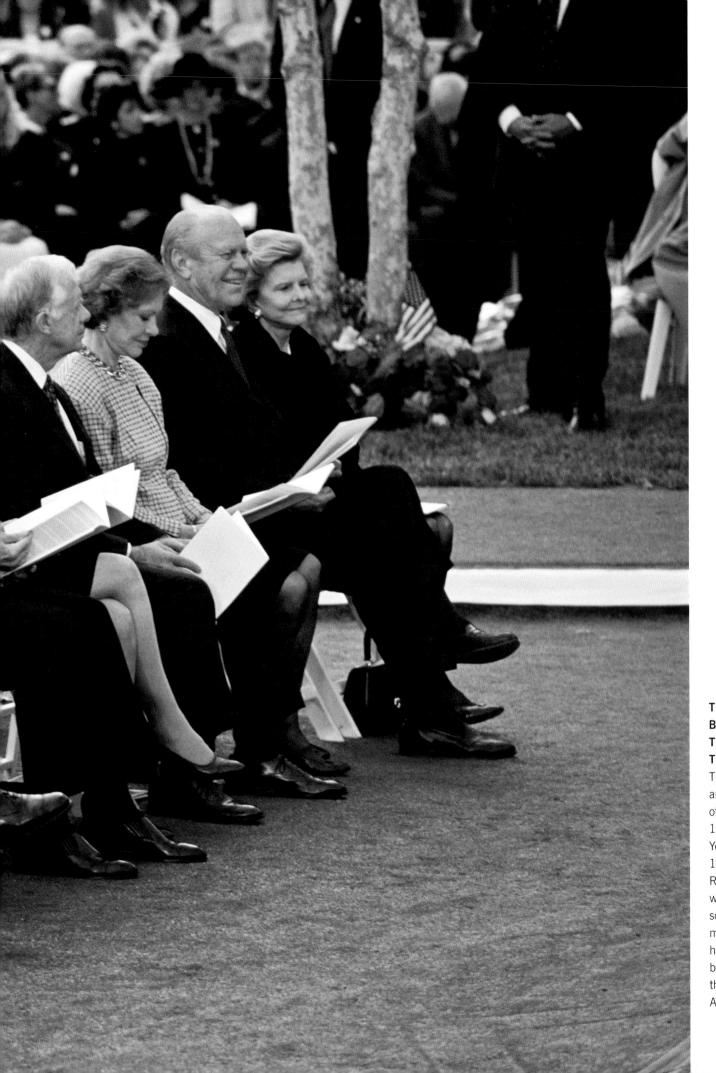

THE CLINTONS, THE BUSHES, THE REAGANS, THE CARTERS, AND THE FORDS

The five living Presidents and their wives attend the funeral of Richard M. Nixon (1913–1994) at the Nixon Library in Yorba Linda, California, April 27, 1994. "When I saw President Reagan, I knew something was wrong—he seemed tentative, somehow. It was only a few months after this day that he wrote that astonishing, brave letter letting us know that he was suffering from Alzheimer's."—D.W.

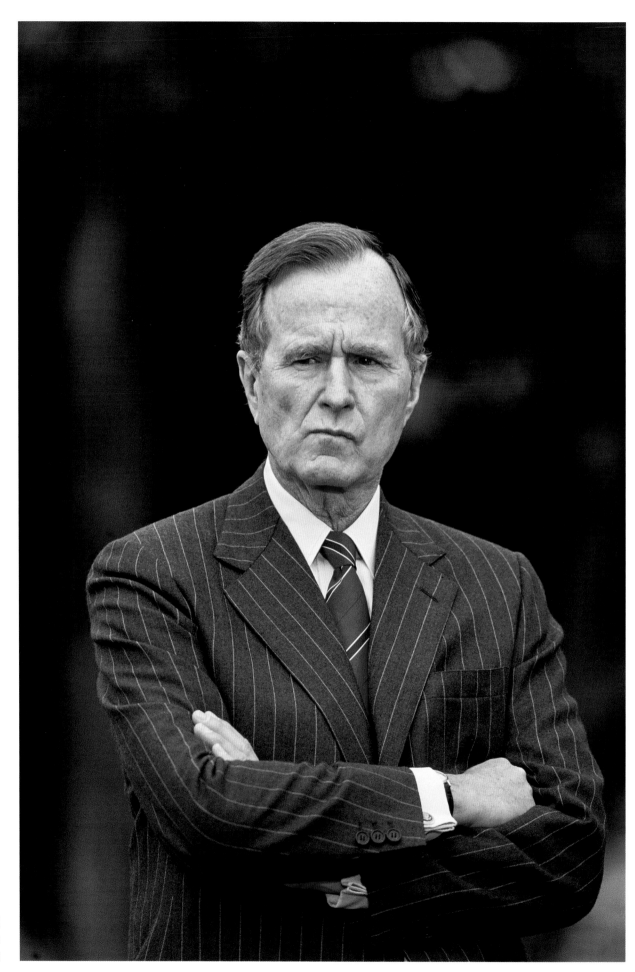

GEORGE H.W. BUSH
The first President Bush, lost in
thought, January 1990

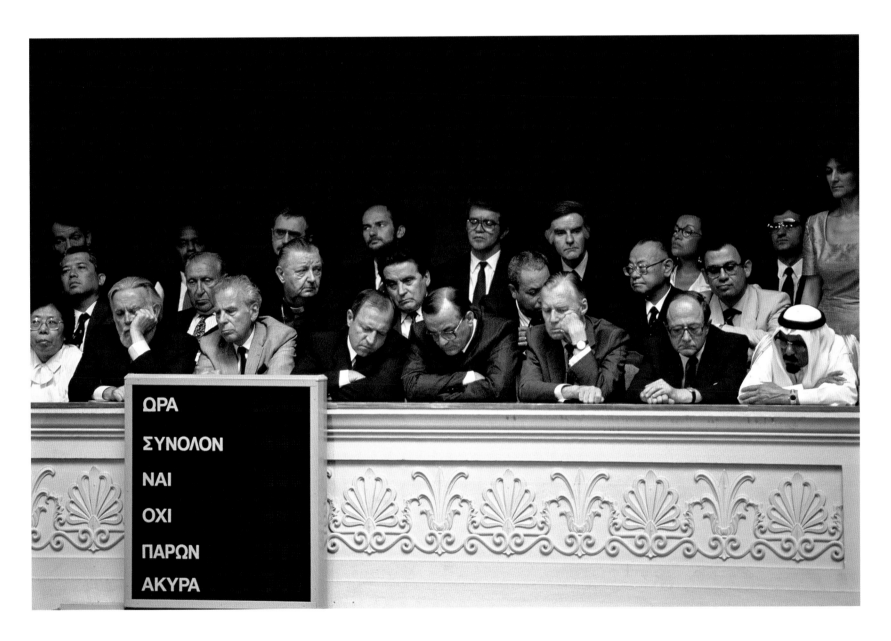

SPECTATORS ON A BALCONY

The audience listens as President George H.W. Bush addresses the Hellenic Parliament in Athens, July 18, 1991.

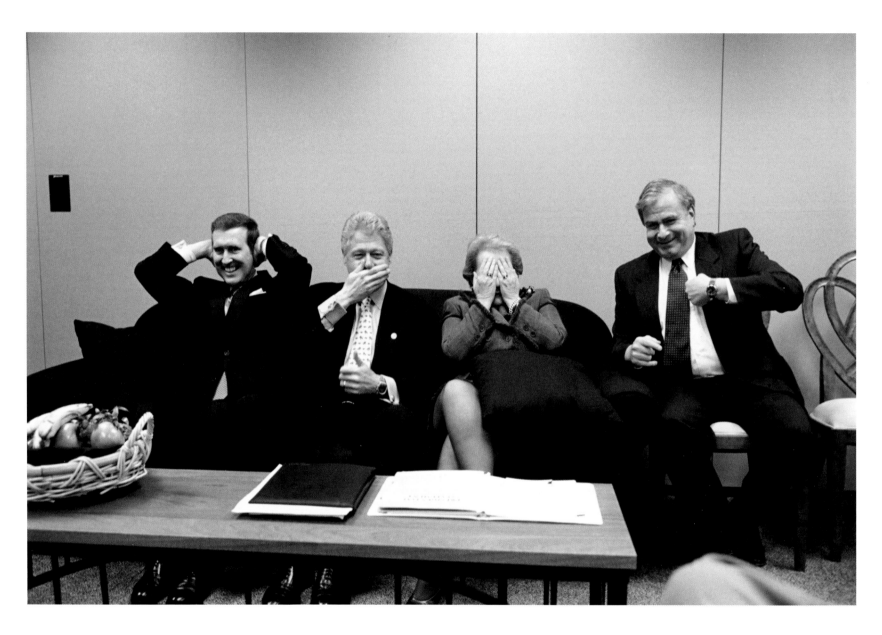

SECRETARY OF DEFENSE BILL COHEN, PRESIDENT BILL CLINTON, SECRETARY OF STATE MADELEINE ALBRIGHT, AND NATIONAL SECURITY ADVISOR SANDY BERGER at the NATO summit in Washington D.C., April 25, 1999

"Well, this was totally spontaneous. We had been in endless meetings, and finally, we were in this holding room, and we ended up on the sofa like this. I don't know who started it, the President? I love this picture."—M.A.

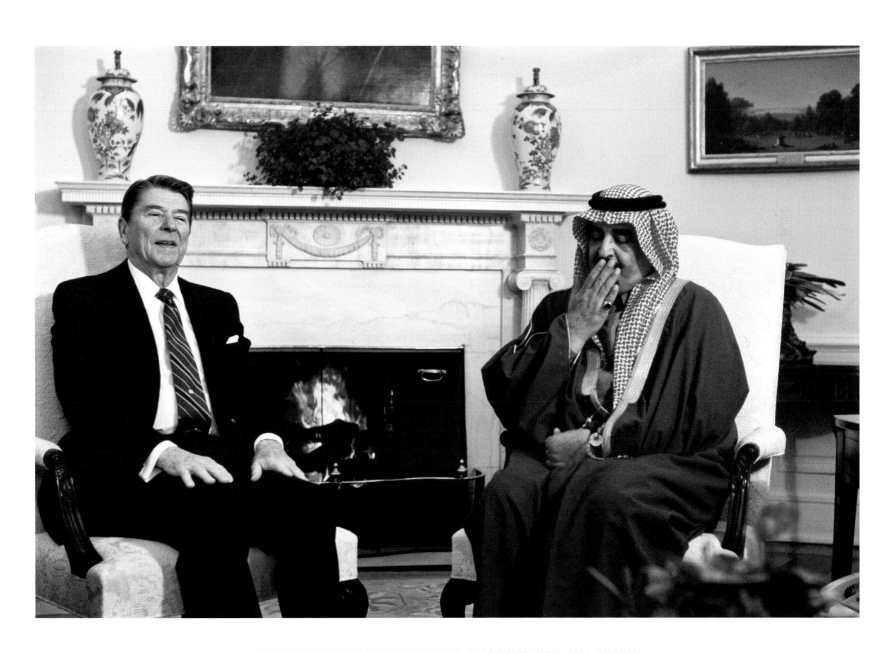

PRESIDENT RONALD REAGAN AND KING FAHD OF SAUDI ARABIA
The Oval Office, February 11, 1995

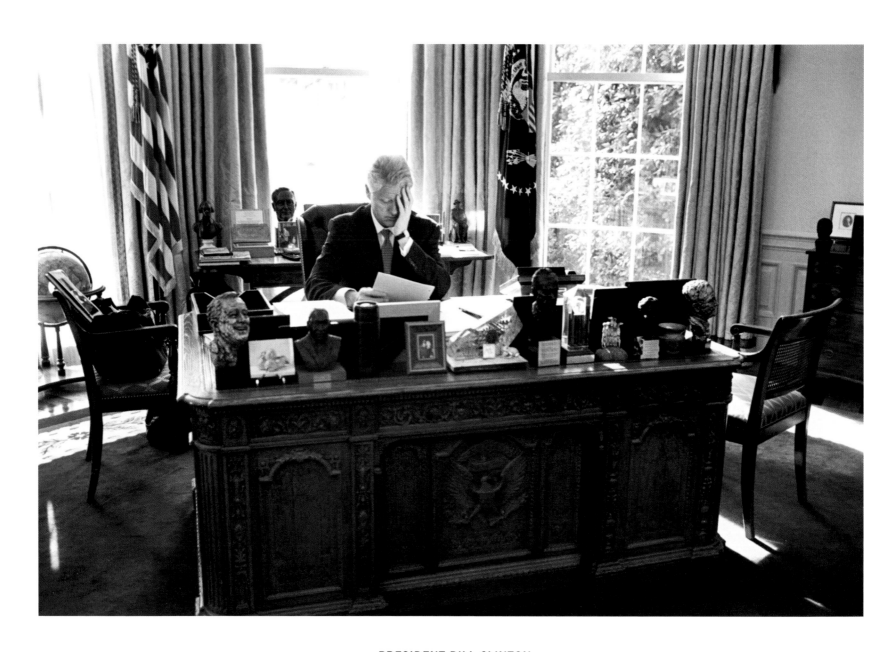

PRESIDENT BILL CLINTON
The Oval Office, January 16, 2001

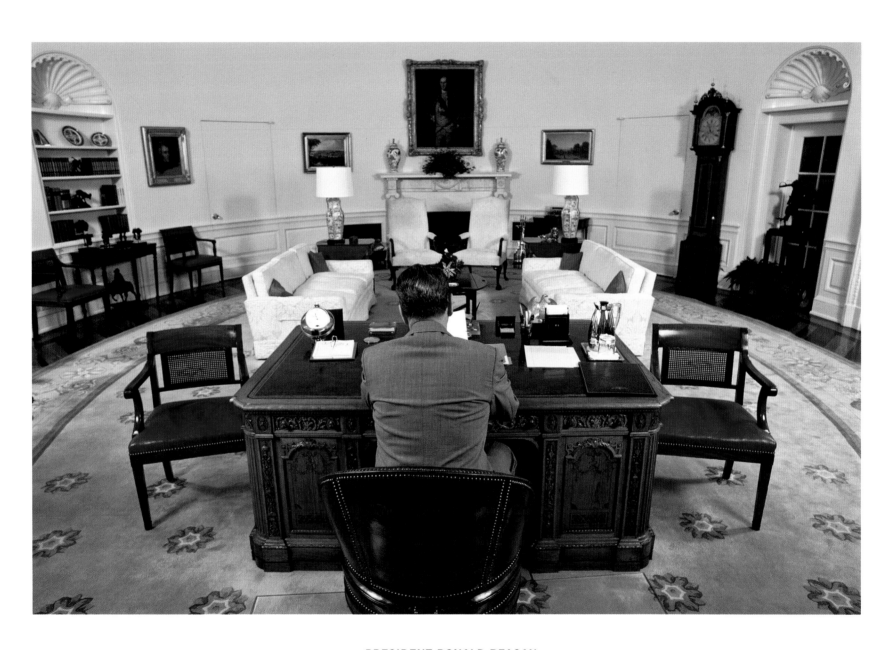

PRESIDENT RONALD REAGAN
The Oval Office, June 1, 1987

PRESIDENT JIMMY CARTER, SENATOR ROBERT BYRD, AND VICE PRESIDENT WALTER MONDALE

President Carter listens to Elie Wiesel at the National Civic Holocaust Commemoration Ceremony, Rotunda of the U.S. Capitol, April 24, 1979
"I wasn't senior enough at *TIME* to have the best position down front with the pool. I had to shoot from way back and high up in the press stand, with a long lens. I think I got lucky."—D.W.

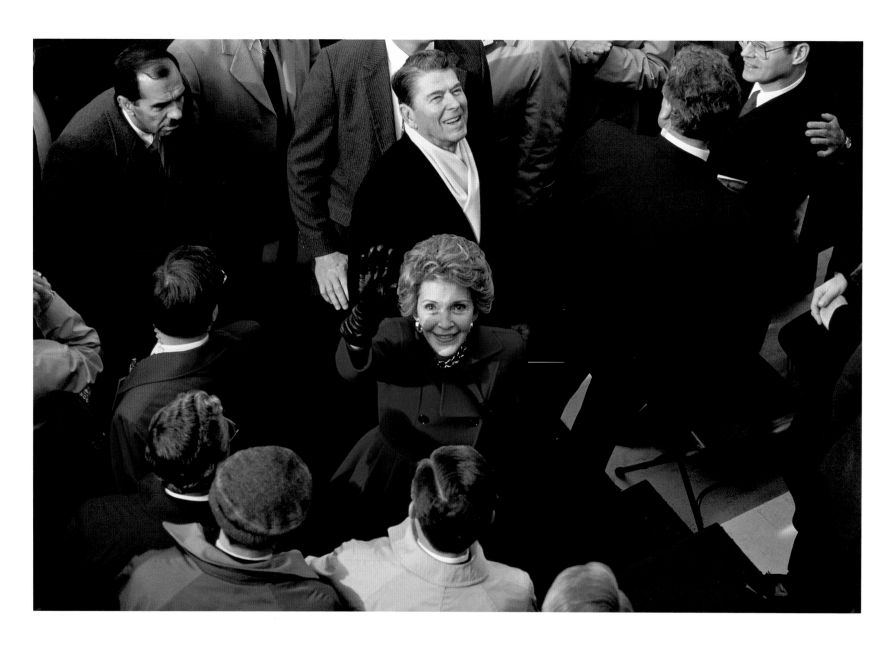

NANCY REAGAN

Inauguration of George H. W. Bush, January 20, 1989. "Breaking my personal rule as a photojournalist never to interfere with the action,
I found myself calling out to Mrs. Reagan, who looked up to wave goodbye."—D.W.

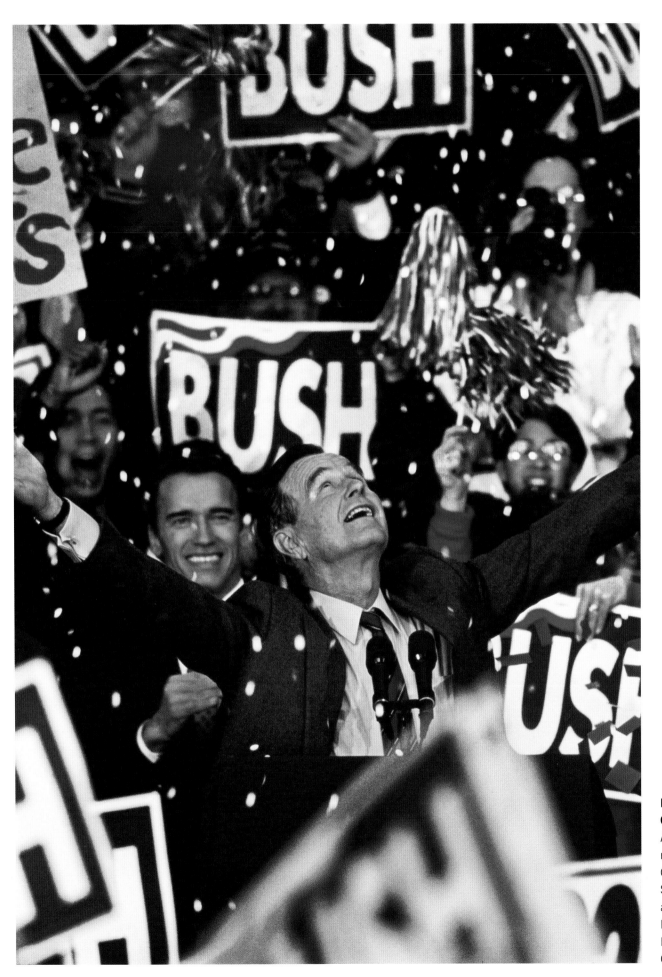

**PRESIDENT
GEORGE H.W. BUSH**

A rally for President's Bush's
reelection in Cleveland,
Ohio, with Arnold
Schwarzenegger, actor
and Chairman of the
President's Council on
Physical Fitness and Sports,
October 28, 1992

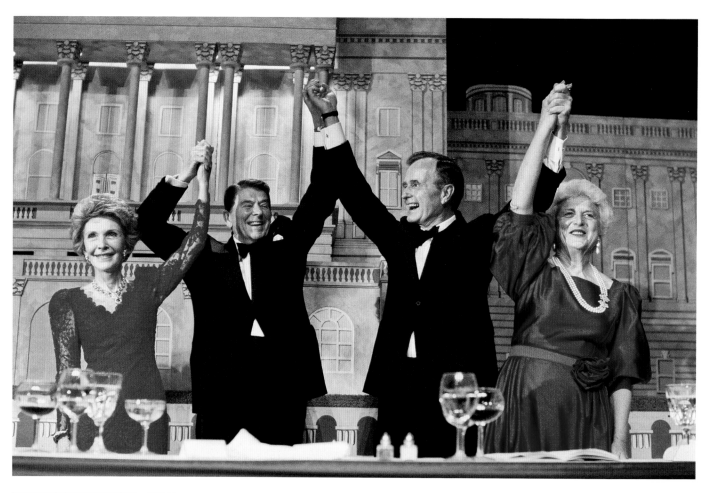

Top: **PRESIDENT AND MRS. REAGAN AND VICE PRESIDENT AND MRS. BUSH**
President Reagan gives his endorsement to George Bush's candidacy for president at the President's Dinner in Washington, D.C., May 11, 1998.

Bottom: **PRESIDENT REAGAN**
The annual convention of the United States League of Savings Associations, New Orleans, Louisiana, November 16, 1982

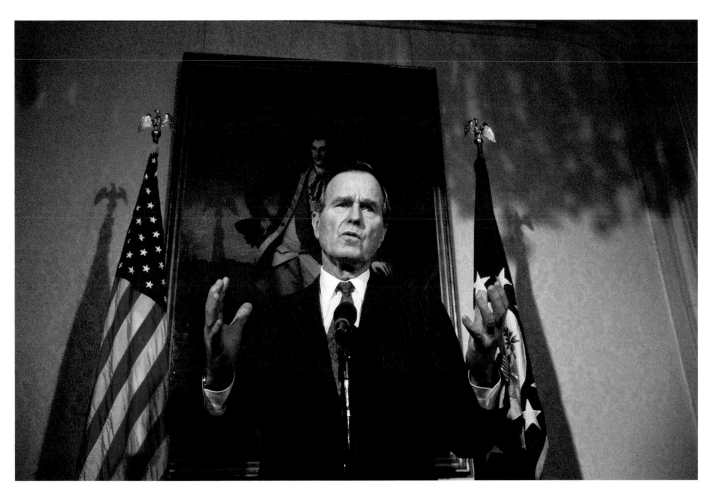

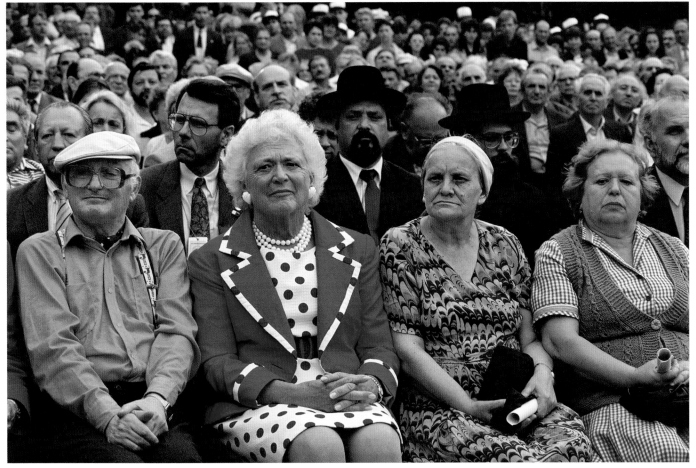

Top: **PRESIDENT BUSH**
The President meets the press at the residence of the U.S. ambassador in Paris on his Thanksgiving trip to Saudi Arabia and Kuwait in support of the troops in Desert Storm, November 21, 1990.

Bottom: **BARBARA BUSH**
The Babi Yar Memorial outside Kiev, Ukraine, August 1, 1991 "During a very moving ceremony, First Lady Barbara Bush is surrounded by survivors of the World War II massacre, in which tens of thousands of Jews, Communists, and Russian prisoners of war were executed by the Nazis between 1941 and 1943."—D.W.

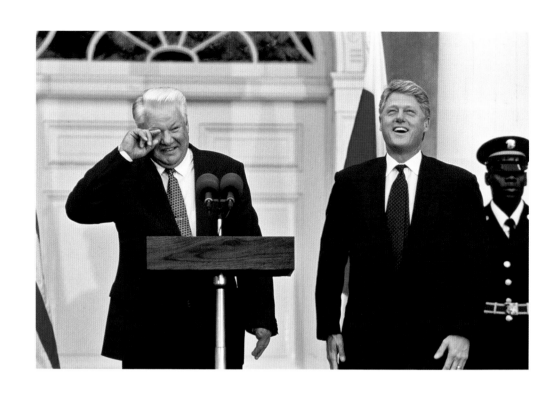

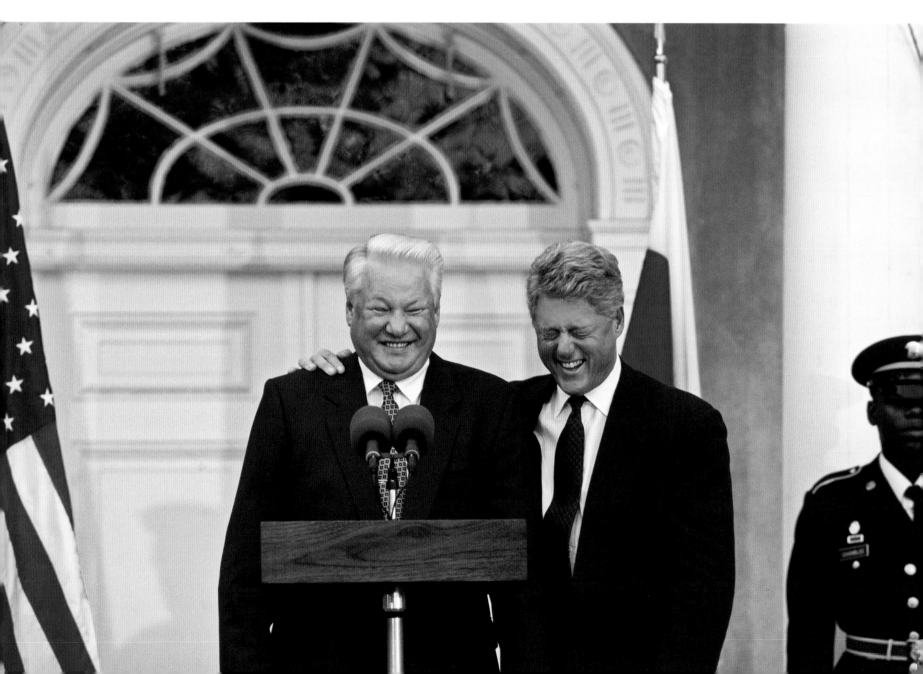

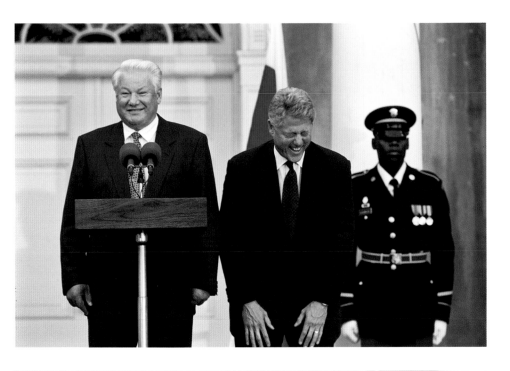

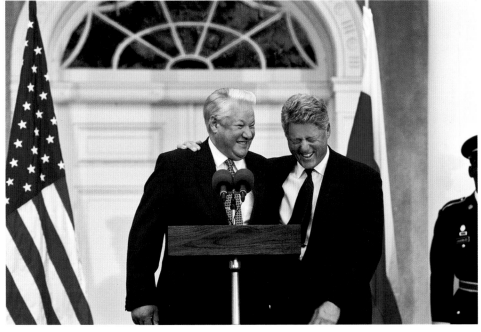

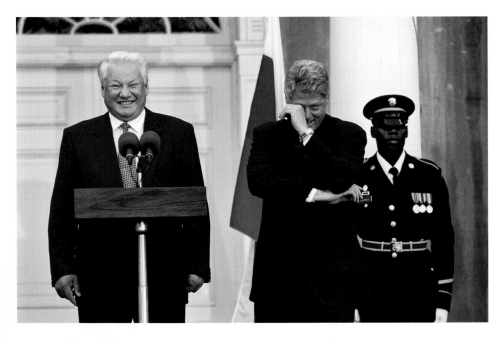

**PRESIDENT BILL CLINTON AND
PRESIDENT BORIS YELTSIN**
The two Presidents come out of
Franklin Roosevelt's Hyde Park
estate to meet the press following
a summit meeting on the occasion
of the 50th anniversary of the
United Nations, October 23, 1995.
"This is when I'm howling.
Yeltsin says to the press, 'You think
I'm ridiculous. You think we're
ridiculous. But you're ridiculous!'
I was laughing so hard because Yeltsin
loved a good laugh. And he was
one of those politicians that could get away
with saying something the
rest of us could never say. Telling
the American press and the world
press they were ridiculous—he made
them laugh about it, too. We were
all laughing. That was Yeltsin's
special quality. He could do that."
—Bill Clinton, 2000

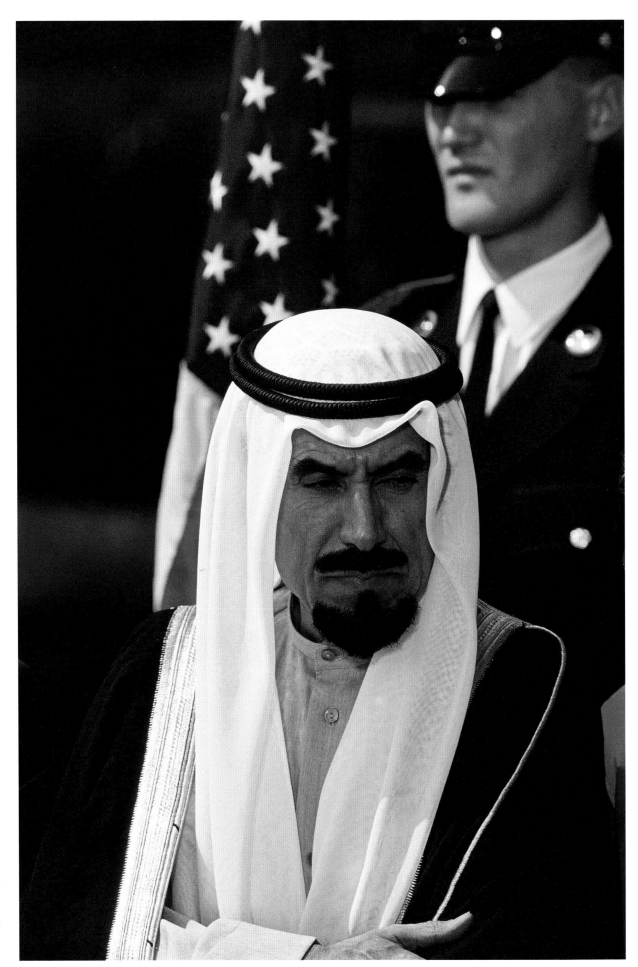

**SHEIKH JABER
AL-AHMAD AL-SABAH**
(1926-2006) arrives at the
White House,
September 28, 1990.

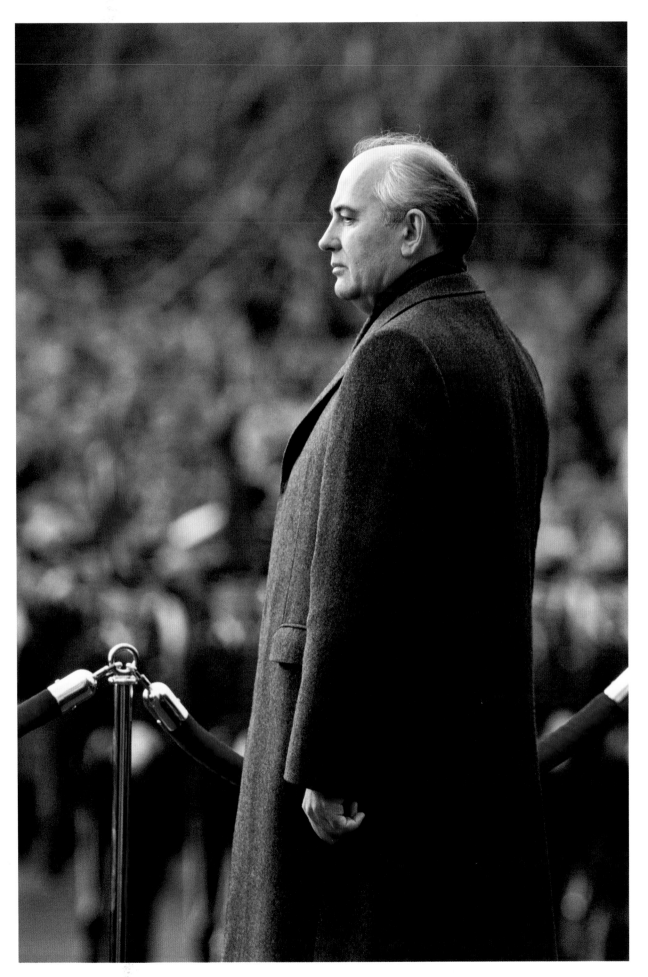

MIKHAIL GORBACHEV
President Gorbachev of the
U.S.S.R. arrives at the White
House for the first time for
a summit meeting with
President Reagan, 1987.

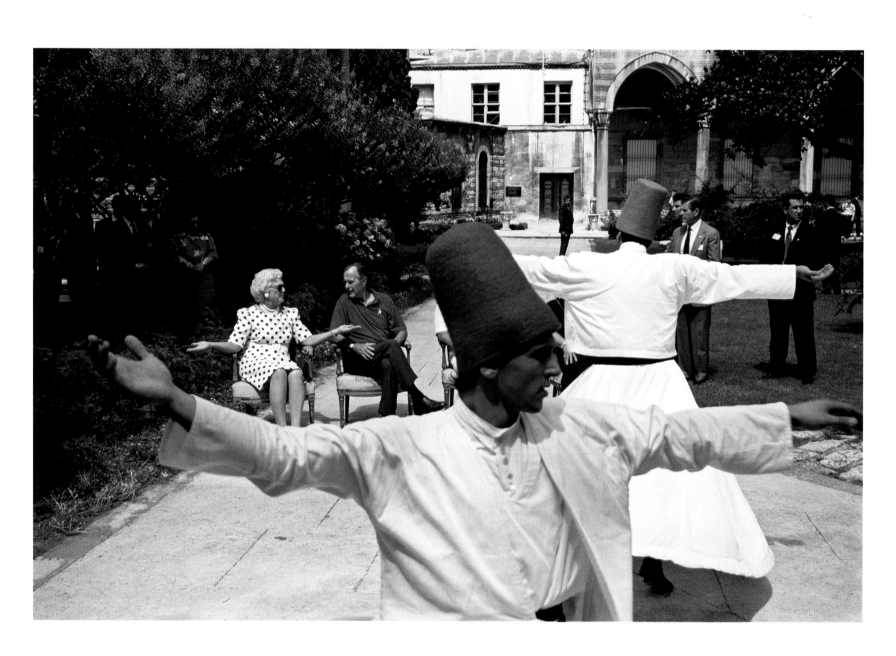

PRESIDENT AND MRS. GEORGE H.W. BUSH
President and Mrs. Bush are entertained by whirling dervishes in Ankara, Turkey, July 20, 1991.

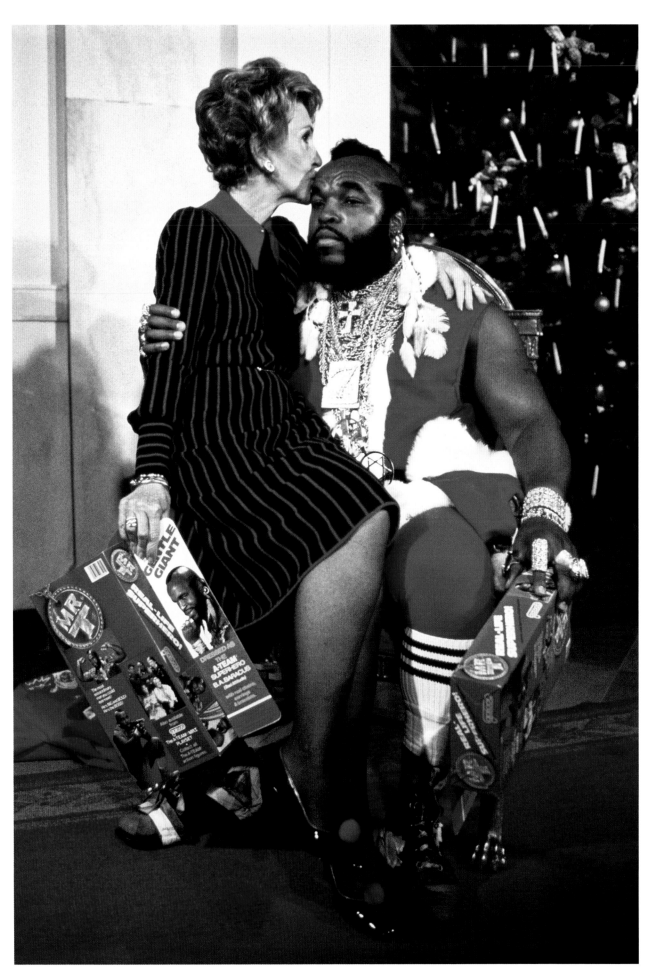

FIRST LADY NANCY REAGAN AND MR. T
"The First Lady traditionally invited a star to be Santa Claus at the White House Christmas parties for children. In 1983, it was Mr. T, whose costume alone made him an unforgettable Santa. At a press preview, the press corps teased Mrs. Reagan about telling Santa what she wanted for Christmas, and she gamely sat on Santa's lap."
December 12, 1983 —D.W.

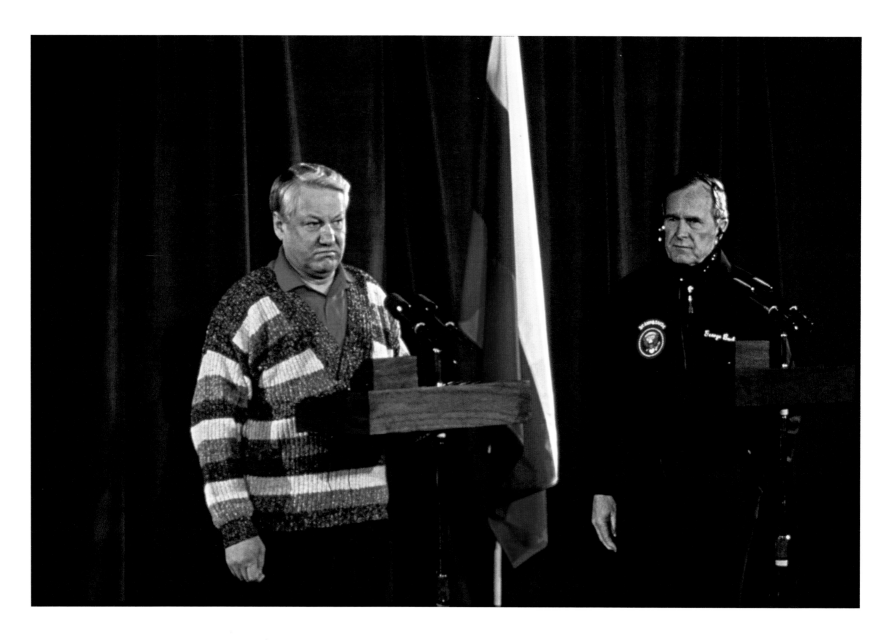

PRESIDENT BORIS YELTSIN AND PRESIDENT GEORGE H.W. BUSH
Presidents Bush and Yeltsin (1931–2007) at a press briefing at Camp David. It was the first meeting of a democratically elected
U.S. President and a democratically elected President of an independent Russia, February 1, 1992.

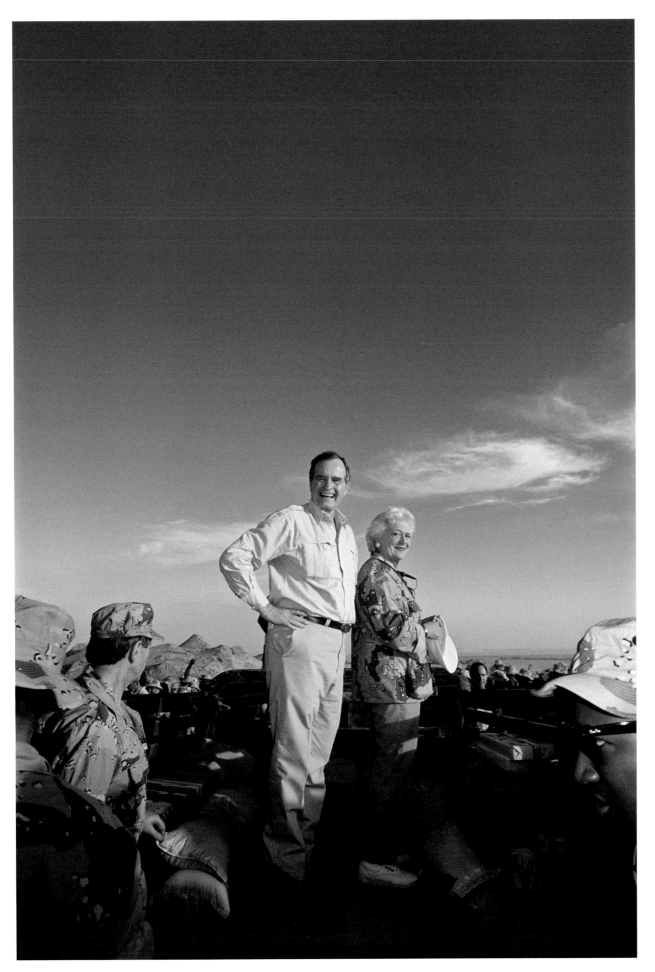

PRESIDENT AND MRS. GEORGE H.W. BUSH
The Bushes in the desert with U.S. troops near Dhahran, Saudi Arabia, during their Thanksgiving visit with the troops of the 1st Division, November 22, 1990

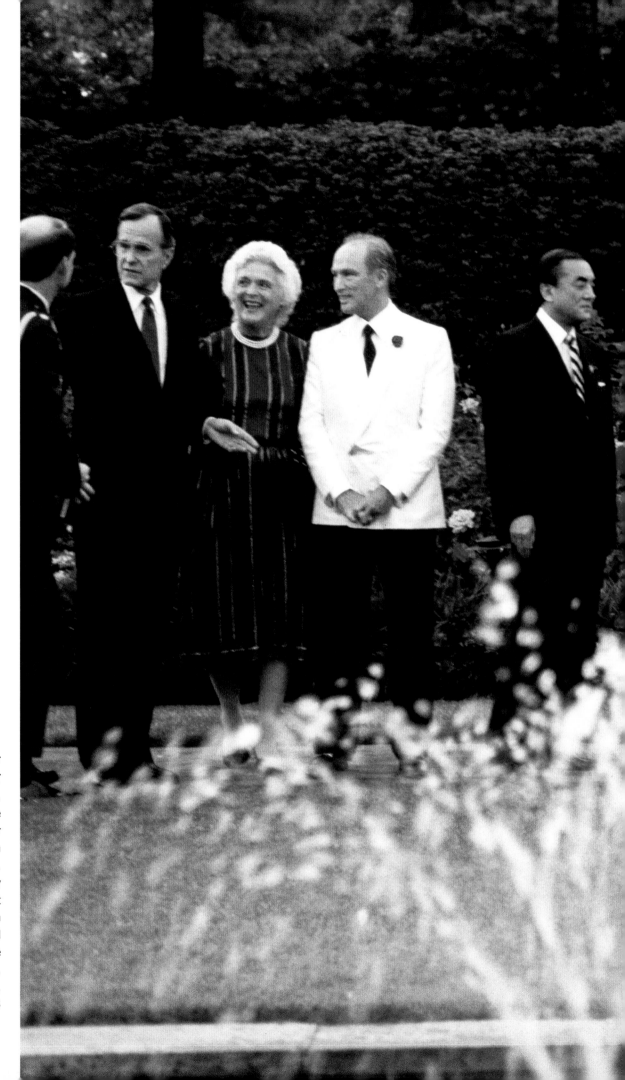

**MEMBERS OF
THE G-7 SUMMIT**
President Bush, Barbara Bush,
Canadian Prime Minister Pierre
Trudeau, Japanese Prime Minister
Yasuhiro Nakasone, Italian
Prime Minister Amintore Fanfani,
President Reagan, Nancy
Reagan, French President
François Mitterand, German
Chancellor Helmut Kohl, and
President Gaston Thorn of the
European Commission,
Williamsburg, Virginia,
May 30, 1983

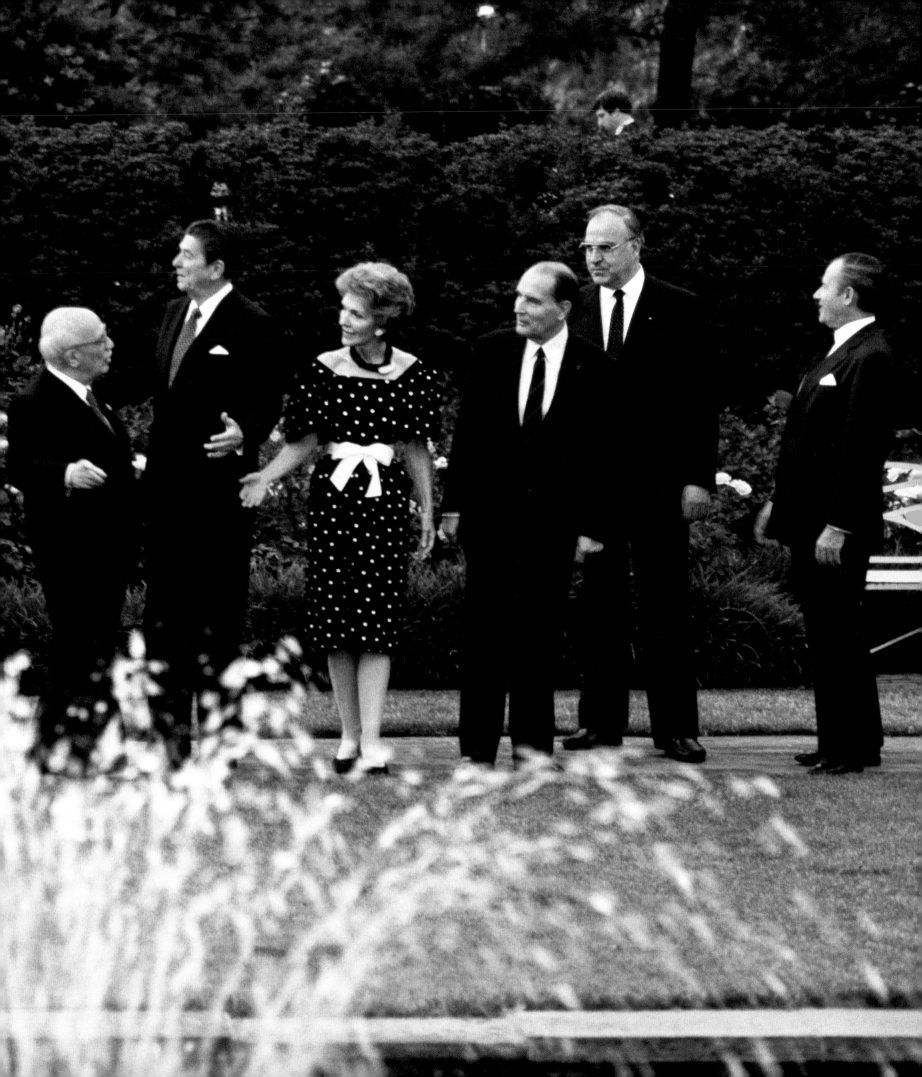

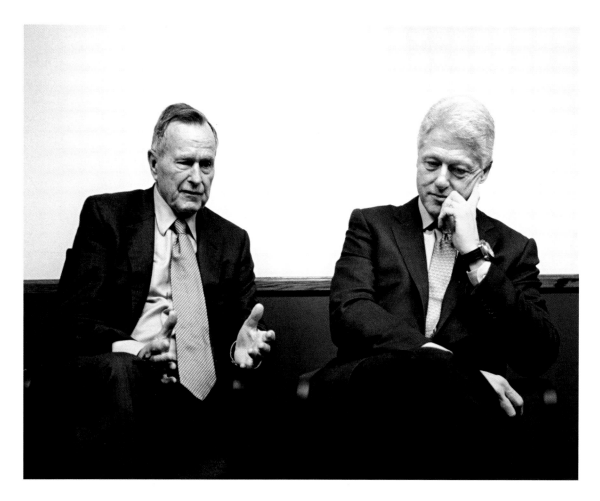

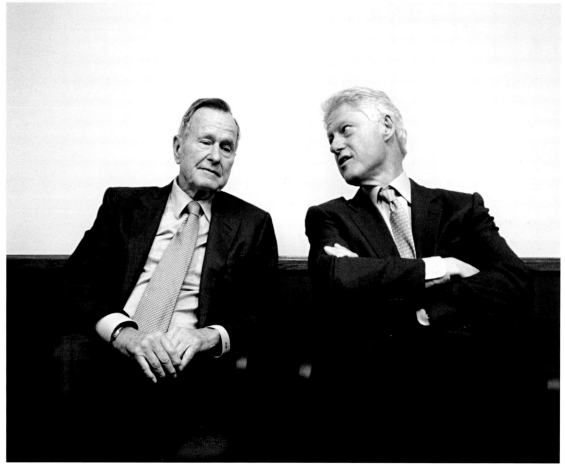

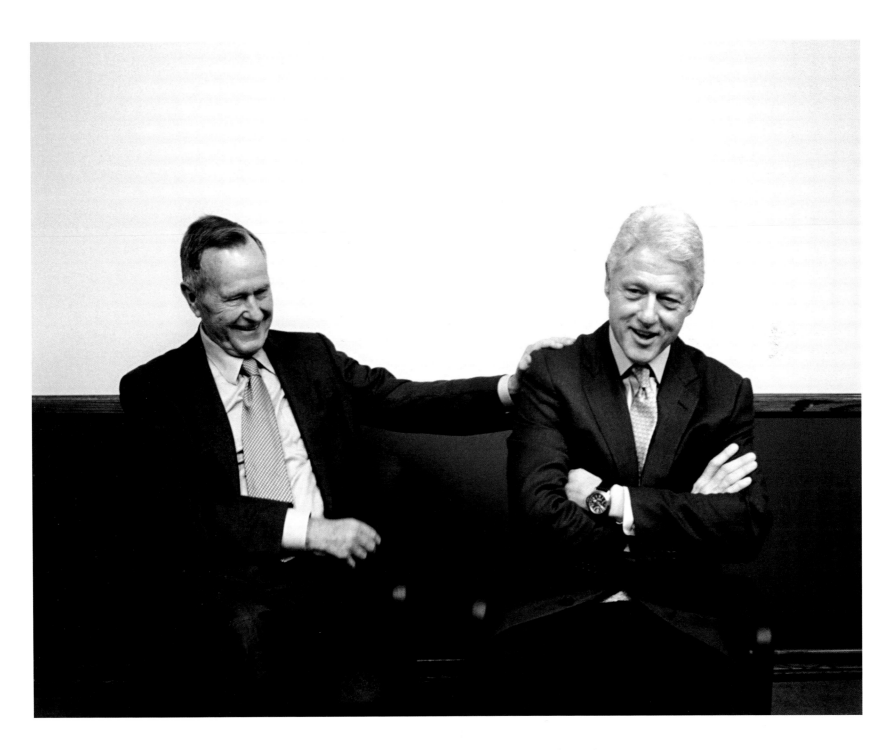

PRESIDENTS GEORGE H.W. BUSH AND BILL CLINTON
The former Presidents in a holding room at the University of New Orleans after announcing the recipients of
90 million dollars in aid in the aftermath of Hurricane Katrina, December 12, 2005

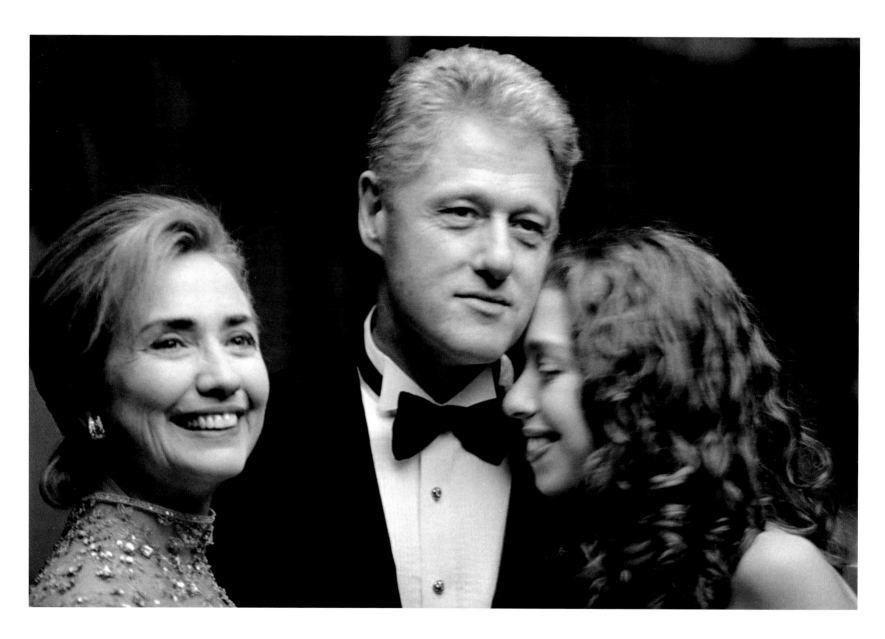

THE CLINTON FAMILY
"Backstage at one of the many inaugural balls, the Clintons stopped for an official portrait.
As the photographer was getting ready, I caught this sweet moment." January 20, 1997—D.W.

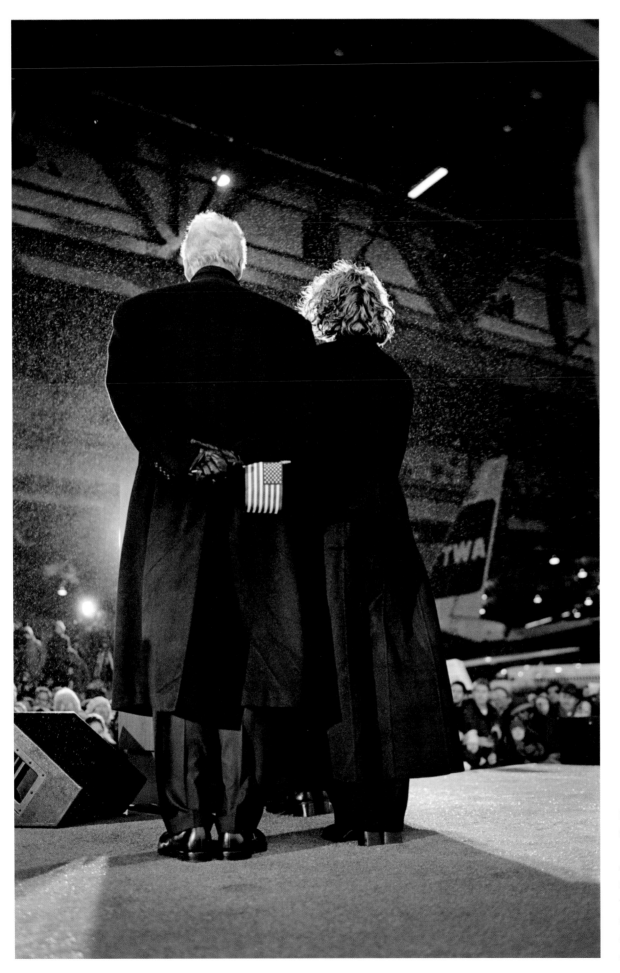

PRESIDENT CLINTON AND CHELSEA CLINTON
Following the swearing-in ceremony of George W. Bush as President, the Clinton family greets a huge crowd of well-wishers in an airplane hangar in New York, January 20, 2001.

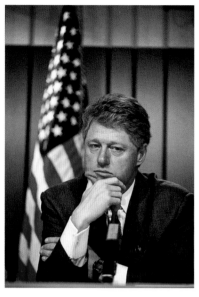
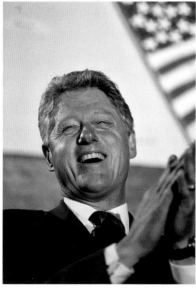
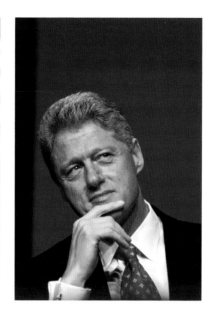
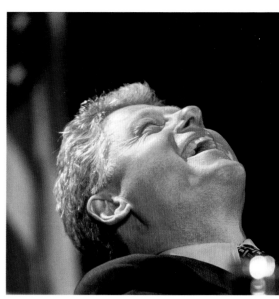
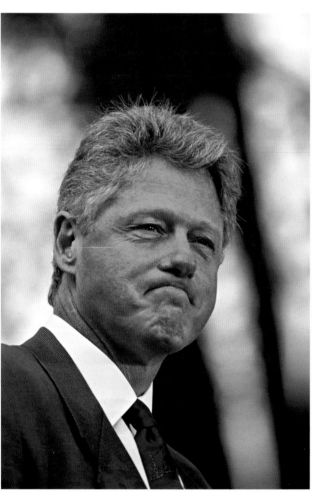
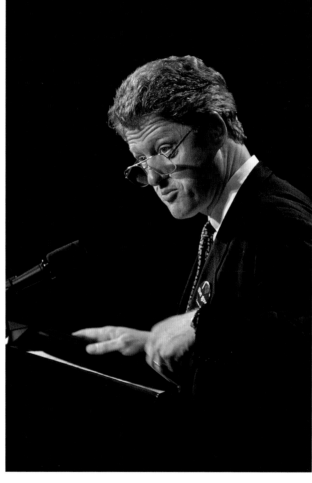
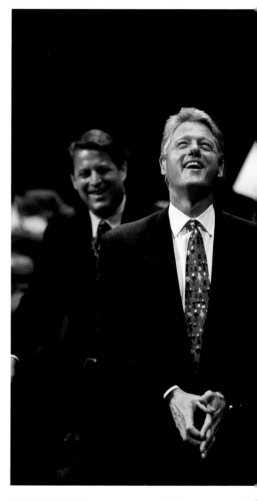
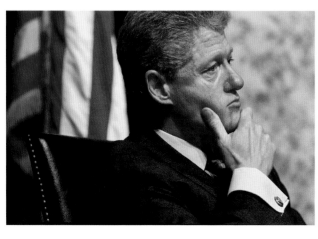
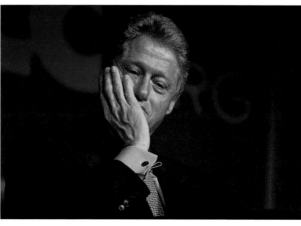
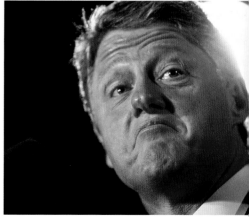

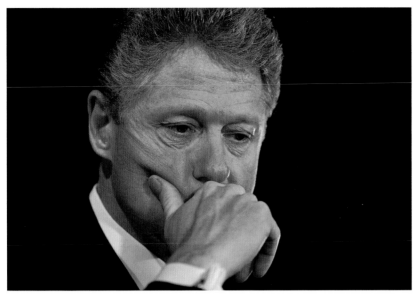
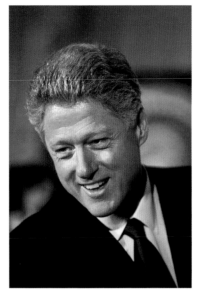
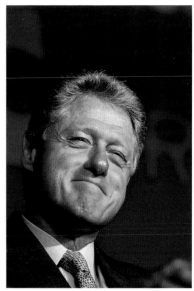
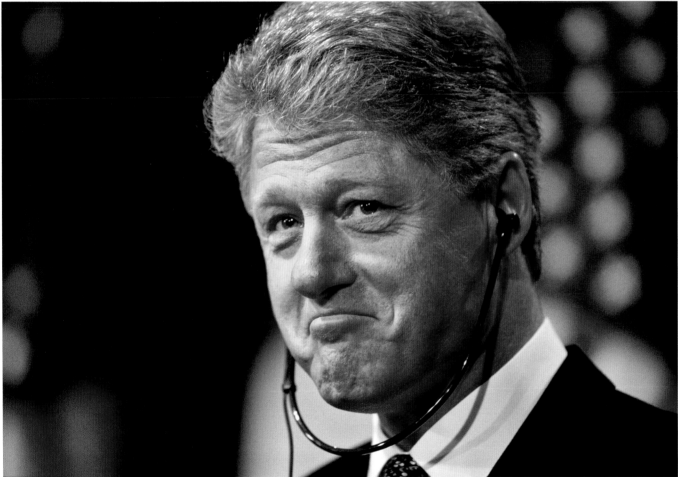
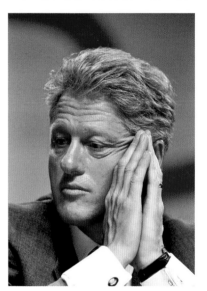
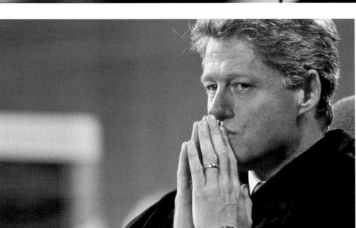
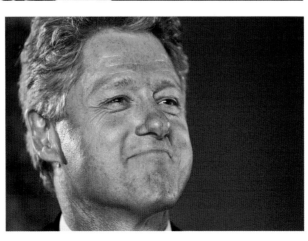

PRESIDENT CLINTON

"Clinton has a wonderfully expressive face. I can't represent him with just a single image. During his eight years in the White House, we photographers became familiar with the array of expressions that crossed his face: the prideful look when the soldiers marched by; the downturned mouth suggesting wry acceptance; his head thrown back in utter delight; and that thoughtful, faraway look when his mind was not on stage. To me, those expressions were true reflections of his personality, his emotions, and it seemed quite wonderful that there they were, written across his face."—D.W.

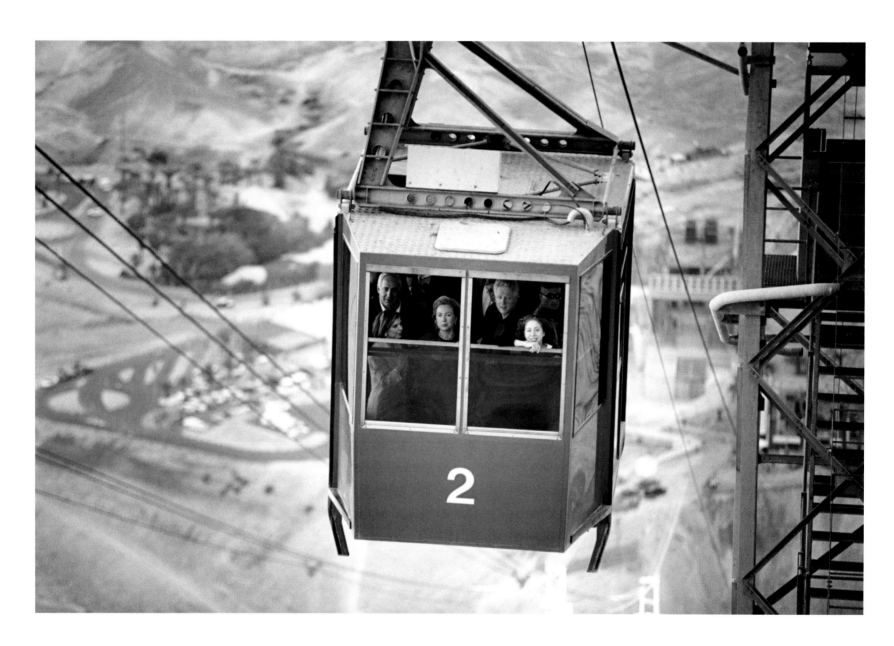

THE CLINTON FAMILY
The Clintons in Israel with Israeli Prime Minister Benjamin Netanyahu and his wife, Sara,
riding a cable car up to the ancient mountaintop fortress of Masada, December 1998

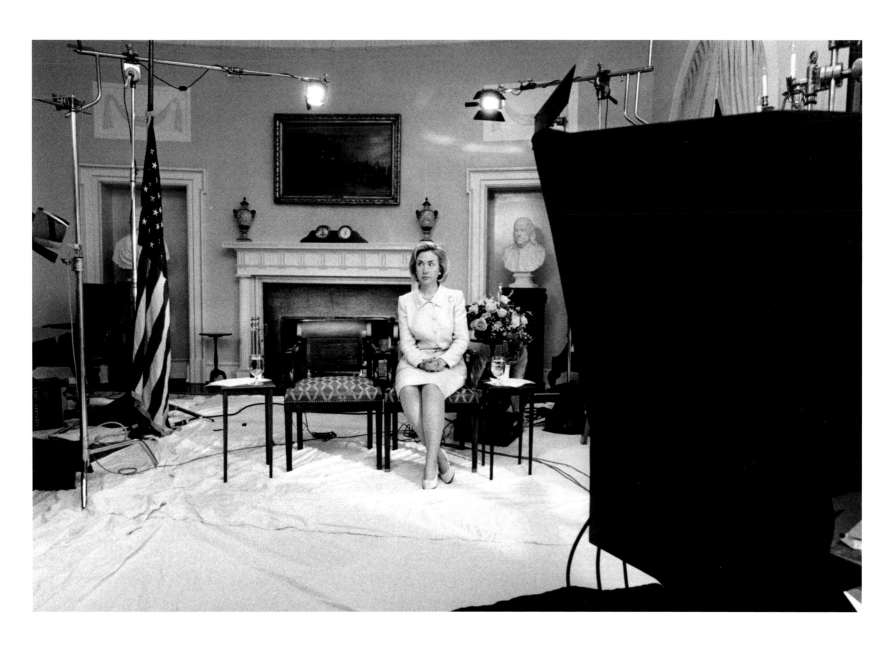

HILLARY CLINTON

The First Lady waits for the President to join her to tape a public service announcement, October 6, 1997.

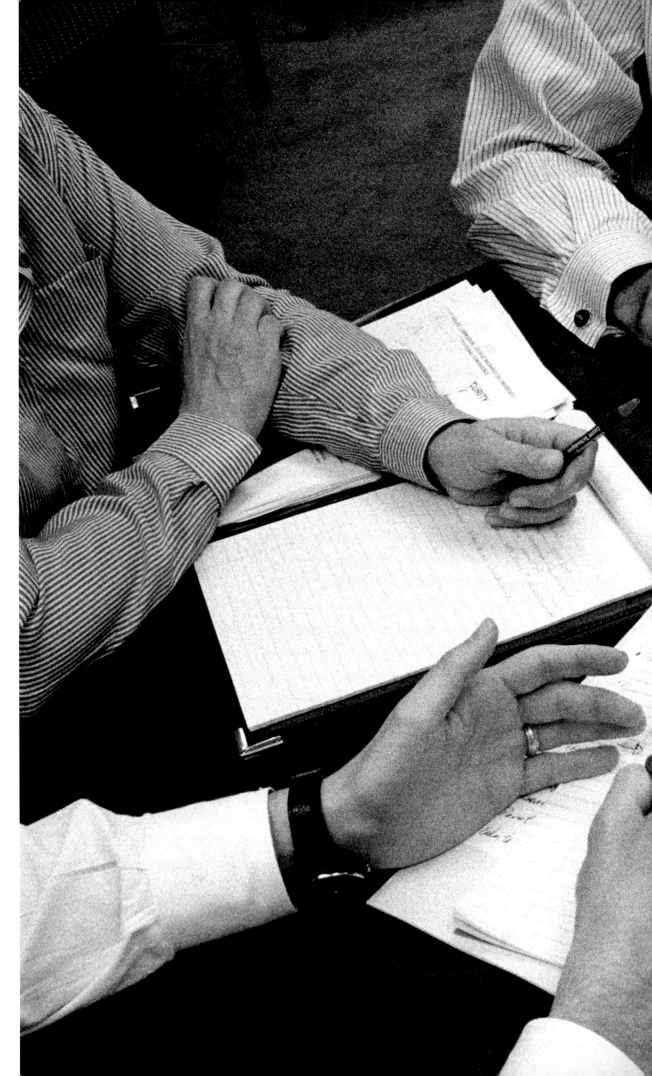

WHITE HOUSE STAFFERS
Members of the Clinton-Gore
staff meet to coordinate speeches
about policy in the final weeks of
the campaign, October 26, 1996.

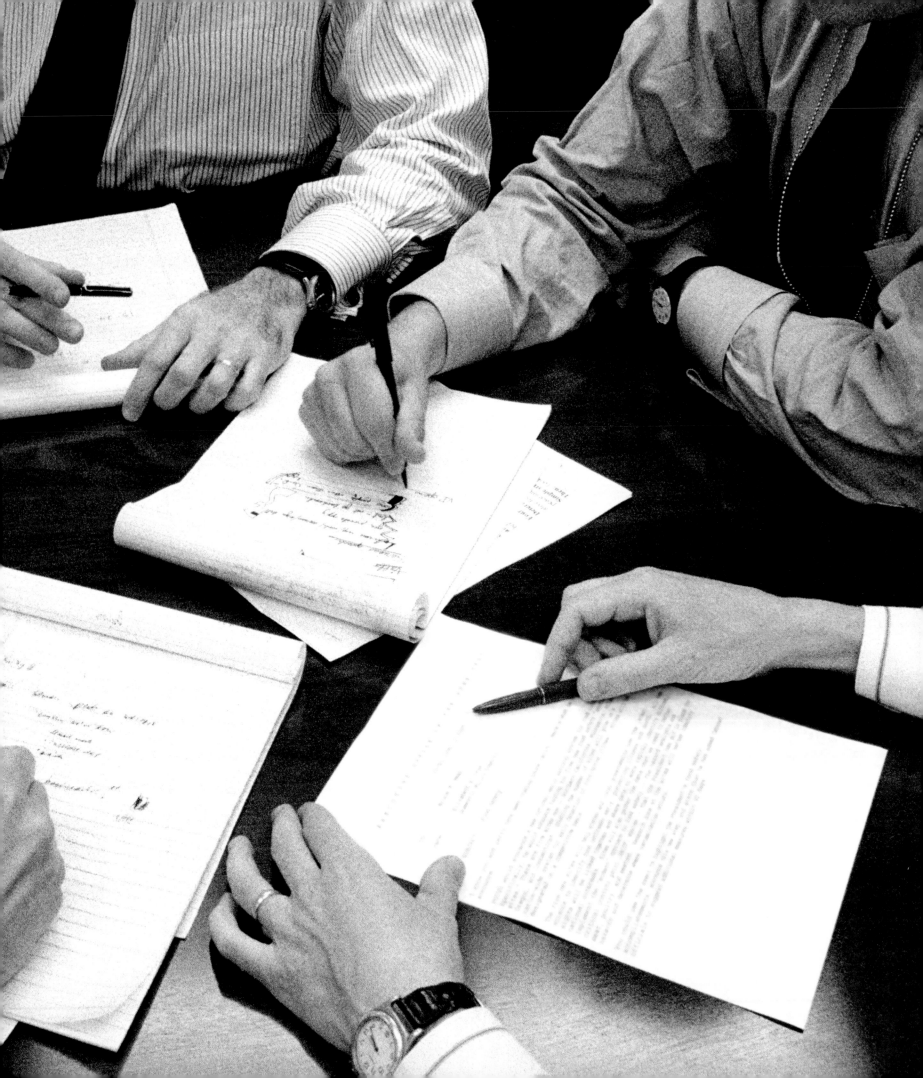

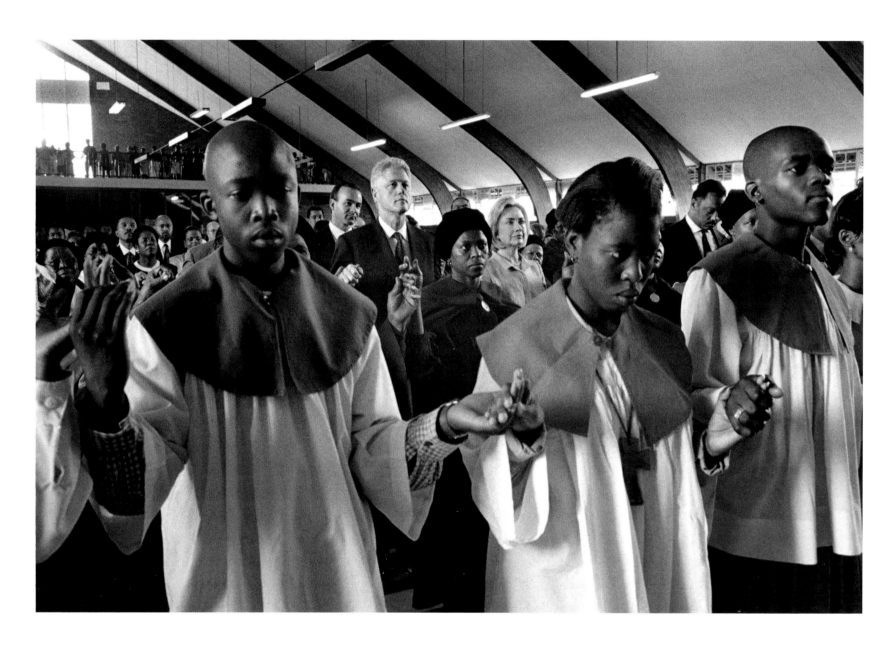

PRESIDENT AND MRS. CLINTON

President Clinton and the First Lady attend a service at Regina Mundi Catholic Church, a historically significant site of antiapartheid activities in Soweto, South Africa, March 29, 1998.

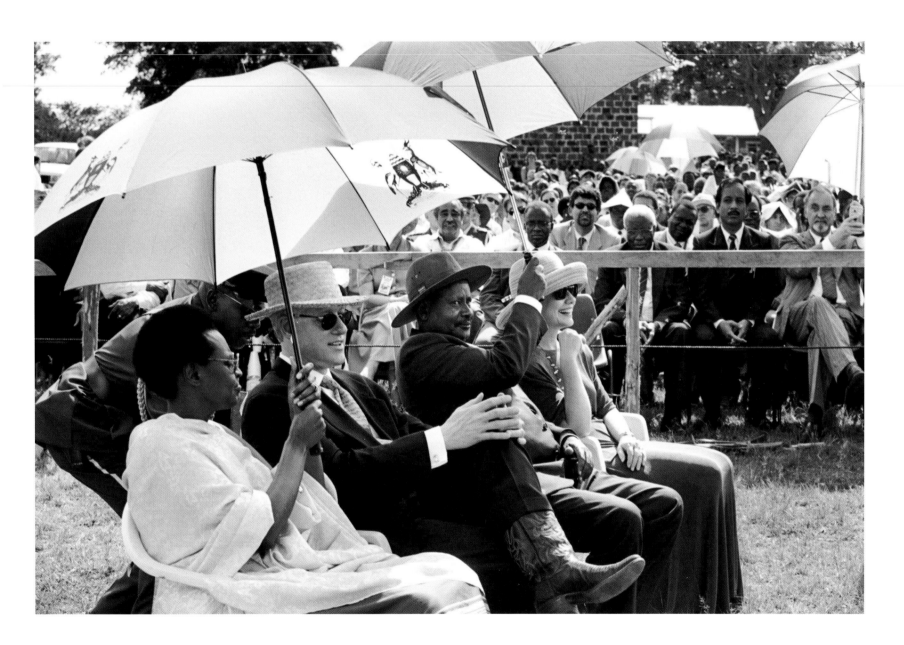

THE CLINTONS AND PRESIDENT AND MRS. YOWERI MUSEVENI OF UGANDA
The Clintons and the Musevenis, under umbrellas, watch an outdoor performance after touring a school, a village,
and local businesses near Kampala, Uganda, May 24, 1998.

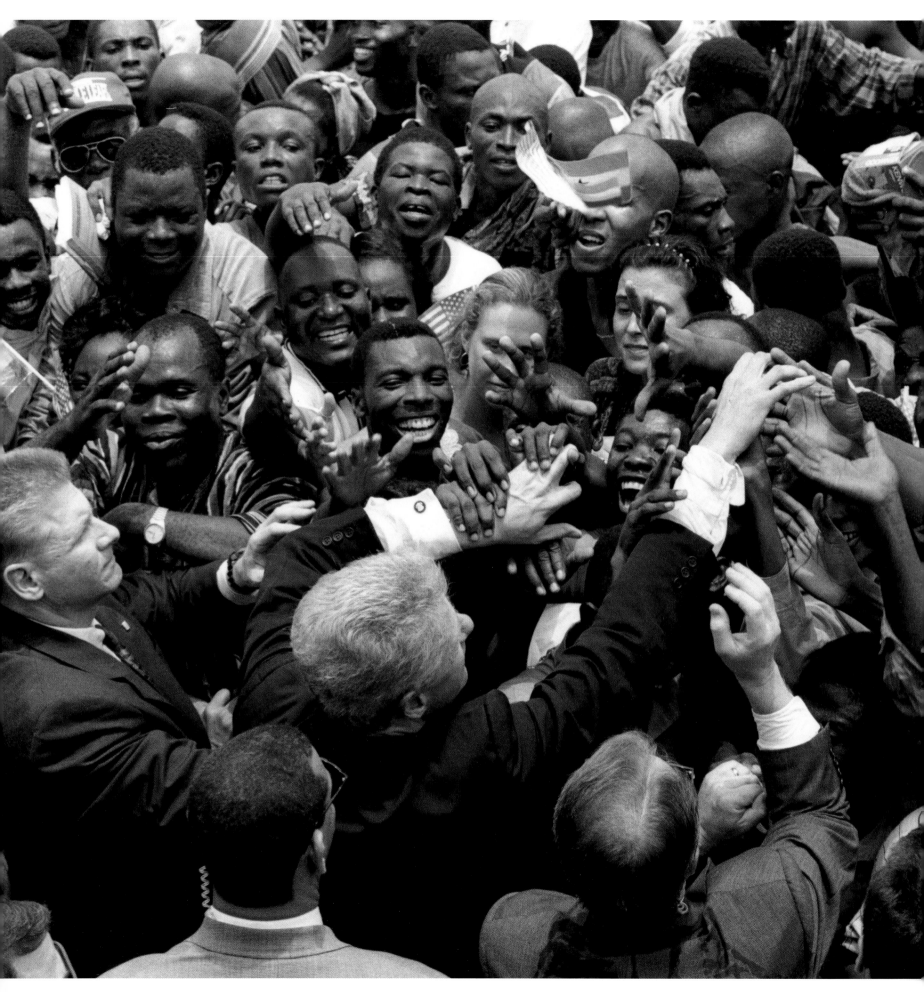

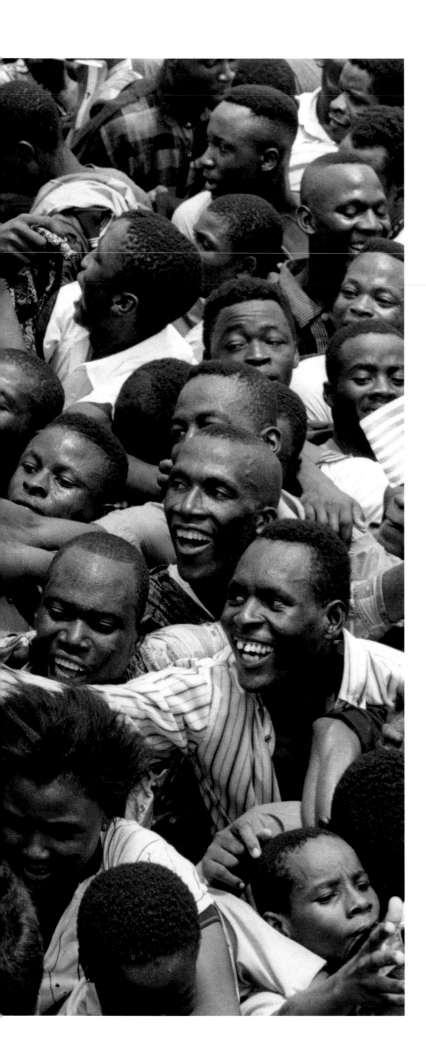

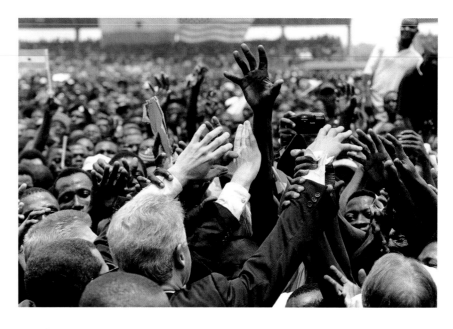

PRESIDENT BILL CLINTON

On his first trip to Africa, President Clinton meets with crowds
at a stadium in Accra, Ghana. March 23, 1998. "Coming straight from the
airport after a long, long flight from Washington, it was extraordinary to see
700,000 cheering Ghanaians packed into a soccer stadium in 110-degree
heat, waiting to hear from President Clinton. Later Clinton worked the rope line,
and one could feel the concern and worry of the Secret Service detail as the
people swarmed around the President."—D.W.

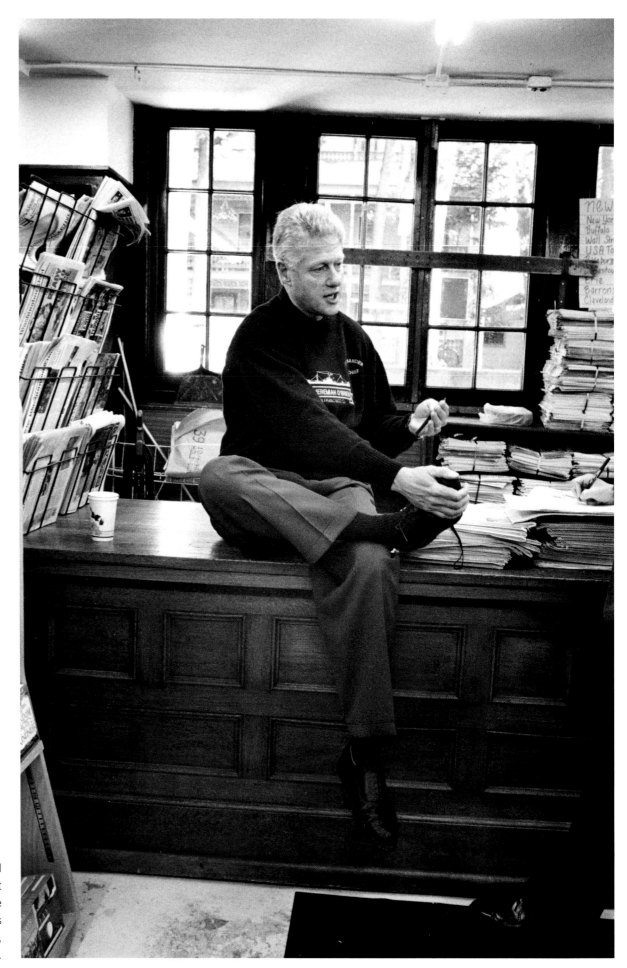

PRESIDENT CLINTON
Clinton, preparing for his first
debate with Senator Bob Dole
in the 1996 campaign, relaxes
in a Chautauqua, New York,
bookstore, October 5, 1996.

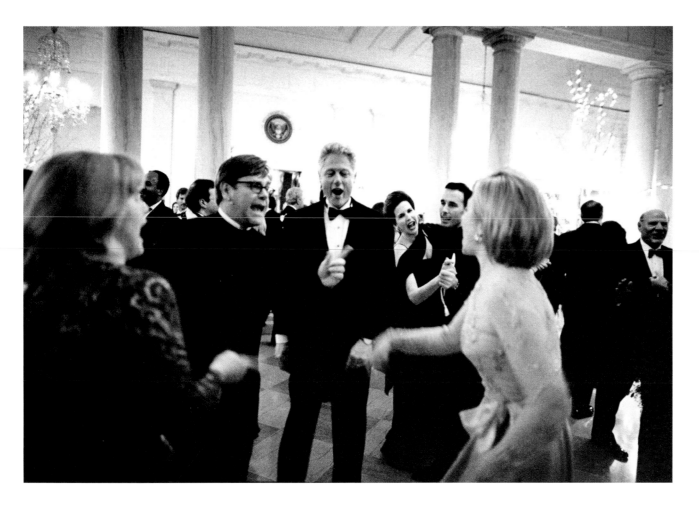

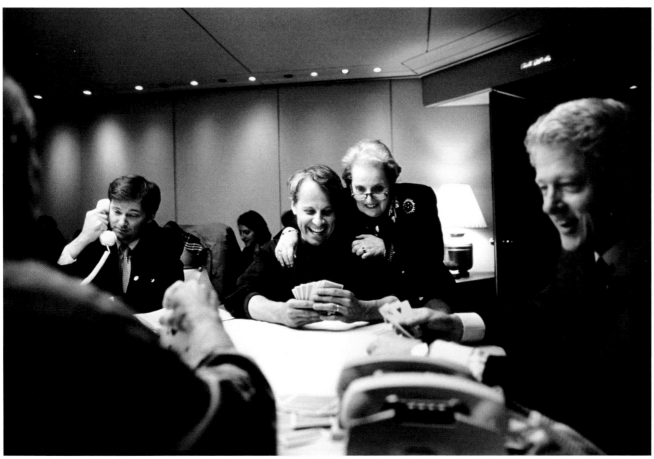

Top: **TIPPER GORE, ELTON JOHN, PRESIDENT CLINTON, AND HILLARY CLINTON** After a State Dinner for Tony Blair and his wife, Cherie, Elton John had plenty of dancing partners, February 5, 1998.

Bottom: **DOUG SOSNICK, MADELEINE ALBRIGHT, AND PRESIDENT CLINTON** Returning to Washington from Europe, a game of hearts is under way aboard *Air Force One*, May 4, 1999. "I am not a good game person. The President is unbelievably good at everything, and he has this incredible memory. So I always felt completely inadequate. I was much better at kibitzing over Doug's shoulder."—M.A.

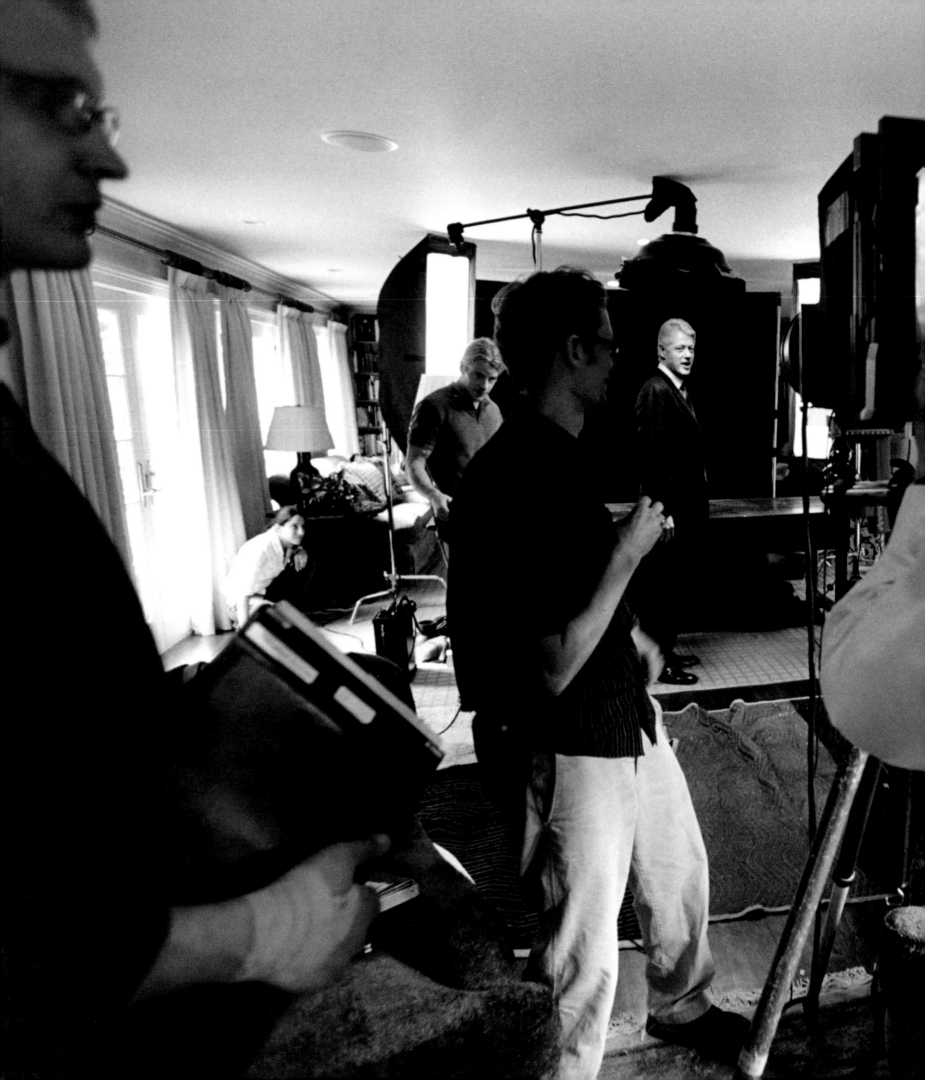

PRESIDENT CLINTON
Gregory Heisler focuses his view
camera for a portrait of citizen
Clinton just as the former
President's autobiography,
My Life, is about to be released,
Chappaqua, New York,
June 17, 2004.

From my conversation with **KARENNA GORE SCHIFF**

"My first memory of being on stage with my family was when Dad won the primary for the House of Representatives in 1976, because it did happen to be my third birthday. The assembled crowd sang to me! I remember it because it was such a shock.

"And this cable car…I remember riding that as a child. It was such a treat. I remember my dad snuck us on a ride between the House and the Capitol. Dad liked to take us to the office, to the Capitol. He'd talk to us about the meaning of what went on on the floor of the House. My grandfather had also served. We would go over and see where his desk had been in the Senate…it was just a tremendous privilege.

"As we went into the election of 2000, what all of us were feeling was excitement and hope. It was so close, but we were all hopeful that it would be a victory. And that it would become a great Presidency. Dad really was an incredible statesman throughout that recount period as well. There were a lot of people who would have liked him to fan the flames and deepen the division. And I think that history will look back and see that the way he behaved really was the best of statesmanship and patriotism. He put a lot of his own stature behind granting the new Bush Administration that trust, that public trust.

"My father has worked very hard and devoted himself since 2001 to making an argument on the issue of climate change that would create public will to solve this problem. I think his having been inside the political process for so long, he recognized that the missing piece to solving it was a real popular movement and support that would encourage elected officials to actually act. With the movie, because of the artistic vision of the director, as well as the incredible work my father put in over many years to perfect the images and to craft his argument, the movie ended up hitting, really hitting it big and has made a huge impact around the world.

"My father has never, no matter how hard people were on him as a person, he has never given up. He's always sort of risen to the challenge and maintained his dignity and been cognizant of the fact that there were so many millions of Americans who had put their trust in him. And he wanted to carry that with him and live up to that.

"He's a great father. And so when you love someone a lot, someone who had ups and downs in a very public way, who is sometimes attacked unfairly, then it can be difficult. But it also gives you the gift of understanding the difference, understanding how much more important substance is than image. That in the end, there are things that are important that you know about yourself, that you know about your family and your loved ones, and your values that no one will take away. Being in such a political family, the lessons come hard and fast. I have immense respect for those who do offer themselves because it's not easy in this country."

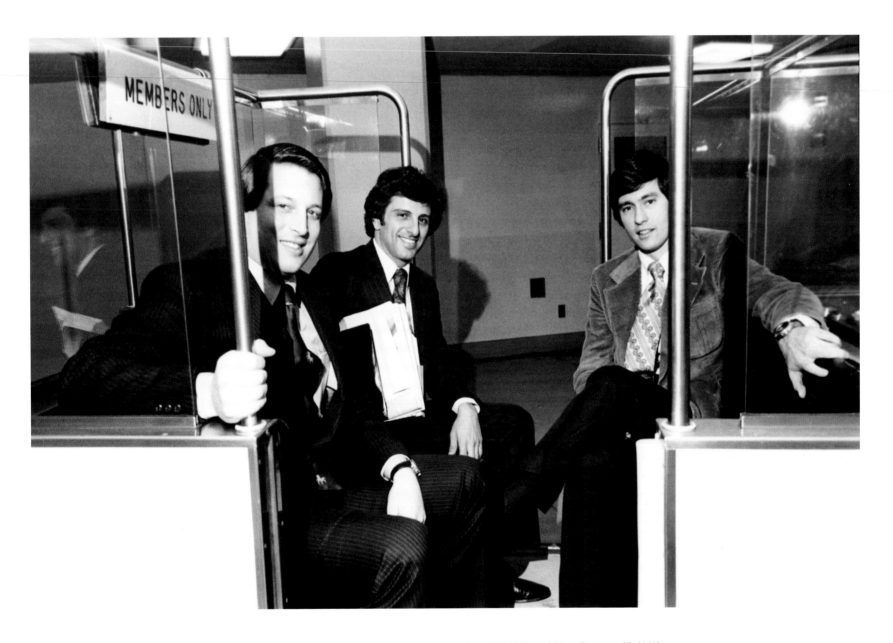

CONGRESSMEN Al Gore (D-Tenn.), Toby Moffett (D-N.Y.), and Tom Downey (D-N.Y.) ride in the Capitol subway, 1976. "They were all new congressmen together. They were my dad's close buddies, who used to play basketball together a lot in the House gym."—K.G.S.

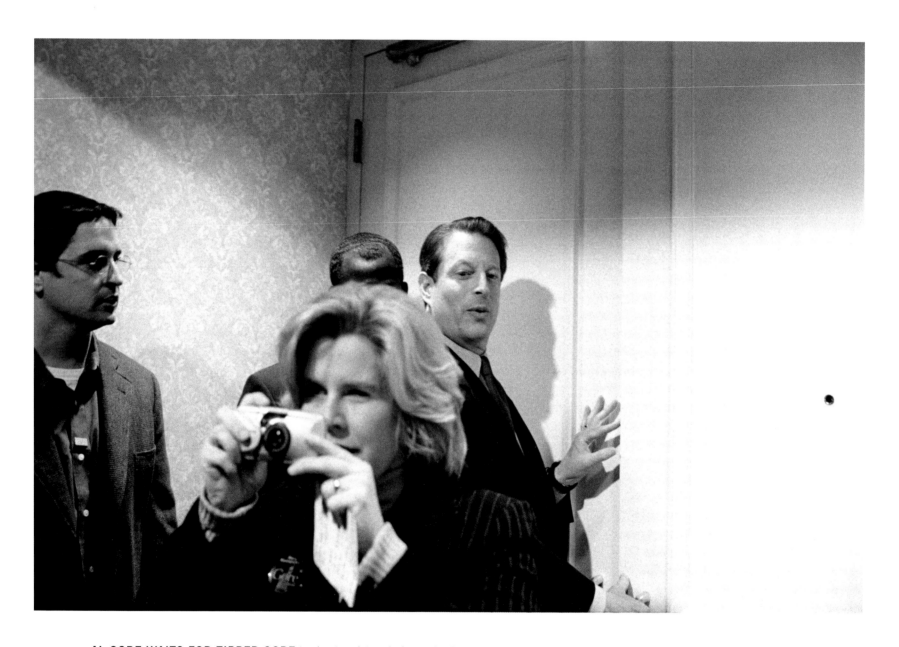

AL GORE WAITS FOR TIPPER GORE to shoot a picture before going into the ballroom at a Manchester hotel to acknowledge his victory in the New Hampshire primary, February 1, 2000. "Here he was realizing the first victory of the Gore 2000 campaign, a victory that really represented him on his own as a Presidential candidate. The challenge from Bill Bradley was very real, so my father fought very hard for victory."—K.G.S.

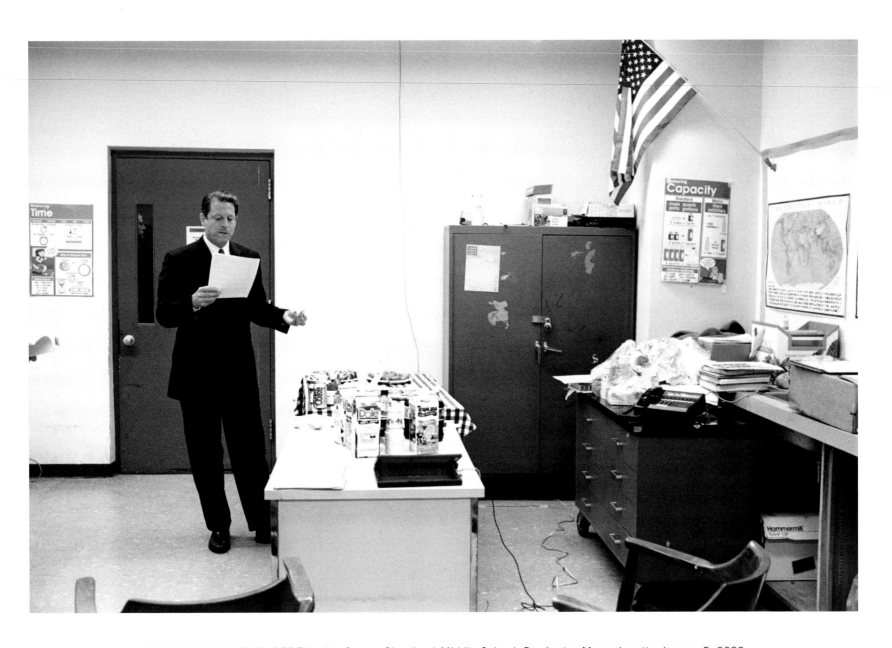

VICE PRESIDENT AL GORE in the Grover Cleveland Middle School, Dorchester, Massachusetts, January 5, 2000
"The candidate has to be parked somewhere for a little while. This is a typical scene in a holding room. It's so hard on the campaign
because you sort of have to eat in every place you go—you don't know when you're going to eat again."—K.G.S.

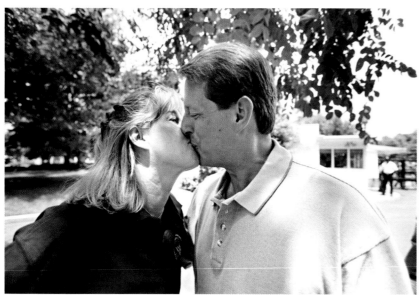

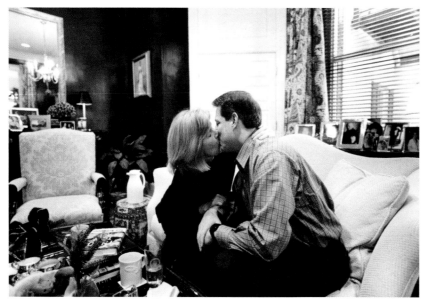

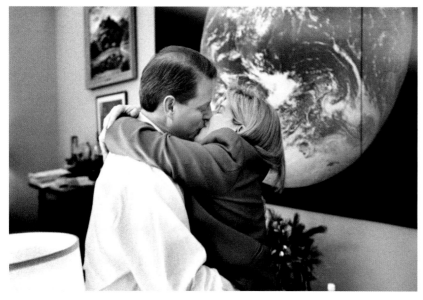

KISSES 1996, 1997, 1997: "Having caught the Gores more than once in a kiss, it became a joke between us."—D.W.

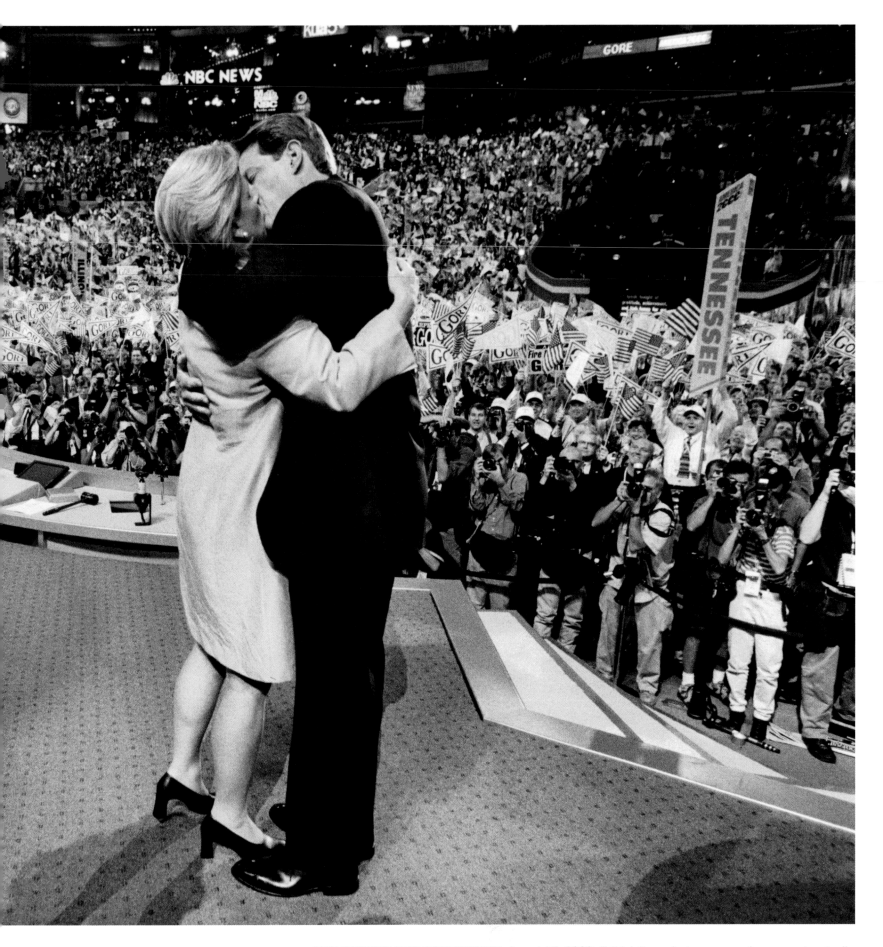

THE DEMOCRATIC CONVENTION, August 17, 2000. "I think it was just a very genuine moment, actually. I certainly recognize it very well as how they are together. For my father, being nominated by that convention was one of the most important moments of his life. I think he was expressing his genuine joy that she was part of it."—K.G.S.

VICE PRESIDENT AL GORE working on his laptop in a holding room at the Department of State, February 23, 1999. "My dad always has his laptop. It's very funny, because the younger generation is supposed to be helping their parents with technology. But my father is always showing me the latest gadget and trying to help me figure out how to use it. He's always been really ahead of the curve on technology. I remember reporters even making fun of him for having a BlackBerry on his belt during the 2000 campaign."—K.G.S.

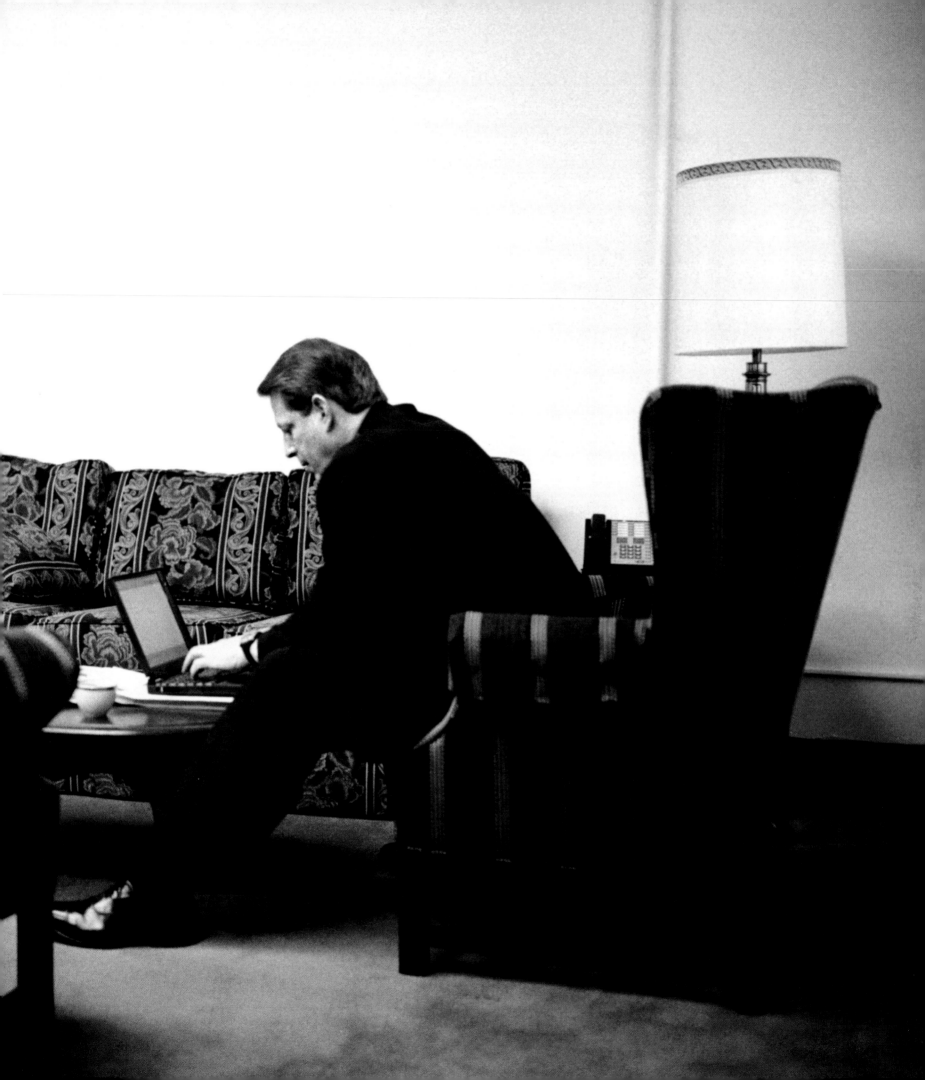

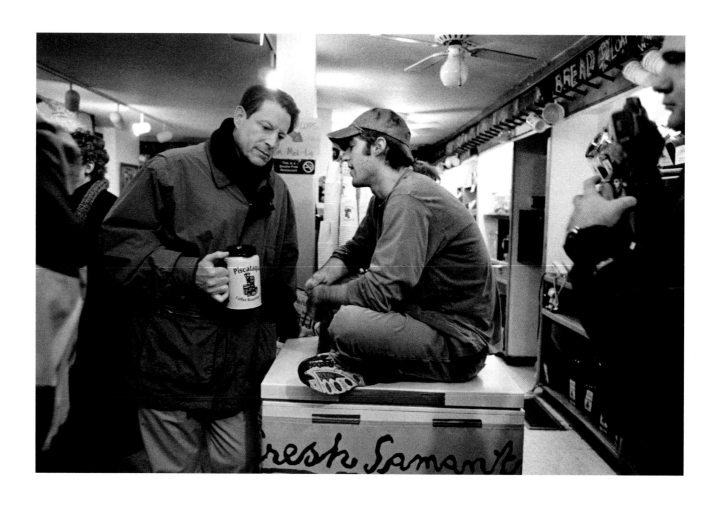

Top: **GORE GREETS A VOTER**, Newmarket, New Hampshire, January 28, 2000. "My dad takes conversations with constituents very seriously. That connection to an individual American is what it should be all about."—K.G.S

Bottom: **GORE PREPARES TO ANNOUNCE HIS RUN** for the presidency at the courthouse in Carthage, Tennessee, June 16, 1999. (left to right, Tipper Gore, Karenna Gore Schiff, Kristin Gore, Tony Coelho, Al Gore, and Wendy New)

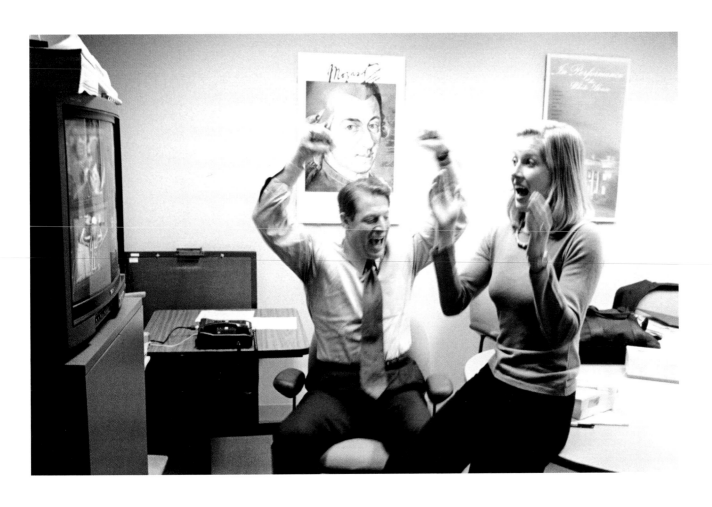

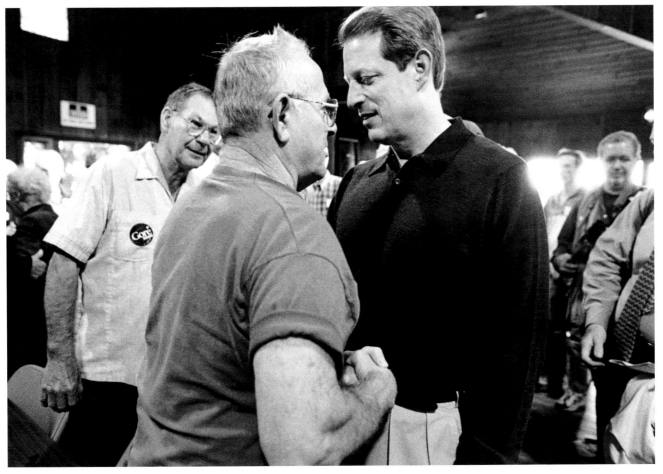

Top: **AL GORE AND DAUGHTER KARENNA** take time out for a football game, February 29, 2000. "It's so nice just to have a bit of distraction and release from the campaign trail. Tennessee is beating Buffalo, which meant that Tim Russert had to deliver Dad buffalo wings."—K.G.S.

Bottom: **GORE AT THE EAGLE POINT LODGE** in Clinton, Iowa, October 28, 1999. "I think sometimes people don't realize how intimate the campaign trail is when they see it on TV. They see a sound bite, but they don't see the many, many moments of contact with individual Americans."—K.G.S.

**BEHIND STAGE AT AN
I.B.E.W. RALLY,
PITTSBURGH,
PENNSYLVANIA,
NOVEMBER 4, 2000**

"In this election, the fact was we had two candidates who were incredibly different. My father would have taken the country, and the world, in a very different direction. It's very poignant to be reminded about the consequences of the process. He had so many supporters there, on the other side of the flag, so much riding on his shoulders. I am immensely proud of how he handled the outcome."—K.G.S.

ALL IN A DAY'S WORK

When I wasn't at the White House for *TIME* magazine, I was off on a variety of assignments for other periodicals: *People*, *Fortune*, the *Village Voice*, the *Washington Monthly*. I even had a wonderful gig for several years doing the annual report of a French oil company, which took me literally all over the world. Much of my work was done in and around Washington, but I was sent off to photograph such disparate things as the presidential election in Peru, welfare mothers in Detroit, heroin addicts in New York, life on the Mississippi today. I even traveled across the country on Route 50, a wonderful adventure with some *TIME* writers and editors, and had a ball photographing Washingtonians at play during the summer months from Florida to Maine. Everywhere I went I was shooting portraits of people, and even portraits of dogs for Elise Lufkin's *Found Dogs* and *Second Chances*, both stories of strays who landed on their feet.

I loved not knowing where I would be the next day, when an editor would call asking if I could go to a valley in West Virginia where the Hatfields still were feuding with the McCoys; or spend a day with Vladimir Horowitz on the verge of his triumphant return to Moscow after many, many years in the U.S. In organizing this book I found a place for this variety of portraits, and here it is: all in a day's work—mine, and theirs.

I begin with this picture of Rosalynn Carter looking totally, wonderfully human. I love the portrait of the very relaxed dress designer Bill Blass, throwing himself on the couch in relief after our sitting was over—all in a day's work! On we go with portraits of a rabbit fancier; a great sports icon; a bemused queen; famous writers, artists, designers, actors; and a brilliant doctor. See the juxtaposition of Russian dissident Natan Sharansky meeting the White House press, placed across the page from an image taken late one evening at an airport behind the Iron Curtain. It's all here—and don't miss the reaction of the MC of the beloved children's TV show "Romper Room" to being bopped in the shins by a little guest!

FIRST LADY ROSALYNN CARTER
Mrs. Carter was in Florida campaigning for her husband's reelection. Her last stop of the day was at the 23rd Annual Florida Democratic Women's Club reception at the Beach Club Hotel in Naples, October 4, 1979.

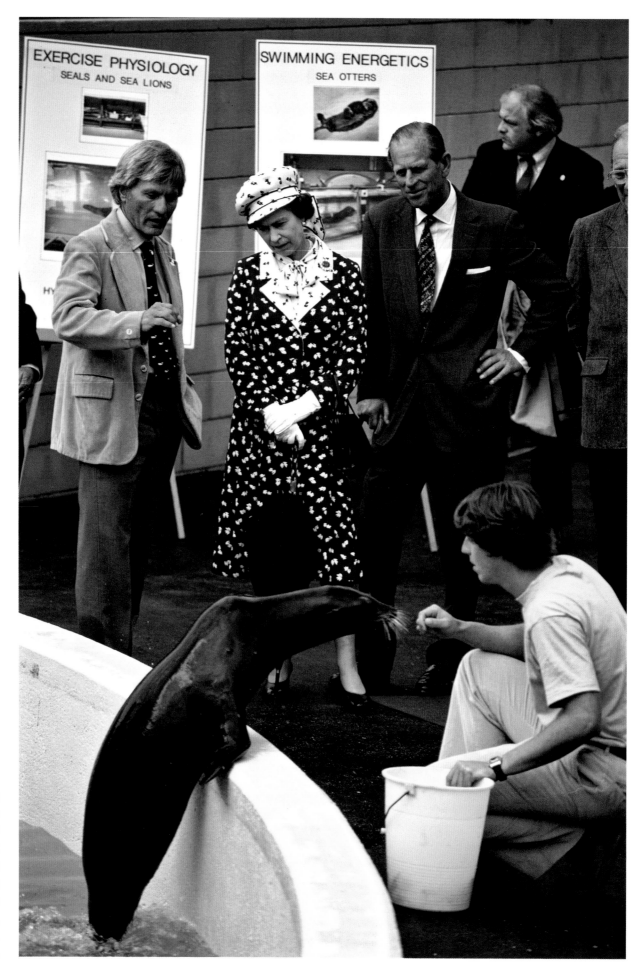

HER MAJESTY QUEEN ELIZABETH II AND HRH PRINCE PHILIP
While traveling around California, the Queen and Prince Philip are introduced to a California Sea Lion at Scripps Institution of Oceanography, UCSD, near San Diego, California, February 26, 1983.

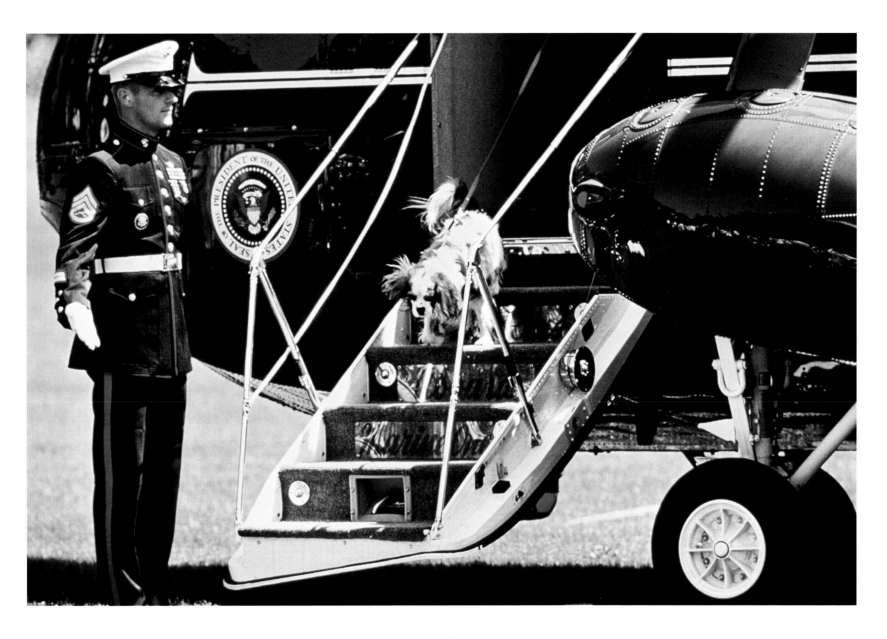

REX
The Reagans' Cavalier King Charles spaniel, Rex (1984–1998), "debarking" from the helicopter after
arriving home from Camp David, May 1998

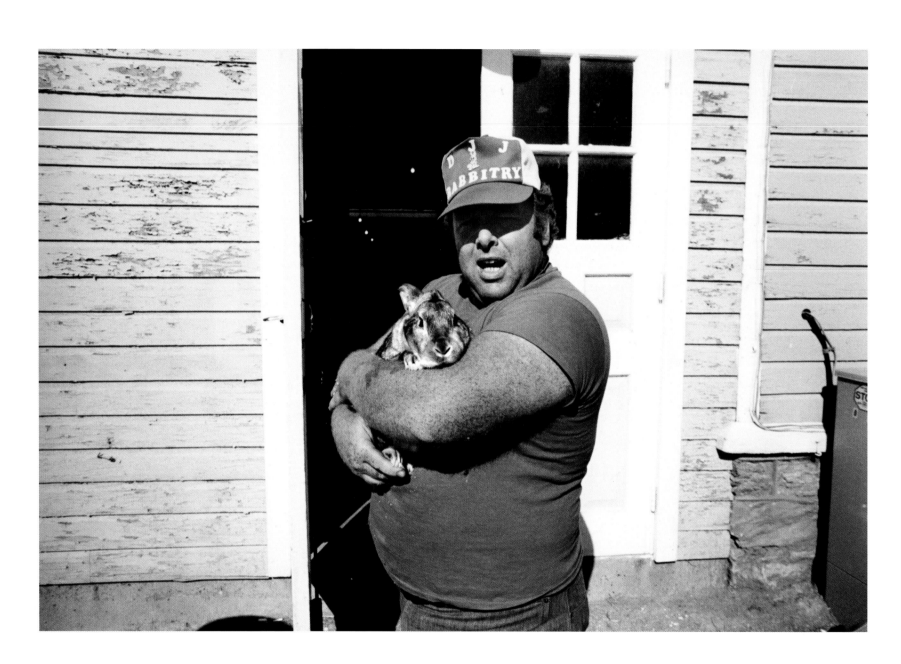

RABBITS
Outside the enclosure, a rabbit breeder shows off his champion, 1982.
"I went off to a regional rabbit competition in York, Pennsylvania, 'on spec.' I had a ball,
and *PEOPLE* magazine ran a five-page picture story."—D.W.

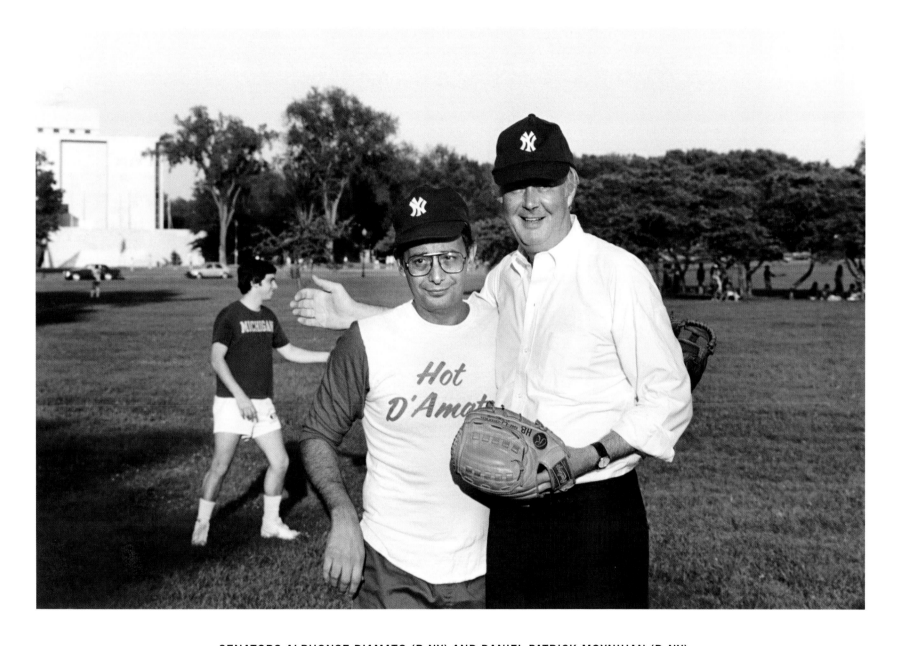

SENATORS ALPHONSE D'AMATO (R-NY) AND DANIEL PATRICK MOYNIHAN (D-NY)
Competitors in the Congressional softball league meet on the Mall. The Moynihan team, "The New York Pat Authority,"
took on the "Hot D'Amatos." Moynihan (1927–2003) got a hit at his only time at bat, June 1984.

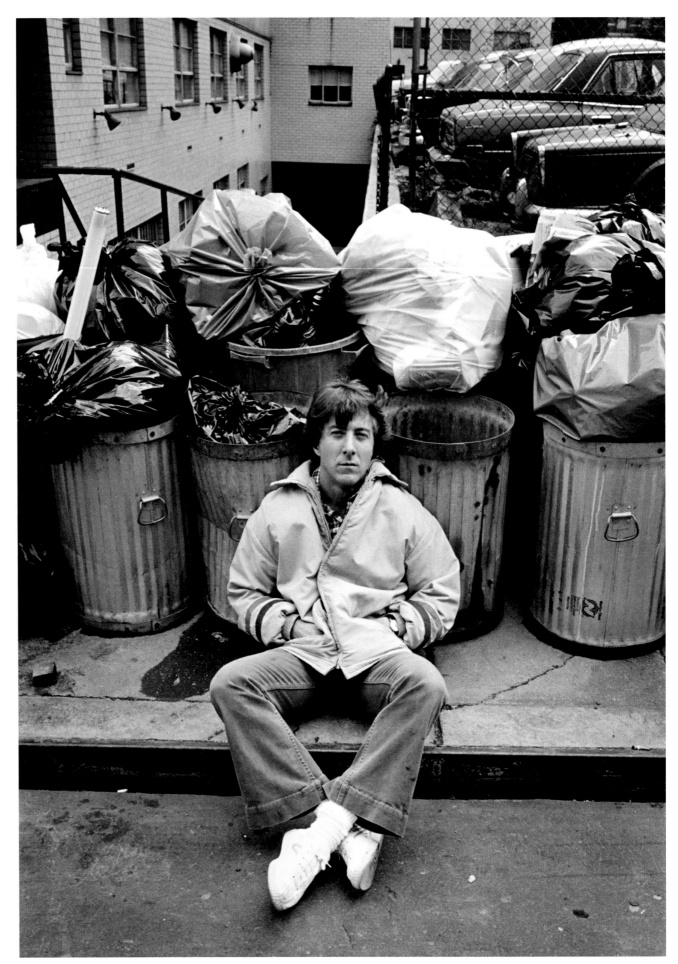

DUSTIN HOFFMAN
New York City, May 1976
"I was doing a portrait of Dustin Hoffman. I don't remember why I asked him to come outside, because there was a huge garbage strike, which he, of course, had absolutely nothing to do with. But he was a very good sport about it, and I had a lot to learn about finding an appropriate background."—D.W.

TOM CLANCY
Best-selling author Clancy at his insurance office near Annapolis, Maryland, after the success of his first book,
The Hunt for Red October, February 1985. "The book became a best seller in great part because President Reagan had read it.
He called it 'the perfect yarn,' and invited its author to the White House for a chat."—D.W.

HALSTON
(Roy Halston Frowick)
Halston, the dress designer, in
his Seventh Avenue office in
New York City, May 1976
"When I took this picture,
early in my career, I knew
absolutely nothing about
how to light a portrait. I got
around it by shooting available
light, and luckily the light that
day was lovely."—D.W.

SALLY QUINN
Journalist Sally Quinn
at home in Washington, D.C.,
November 1977
"I took this photograph for
the cover of *Dossier* magazine,
a 1980s Washington
periodical. Sally's house,
with its light and color, was
an ideal studio."—D.W.

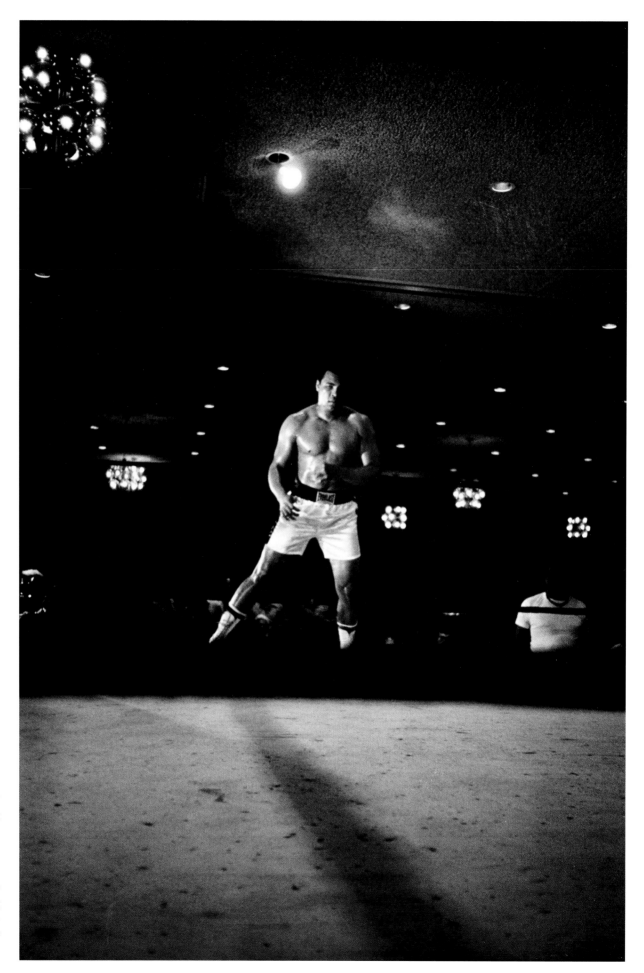

MUHAMMAD ALI
spars at a press preview
prior to a heavyweight
championship fight at the Capital
Center in Landover, Maryland,
against Jimmy Young. Ali won a
controversial but unanimous
decision despite being
at his heaviest weight, 230
pounds, and out of
condition, April 1976.

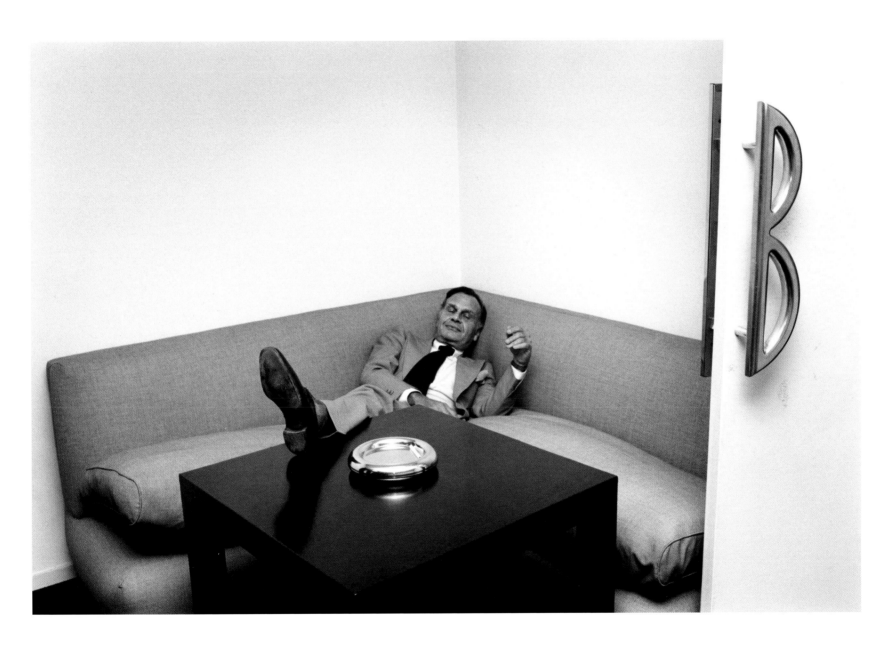

BILL BLASS

At his New York showroom, April 1976. "I had known Bill Blass (1922–2002) for a long time, having been in the retail dress business
with my mother, so he was wonderfully patient with me when I photographed him. I learned a lesson that day that I have lived by ever since:
Always reload your camera when you've finished the shoot. Invariably, the minute you say, 'thank you very much, I'm done,'
your subject will be so relieved that he or she will totally relax!"—D.W.

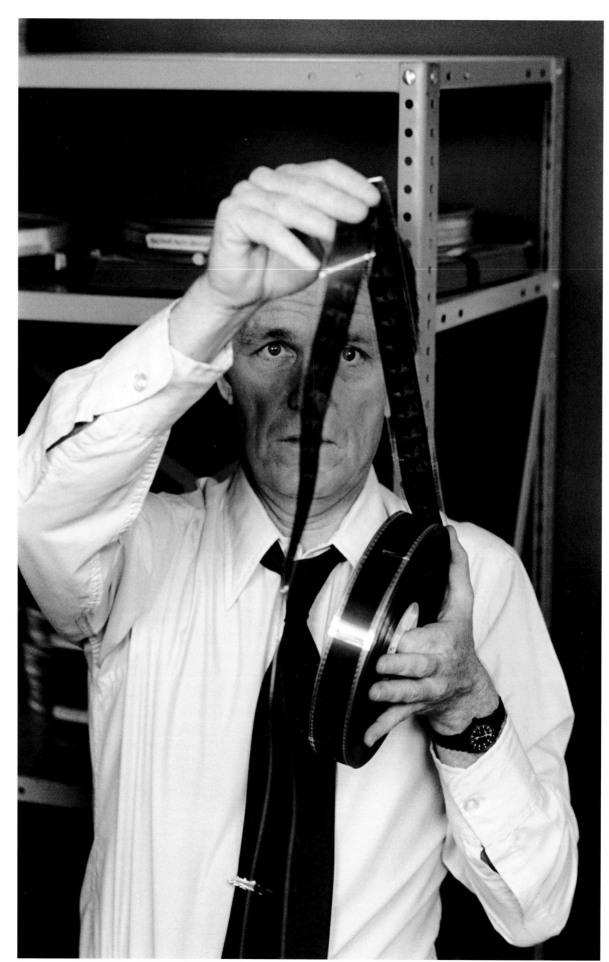

GEORGE STEVENS, JR.
George Stevens inspects film at the AFI office in Washington, December 9, 1977. "When working for *PEOPLE*, I often introduced my subjects with something that illustrated their work. George Stevens, Jr., was the founding director of the American Film Institute. He is also a producer, an author, and now a playwright."—D.W.

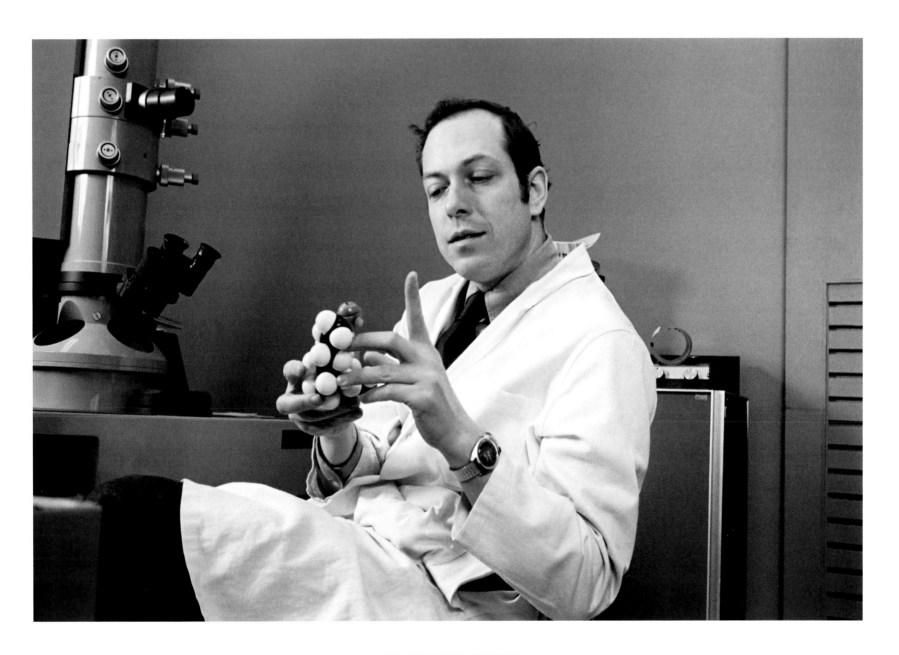

DR. SOLOMON SNYDER

Dr. Snyder is a professor of neuroscience at Johns Hopkins School of Medicine. He received the Albert Lasker award in 1978
for his discovery of opiate receptors. His techniques and discoveries have led to the design of new drugs to treat mental illnesses,
including schizophrenia, depression, and anxiety. He won the National Medal of Science in 2003. February 24, 1978

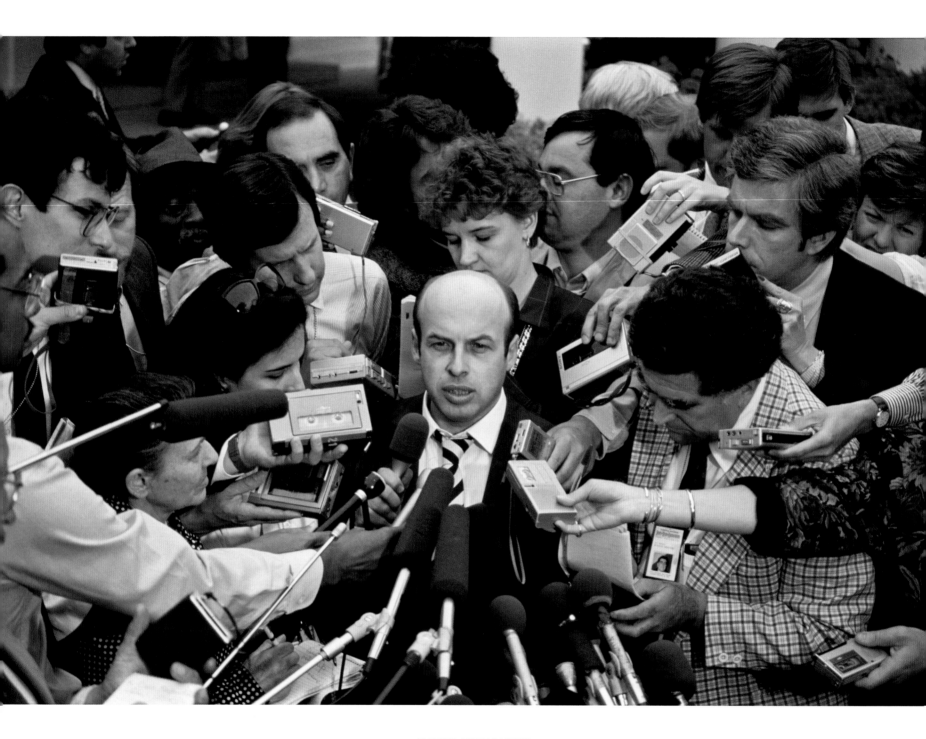

NATAN SHARANSKY

Sharansky meets the press in the White House driveway, May 13, 1986. An international campaign supported by Presidents Carter and Reagan led to the Soviet Jewish dissident's release on February 11, 1986, as part of an East-West spy exchange.

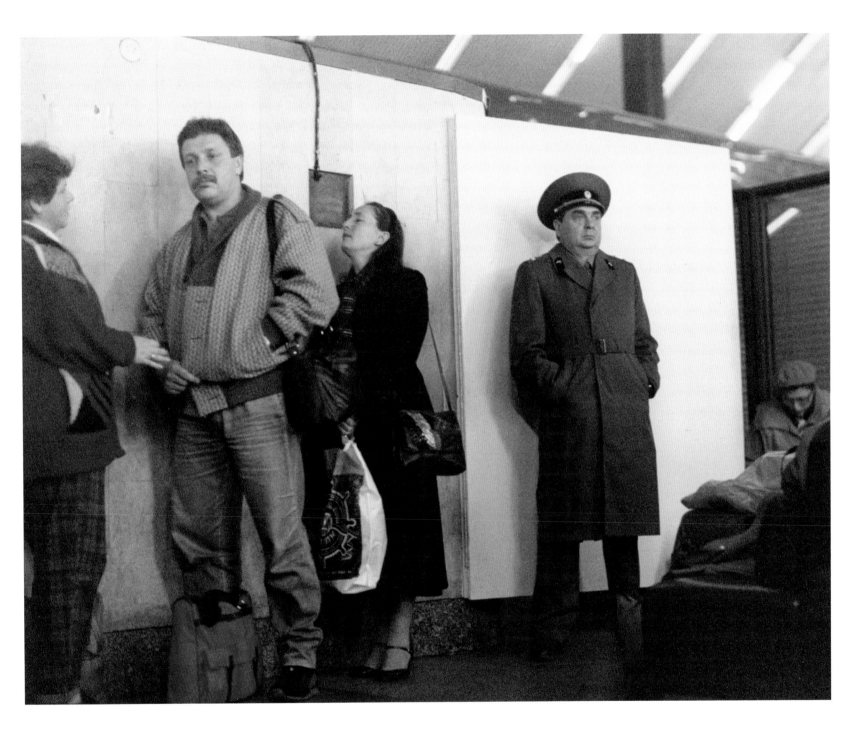

MOSCOW AIRPORT
Waiting for the plane behind the Iron Curtain, September 1990

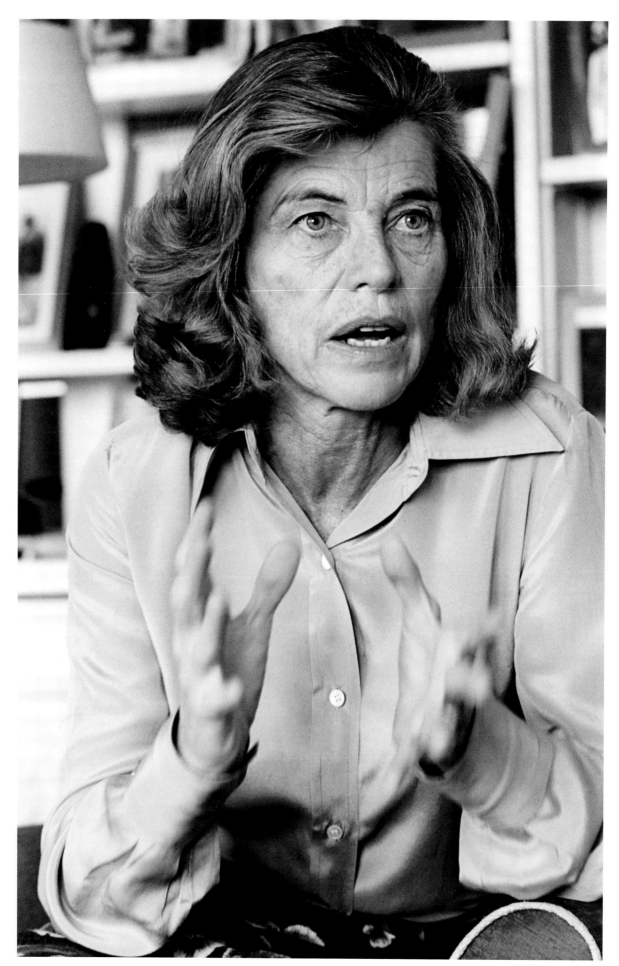

EUNICE KENNEDY SHRIVER
The founder of the Special Olympics during an interview, 1975

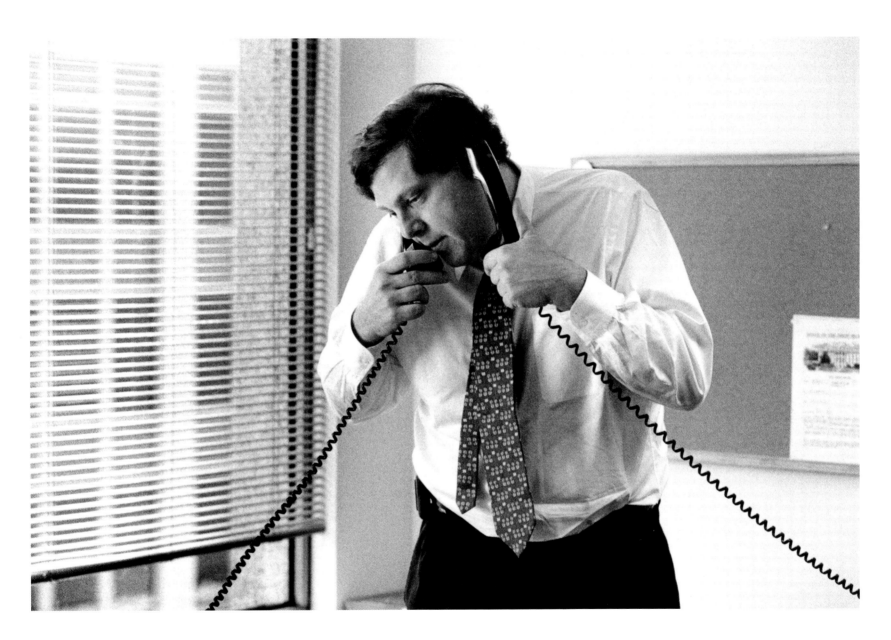

MARK PENN
The pollster at work on the Clinton-Gore campaign, Washington, D.C., October 23, 1996

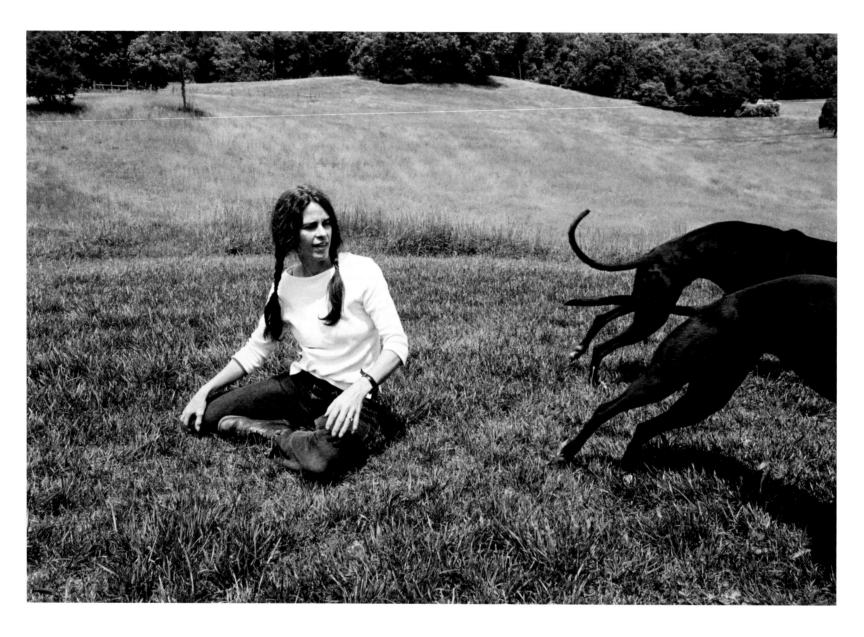

SALLY MANN on her farm in Lexington, Virginia, 2002

"Just as I lifted my camera to shoot this portrait of the great artist-photographer and her adopted greyhounds,
for the book *Second Chances, More Tales of Found Dogs*, her dogs simply took off. Tails, I'll say."—D.W.

ALEXANDR SOLZHENITSYN
After his expulsion from the Soviet Union, Solzenitsyn, author of *The Gulag Archipelago, 1918–1956*, makes a speech on Capitol Hill, Washington, D.C., July 1975.

SALLY BELL

Sally Claster Bell, daughter of Nancy Claster, founder of the popular children's TV show "Romper Room," December 1, 1977. "What a funny moment it was. Suddenly Sally got bopped in the shins by one of her little guests."—D.W.

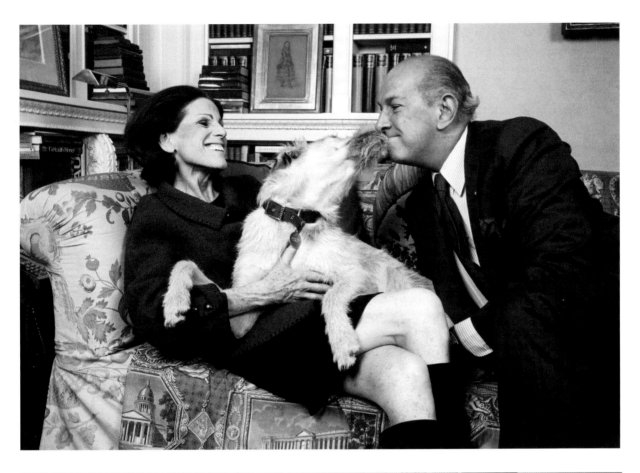

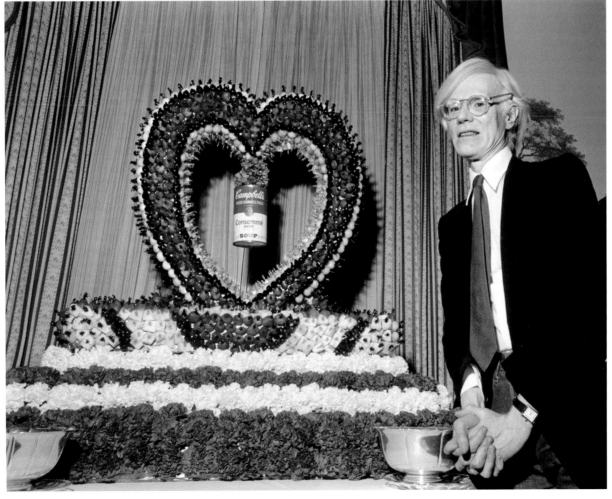

Top: **ANNETTE AND OSCAR DE LA RENTA**
Fashion designer Oscar de la Renta and his wife, Annette, in their New York apartment, 2002. "The de la Rentas have a soft spot for lost dogs. This is Cinco, whom they retrieved from a plastic bag in the Dominican Republic."—D.W.

Bottom: **ANDY WARHOL**
The artist appears at a party given for him by Ambassador Ardeshir Zahedi at the Embassy of Iran, February 14, 1977.

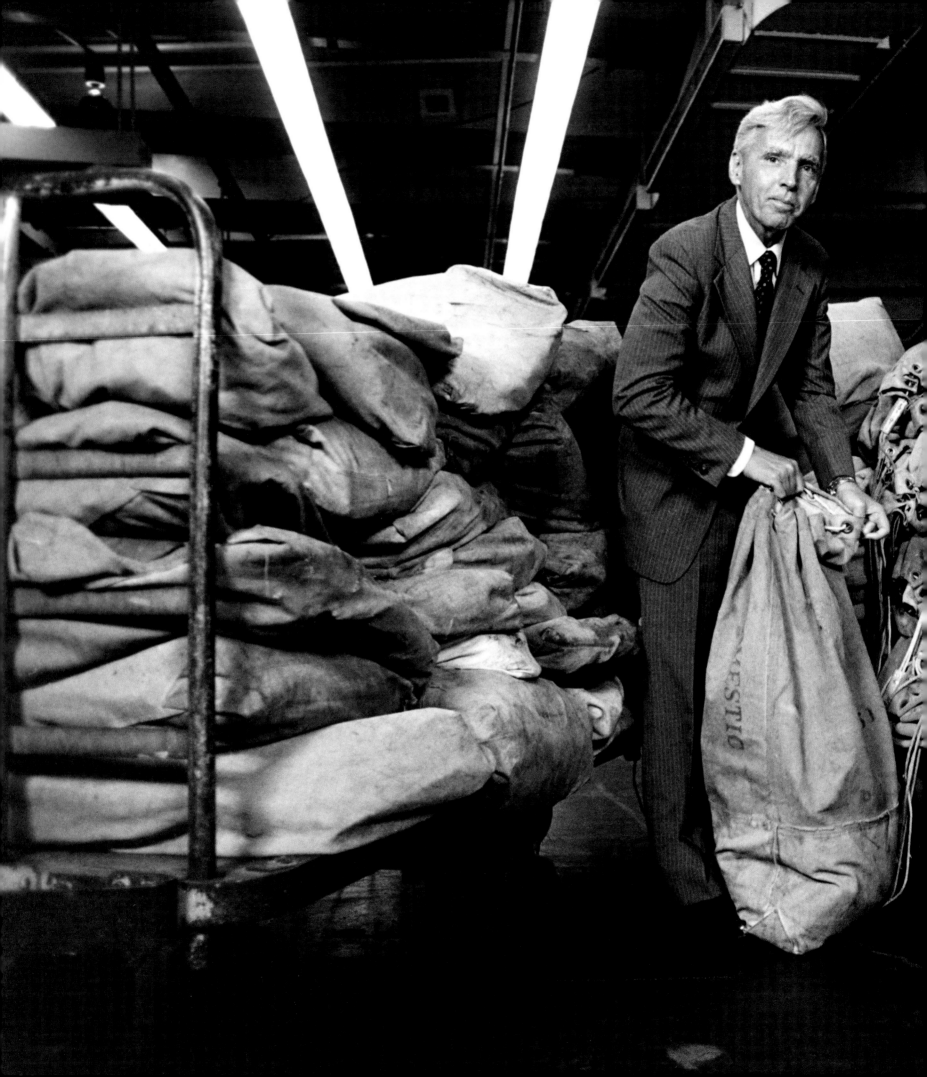

WILLIAM F. BOLGER
The Central Post Office, Washington D.C., September 1980. "In another opener for *PEOPLE* magazine, Postmaster General William Bolger (1923–1989) poses with mailbags. He was certainly game, and I was certainly literal."—D.W.

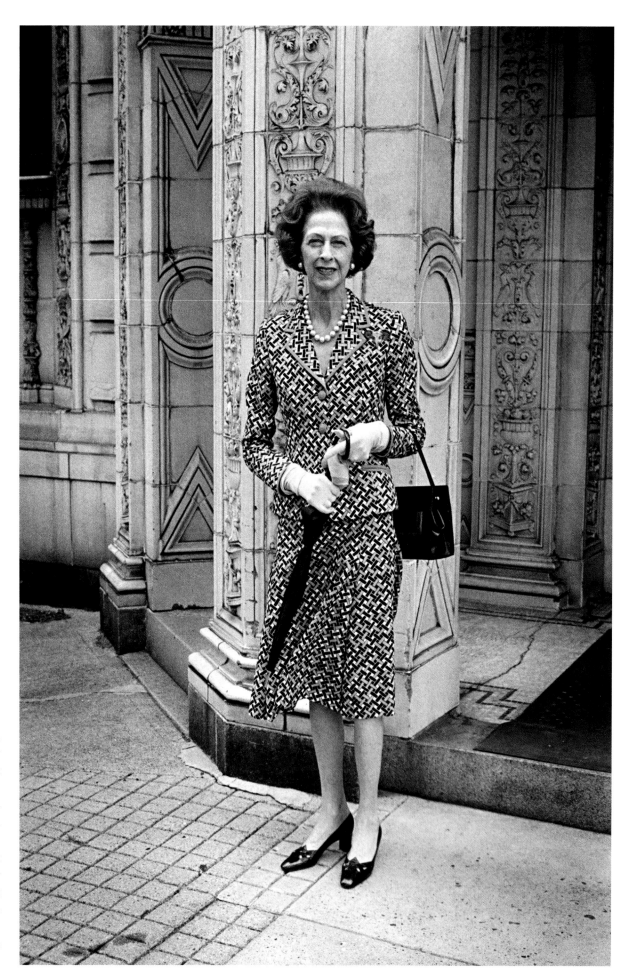

MRS. SIDNEY KENT LEGARE
Mrs. Legare in front of her apartment at 2029 Connecticut Avenue in Washington, D.C., 1975. "Minna Legare (1905– 1988) was one of Washington's truly great ladies of her day. Elegant and chic, she never lost her charm, her kindness, or her curiosity, all of which she must have brought with her from the small town of St. Matthews, South Carolina, where she grew up."—D.W.

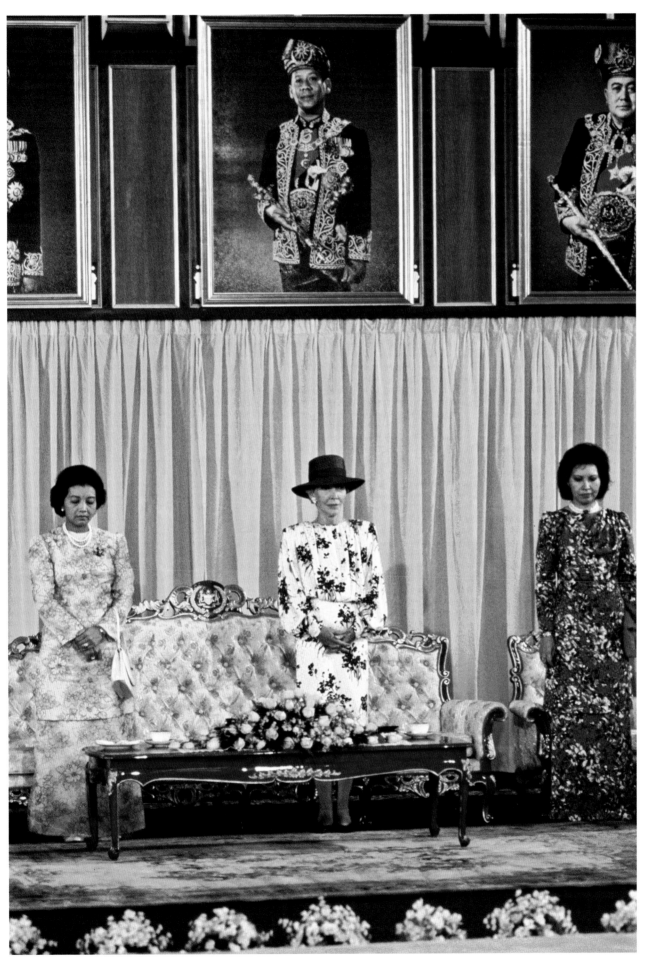

**FIRST LADY
NANCY REAGAN**
Mrs. Reagan, on her way to join
President Reagan at a G-7
meeting in Tokyo, attended a tea
and fashion show at the palace in
Kuala Lumpur, Malaysia,
May 2, 1986.

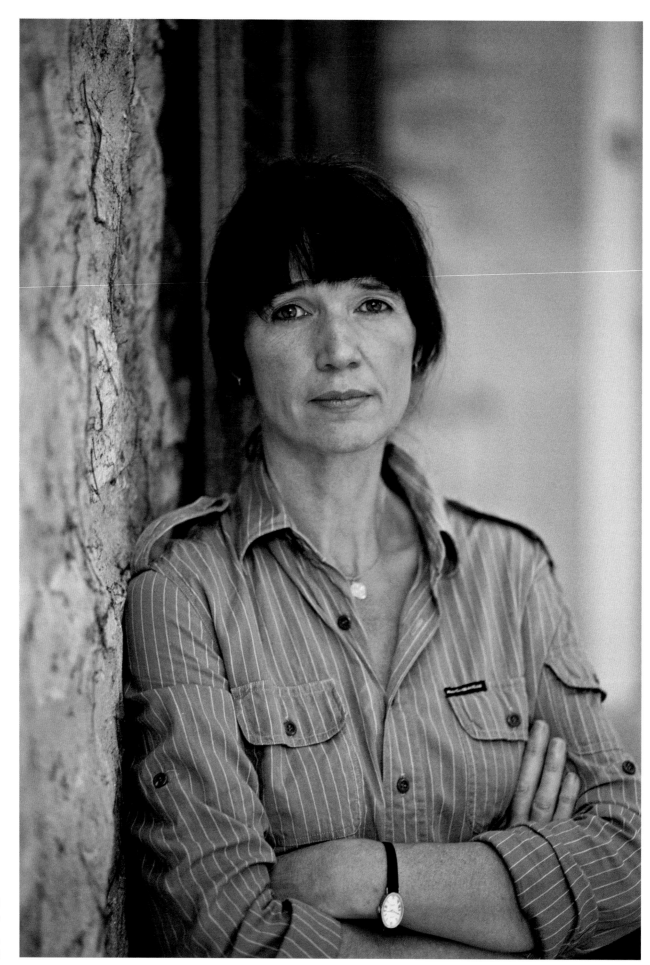

ANNE TYLER
The author Anne Tyler
at home in Baltimore,
Maryland, 1985

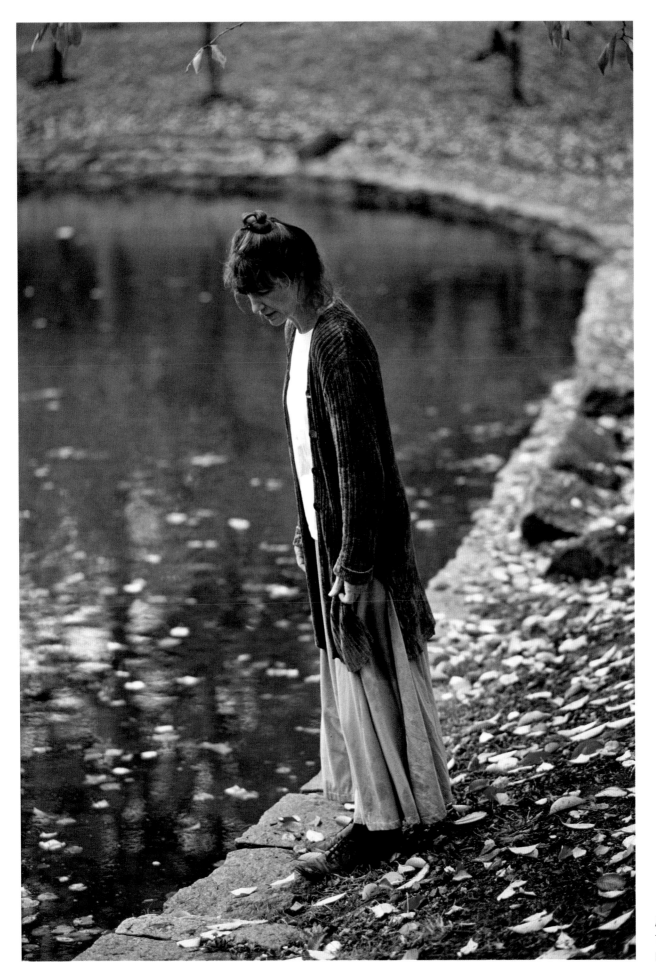

ANNE TYLER
The author at a pond near her home in Baltimore, 1995

From my conversation with **JAMIE LEE CURTIS**

"Well, I'm an actor, so by nature someone is always taking your picture. I'm not a politician, obviously, but I've played one on TV. I understand how it feels. I'm a "thing" often in a picture. People are just constantly grabbing their cell phones now, trying to capture an image of you or me. It feels a little like the old adage that it has stolen a little piece of me. I understand both sides of it. I'm a bit of a hypocrite because I don't particularly like to be in front of the camera, yet I love to take pictures. Love to, like a passion I have.

"You know, a portrait can be a 'sit down and I'm taking your picture,' or a portrait can be conceptually a portrait of a person, a photograph as a portrait of that moment. Not everybody gets that bigger picture. Not everybody gets the full frame. They get a portion of it. They get what the press, or the government, the studio, or whoever it is wants them to get.

"When I'm out front, that's a whole different persona. That's a very confident, playfully aggressive persona that I have turned into a career—a fully fearless persona. Fearless. And that is not me. I don't like 99 percent of the pictures that are taken of me in this milieu. And in this milieu of my business, this is the constant thought: How's my hair, how's my thing, how am I looking? It's con-stant, it's my antennae firing. You get out of that car at the Oscars and from the moment your foot hits the ground, they're shooting. Many people are looking for something negative. They're looking for a way to humiliate you. Look at today's press. Look at today's magazines. It's a stalking, and it's a very aggressive media that's going after people now. That doesn't make you feel safe.

"I feel different in front of a lens with you. I don't worry about it ever. You're not looking for something negative. There is rarely a picture of me that you've taken that I don't like. Now, what is that? It's intimacy. The intimacy of spending time with someone is vital. I'm not putting on the 'Jamie' face in these pictures. Many of these, I have nothing on my face. I have not brushed my hair. I am not imagining what I look like. So there's a naturalness to it that's just beautiful.

"It's the idea of getting to know someone beyond that little slice that most people get that's great. You've had the opportunity to do so with a bunch of people for a long time, and that's just unusual, to have shot somebody over a long period of time. The picture on the top of the hill (page 160)—I know it's me; that's why I recognize it. That's why every time I've seen it, I'm, like 'Aah,' it's unbelievable, it's just beautiful."

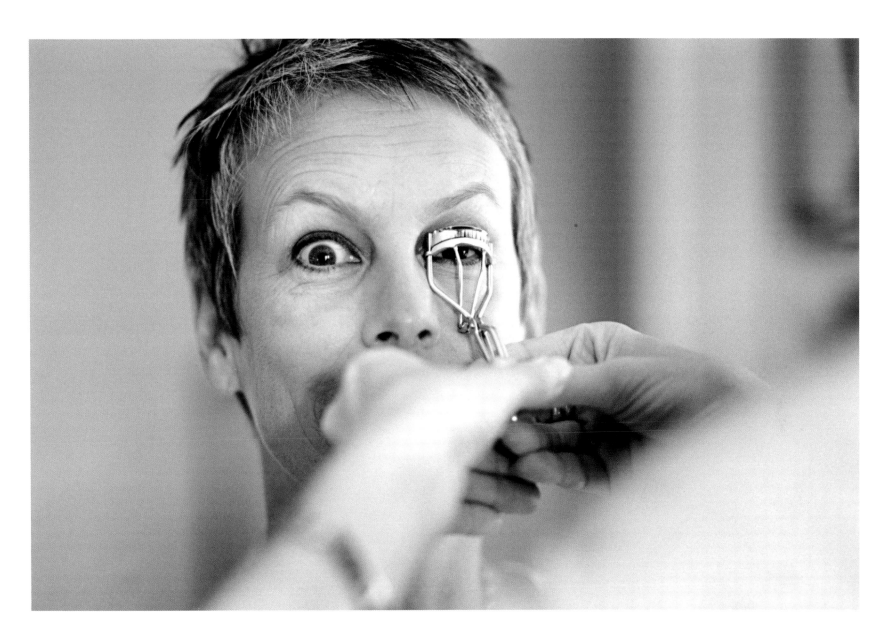

JAMIE LEE CURTIS being made-up, April 8, 2005. "There is something so humiliating about getting your eyelashes curled. The only really good news about this picture is you can tell I haven't had Botox, because of the lines on my forehead."—J.L.C.

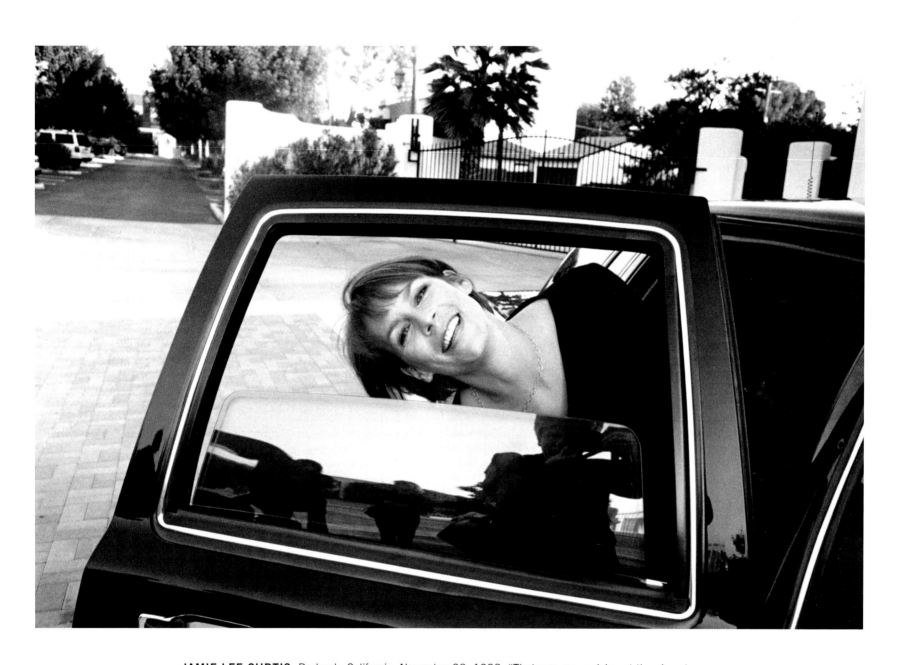

JAMIE LEE CURTIS, Burbank, California, November 22, 1998. "That was me, arriving at the airport on my 40th birthday. I was taking my closest women friends to Vegas to see the Cirque de Soleil show. That's me kind of half acting for you and half just being me. It was me, kind of as a hybrid."—J.L.C.

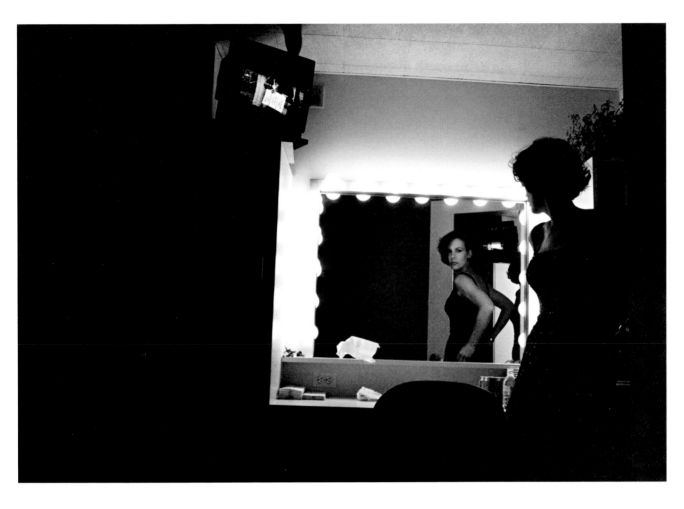

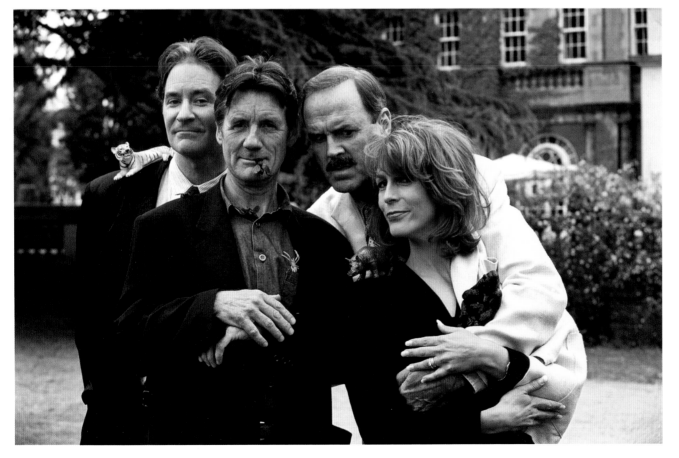

Top: **IN THE DRESSING ROOM** of the Letterman show, at the time of *True Lies*, New York City, 1994 "I'm just in the zone. All I'm interested in, is what do I look like? I'm absolutely in that pre-going-out-there moment."—J.L.C.

Bottom: **KEVIN KLINE, MICHAEL PALIN, JOHN CLEESE, AND JAMIE LEE CURTIS** making *Fierce Creatures*, London, 1995 "This reunited foursome was about to embark on what was supposed to be a brilliant and funny sequel to *A Fish Called Wanda*. As it turned out, it was a dismal failure in every possible way. But that's the persona, that look. I'm not smiling, and I'm highly aware of what I look like, of what my hair is looking like. I am playing it for the photographer, and it's the Jamie smirk. It's the 'I'm not letting you in anywhere near me.'"—J.L.C.

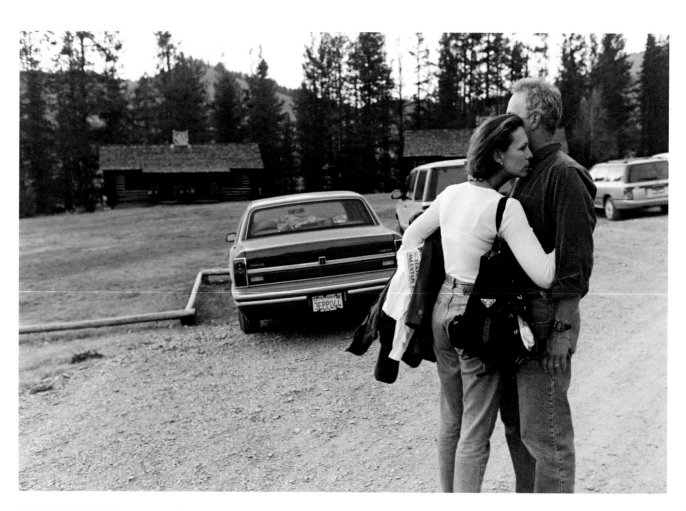

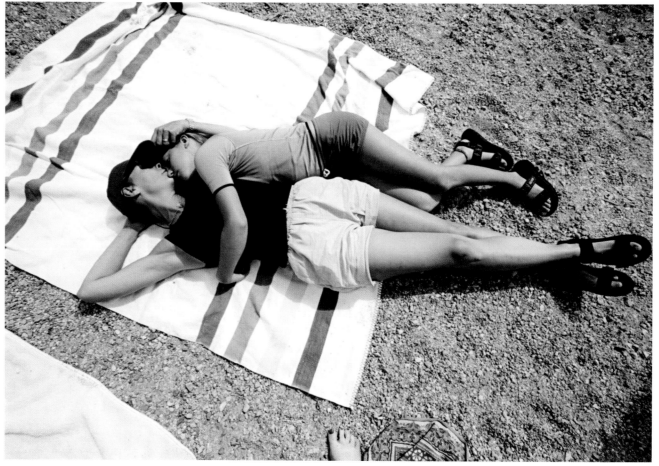

Top: **JAMIE AND HER HUSBAND**, actor, director, and writer Christopher Guest, near Stanley, Idaho, August 1997. "Marital relationships are very difficult to take pictures of, and my husband is intensely uncomfortable in front of the camera, except when he's a really weird character in a film. Then, he's incredibly funny, but he's very, very private."—J.L.C.

Bottom: **JAMIE AND HER DAUGHTER**, Annie, Red Fish Lake, Idaho, 1997 "This shows what I hope is the lack of a gap between me and my daughter, Annie. I don't remember what the moment was—but it was certainly not posed. And it was intimate. These connective moments with my kids are really important to me."—J.L.C.

JAMIE AND HER SON,
Tom, Santa Monica, 1996.
"I remember this. My son
was not walking yet. He might
have been toddling a little.
There's nothing like a little
boy for a mommy. He's just my
little guy. I remember it was a
very hard time. My father-in-law
had just died, and it was a
stressful time, but I remember
feeling that you knew all that,
and that's why the picture's
so good."—J.L.C.

JAMIE AND HER MOTHER,
actress Janet Leigh (1927–
2004), flying to Las Vegas,
November 1998
"My relationship with my mom
was not that intimate. And,
you know, this picture almost is
evidence of that by the chasm
between us. And yet, there is
contact, because we did have
some."—J.L.C.

**JAMIE, NEAR
SANTA MONICA, 1994**

"There is something so beautiful
and hopeful about the way the
light has hit me. There's
something really serious about it,
because for all my jokey, self-
deprecating silliness, I am a very
serious person. I have a lot of
stuff, and that captures all of it.
The way the light is coming down,
I feel like I'm being touched by
God; I really do."—J.L.C.

PARTIES

There are many kinds of parties. I begin this section with a small, impromptu get-together, followed by a very large, very formal banquet. First is a small gathering of Reagan's inner circle, in a room adjacent to the Oval Office. It's a favorite of mine, a shot taken behind the scenes for CBS of a champagne party honoring Walter Cronkite upon his retirement as anchor of the CBS Evening News. From the look of it, the joke must have been pretty good! On the following page is a picture taken at a dinner for 90 guests, honoring President and Mrs. Reagan, given by Queen Elizabeth II at Windsor Castle. I love the way the President is looking across the table at Mrs. Reagan. I bet he was thinking what a swell party this is!

On foreign trips following the President, often I would volunteer to photograph state dinners, since my TIME colleagues sometimes preferred to visit the best restaurant in town. I found it fascinating to witness a dinner given by the Emperor of Japan, or observe how the Queen's table was set. When you have 90 people to dinner, does the china all match? Being ushered through the dining room before the Queen's banquet (page 164–165), our pool of photographers was surprised to see a young man with felt boots on his feet walking gingerly down the center of the table adjusting the candelabra. We all quickly snapped a shot, but were later informed by the protocol office that pictures may not be published from behind the scenes at palace events.

Shooting parties was really not my strong suit. Believing that a photojournalist shoots what he sees, and does not stop conversation or interfere, ever, I usually found nothing but people's backs as I maneuvered in a crowd. But sometimes I got it right. Several of these photographs were taken at the Kennedy Center Honors, which I officially photographed for 25 years. I always found it to be great fun. Where else could you find a group like Fred Astaire, Arthur Rubenstein, Ginger Rogers, and the Douglas Fairbanks, Jrs.? The last picture in the chapter, once again of Kennedy Center honorees, is enhanced by a letter I received from silent-film star Lillian Gish, describing her enchanting evening.

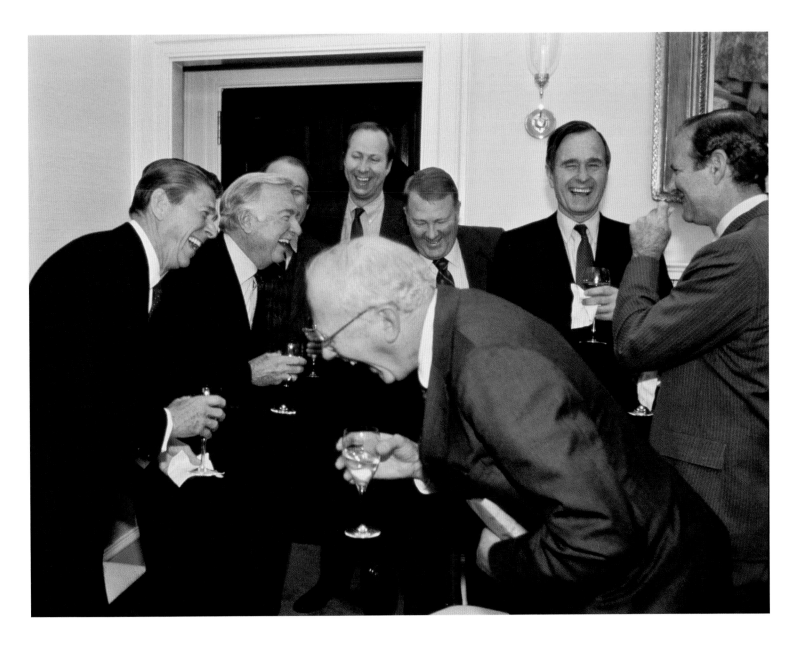

PRESIDENT REAGAN, WALTER CRONKITE, JAMES BRADY, DAVID GERGEN, ED MEESE, VICE PRESIDENT BUSH, JIM BAKER, AND CBS'S BUD BENJAMIN
Sharing a joke at the White House, March 3, 1981

HRH PRINCESS MARGARET, PRESIDENT REAGAN, AND HER MAJESTY QUEEN ELIZABETH II
A dinner given by the Queen in the Reagans' honor, Windsor Castle, England, June 8, 1982

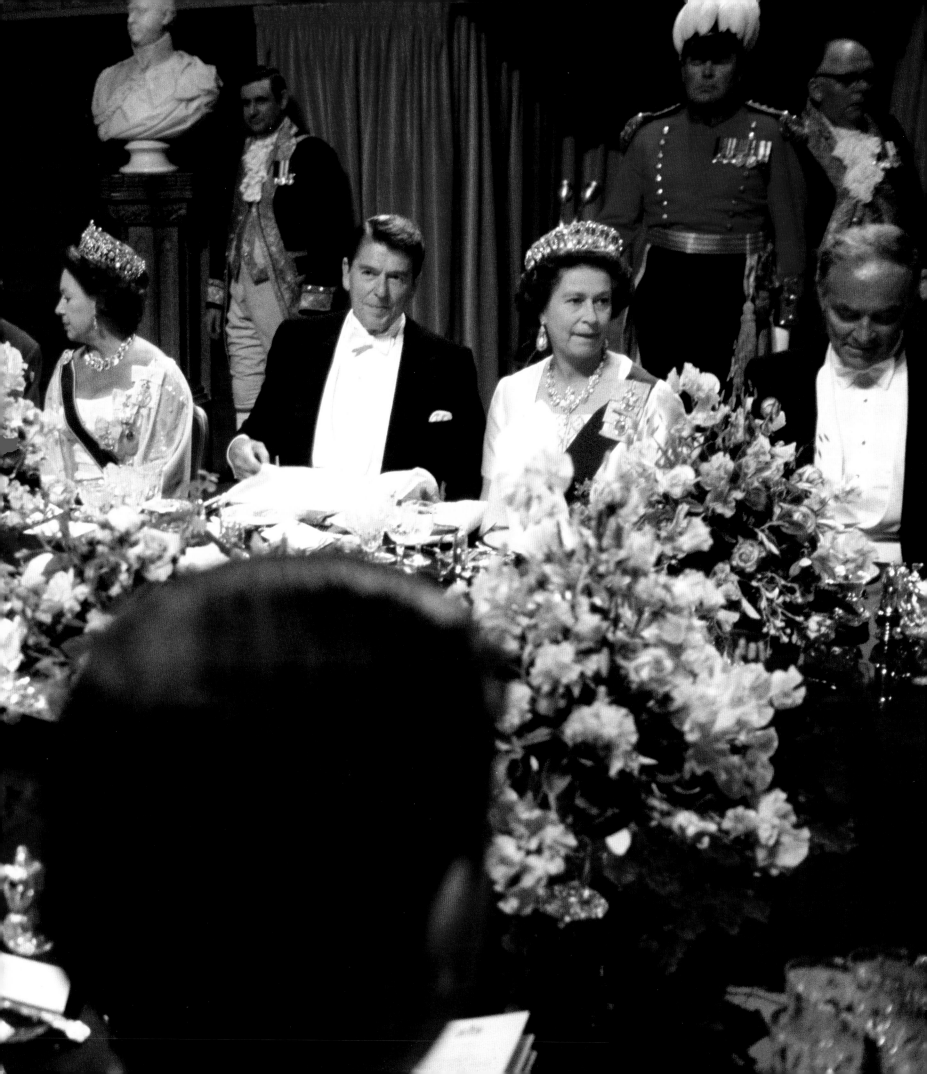

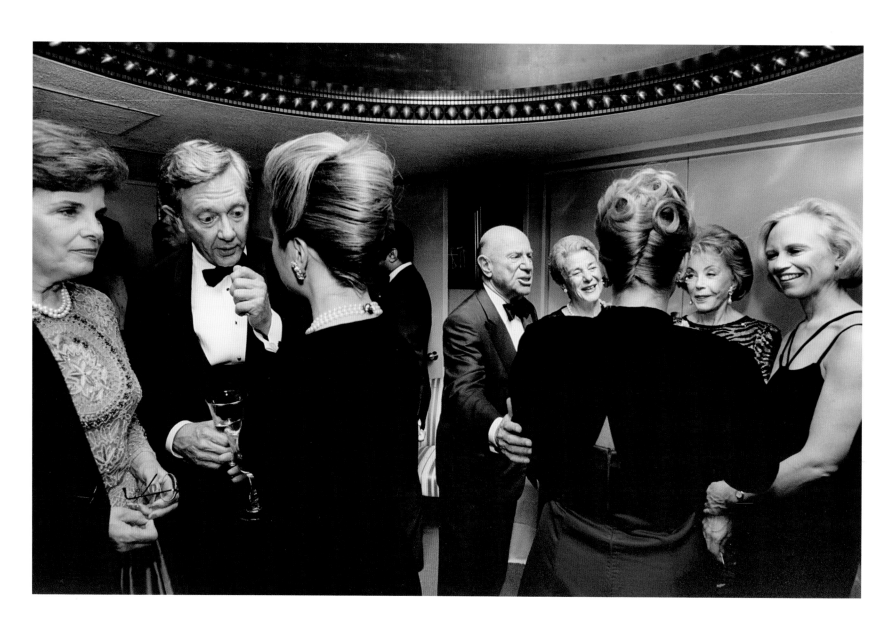

PRESIDENTIAL BOX, THE OPERA HOUSE, THE KENNEDY CENTER HONORS
Senator Dianne Feinstein (D-CA) and Secretary of the Interior Bruce Babbitt speak to Hillary Clinton, while Laurence Tisch, Billie Tisch, Anne Douglas, and Hattie Babbitt speak to Tipper Gore. Kirk Douglas was a Kennedy Center honoree, December 4, 1994.

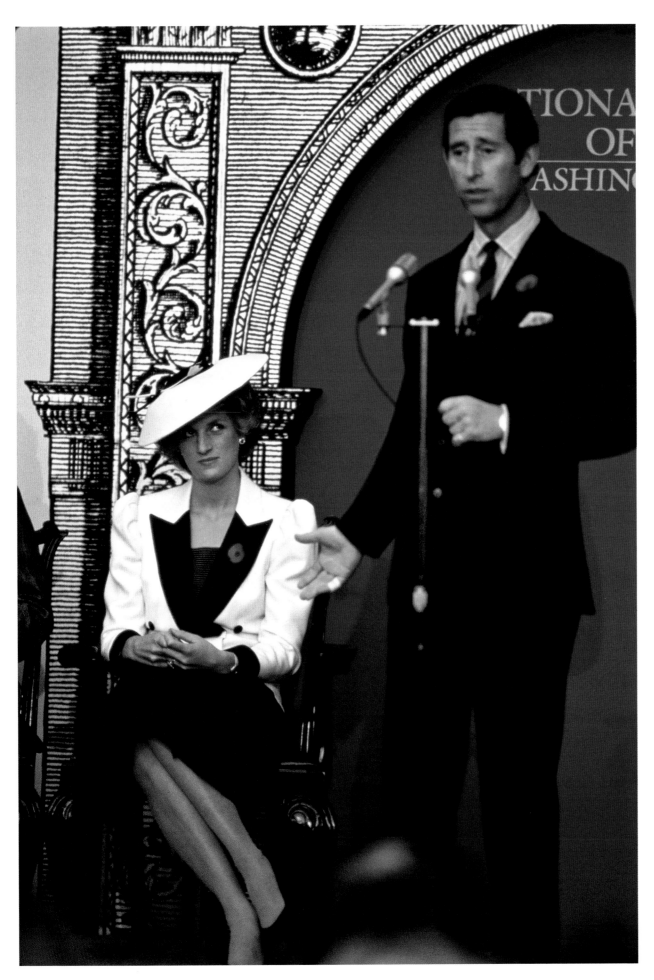

THE PRINCE AND PRINCESS OF WALES
The royal couple visits the National Gallery of Art's 1985 show "The Treasure Houses of Britain," in Washington, D.C., November 1985.

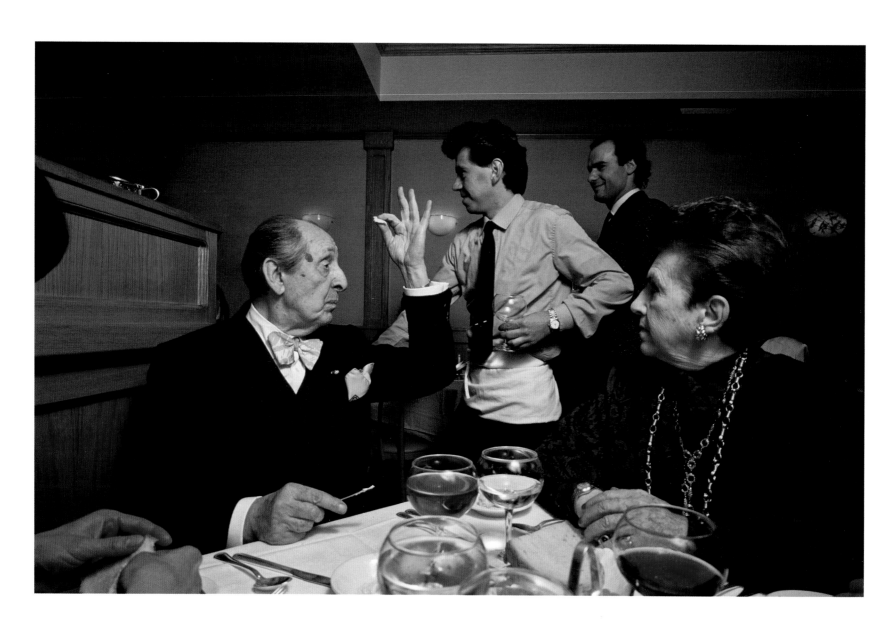

VLADIMIR AND WANDA HOROWITZ

Maestro Horowitz (1903–1989) and his wife, Wanda (1907–1998), daughter of Arturo Toscanini, have dinner at Sistina just prior to his triumphant return to Moscow to give a concert, the first since he'd left the Soviet Union, New York, March 1986.

MARY LEE FAIRBANKS, FRED ASTAIRE, ARTHUR RUBINSTEIN, DOUGLAS FAIRBANKS, JR., AND GINGER ROGERS
At the party following the first Kennedy Center Honors, at which Fred Astaire and Arthur Rubinstein were among the honorees, 1978

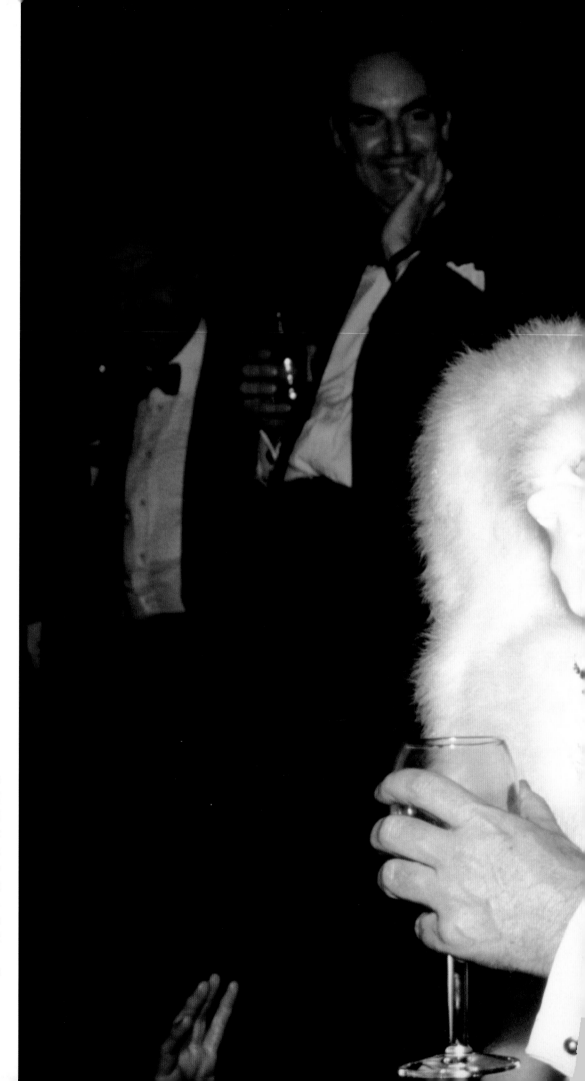

THE MIME AND TERENCE SMITH

Longtime newspaper and television journalist Terry Smith at a Washington party, December 1985 "I was walking along, minding my business, with a Leica, of course, when suddenly, there was this slinky brunette in what appeared to be white ermine. Flashing her Mylar chest, she caught Terry in mid-leer. What a moment!"—D.W.

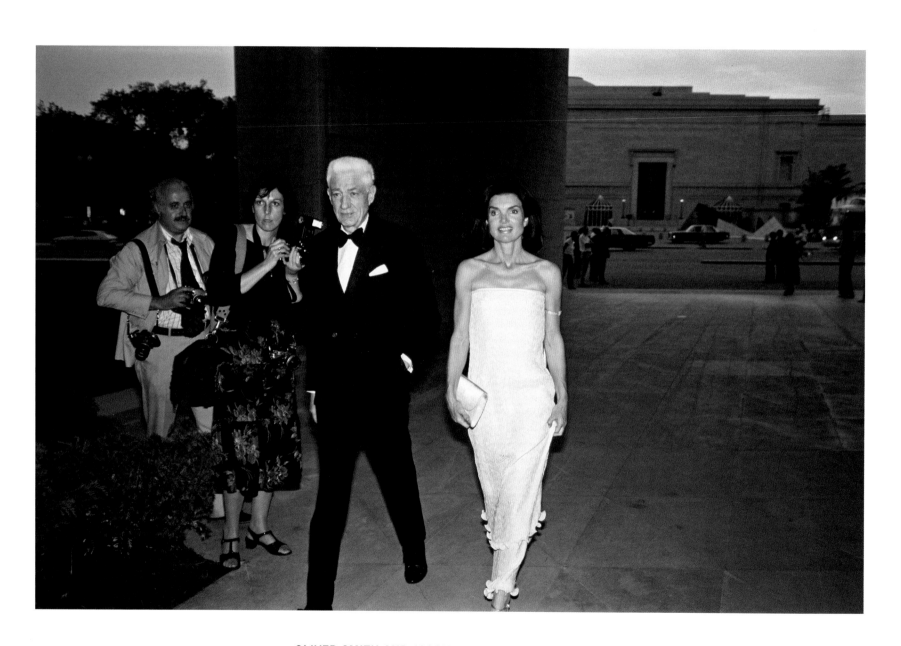

OLIVER SMITH AND JACQUELINE KENNEDY ONASSIS
Scenic designer Smith (1918–1994) and the former First Lady (1929–1994) arrive at the East Building of the
National Gallery of Art for the opening dinner hosted by the Paul Mellons. Photographers Harry Naltchayan and Theresa Zabala
lurk in the shadows, Washington, D.C., May 30, 1978.

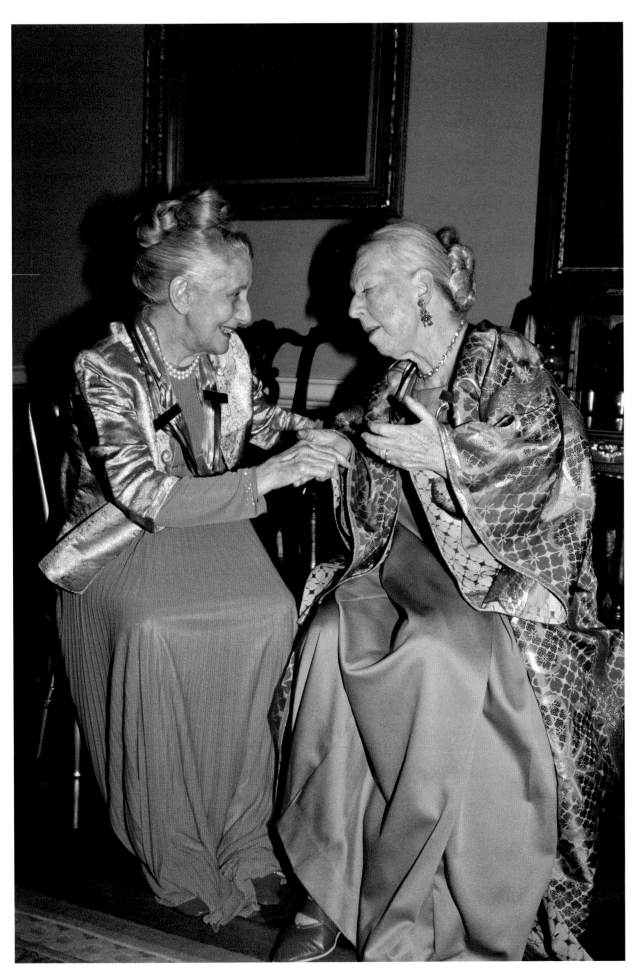

**LYNN FONTANNE
AND AGNES DE MILLE**
Actress Fontanne (1887–1983)
and dancer and choreographer
de Mille (1905–1993) chat
at the Kennedy Center Honors
after receiving their awards
at the U.S. Department of State,
December 1980.

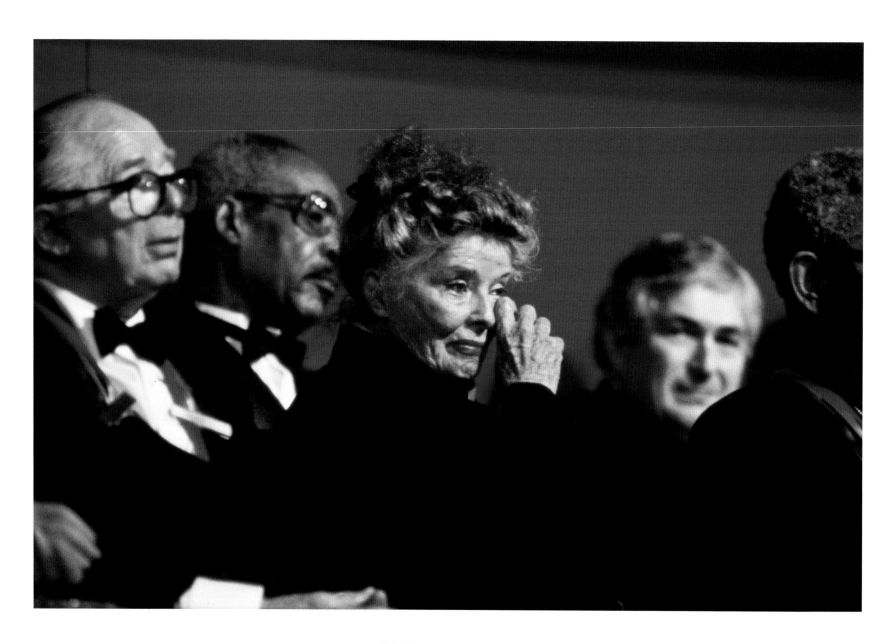

KATHARINE HEPBURN

The great actress (1907–2003) is moved to tears by the tributes paid to her as she is awarded
the Kennedy Center Honors, December 1990.

SHIRLEY MACLAINE
At a party in Georgetown
after the opening of
The Turning Point, a movie in
which she had a starring role,
Washington, D.C., 1977

**GEORGE ABBOTT,
BENNY GOODMAN,
LILLIAN GISH,
GENE KELLY, AND
EUGENE ORMANDY**
Kennedy Center Honors,
December 4, 1982
"When my beloved sister, Dorothy,
and I were touring as children in
10-, 20-, 30-cent melodramas,
we loved to play in Washington
because our mother would always
take us to all the monuments to
teach us our history. The biggest
thrill of all was climbing to the
top of the Washington Monument.
In this photograph, my four
distinguished colleagues and
myself have just had our Kennedy
Center Honors ribbons placed
around our necks after a delicious
dinner in the State Department's
elegant Benjamin Franklin room.
It is no wonder my feet are off the
floor, because I am flying right
back to the top of the Washington
Monument—and the view is more
glorious than the first time."
—Lillian Gish, 1989

From my conversation with **HILLARY CLINTON**

"Being First Lady was exciting, satisfying, gratifying, an honor. Just looking back on it, every emotional response for me is what an honor it was to be there for those eight years, to have a chance to serve and to meet people, to travel the world to represent my country, and to try to make life better for people.

"I never really thought about running for office myself. Whenever someone would ask, my response was always that I was happy doing what I was doing—because I was! From a young age, I wanted to be an advocate for children and families. And that was the role I tried to fulfill at the Children's Defense Fund in Arkansas, and, you know, in the White House. In the end, I decided to run for Senate because I believed I could make a difference on the issues I've fought for my whole career: children's health, help for struggling families, giving people a chance.

"In the Senate, I am proud to have achieved results—whether pursuing body armor for our troops, health care for children, or increased homeland security after the 9/11 attacks. The gratification of serving New York has been overwhelming, and I was honored to receive 67 percent of the vote in my reelection; that was great!

"I decided to enter the arena and run for President because I believe I'm the best equipped to hit the ground running from day one and that I can win the marathon to get there. It has been disheartening, to say the least, over the past six years to see so many decisions that have hurt our country. America is really ready for change, for leadership that sees and addresses big challenges that to this administration are just invisible— from health care to energy to global climate change and global competition. That's why I'm running. And so far it has been quite an adventure!

"The campaign trail is wonderful. It's very intense, but fun. People are so nice. They are really excited and supportive. They want to talk about all the issues with a sense of, you know, seriousness and purpose that I find so touching. I love it. I think it's going really well. I just think that it's off to such a fast start. It's turbocharged. I've never seen anything like it. And I don't quite understand all the reasons why it's so much faster and more intense now than I think it's ever been. But that's the way it is, so I'm going to get out there and do the best I can. And so far, so good."

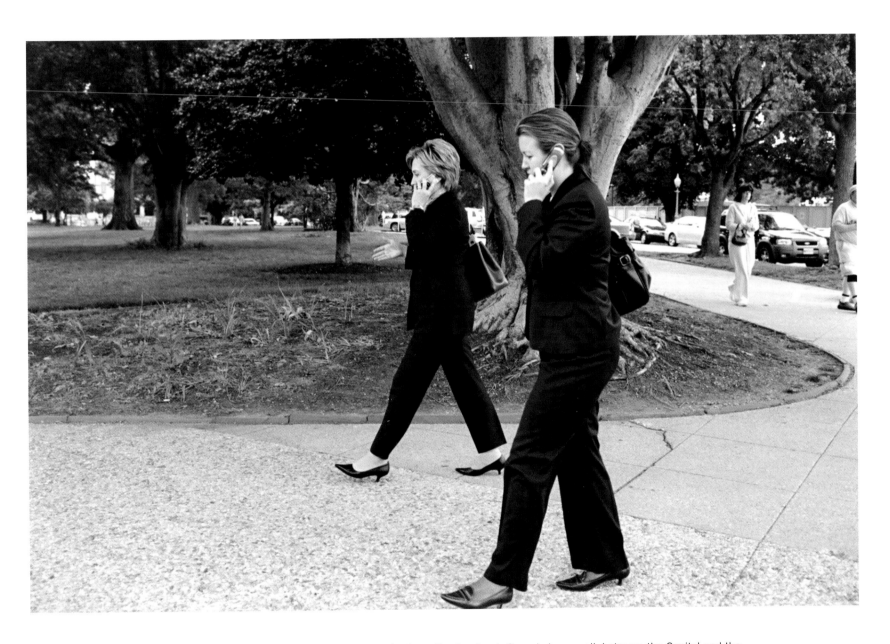

SENATOR CLINTON and her deputy communications director, Sarah Gegenheimer, walk between the Capitol and the Russell Senate Office Building, Washington D.C., May 16, 2007. "What this reminds me of is how there's never an idle moment, you know, we're just working all the time."—H.R.C.

FIRST LADY HILLARY CLINTON rides in her limo with her chief of staff, Melanne Verveer, October 3, 1997 "There we are, having a laugh, probably at my expense, undoubtedly."—H.R.C.

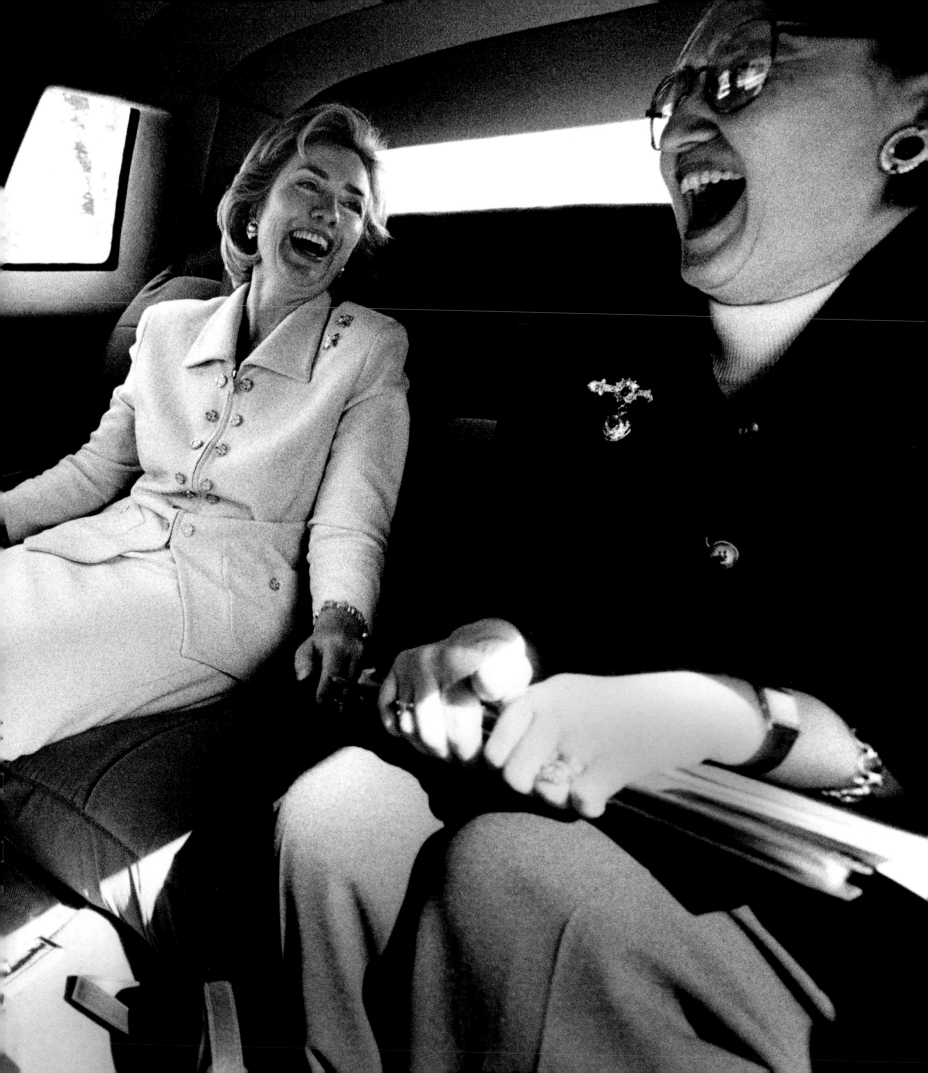

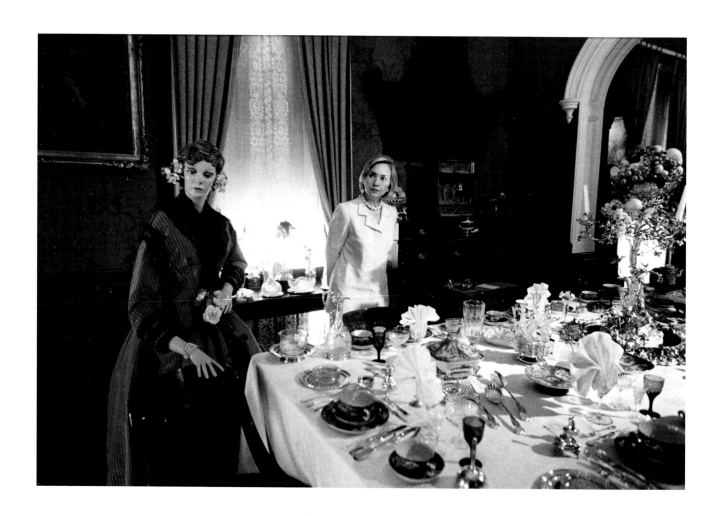

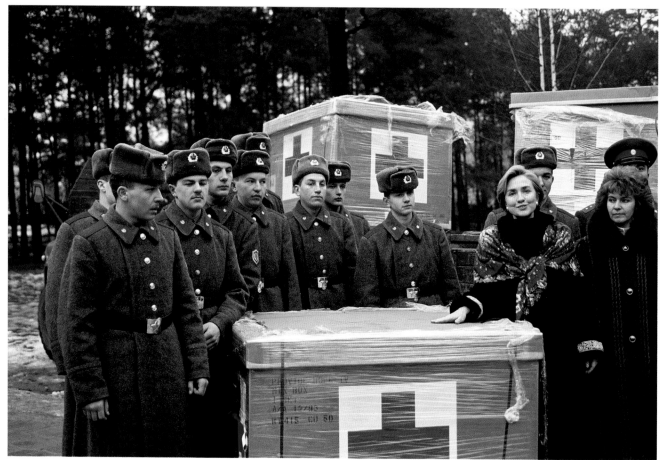

Top: **HILLARY CLINTON** at the William H. Seward (1801–1872) House Museum, Auburn, New York, July 15, 1998. "Here I am in Mrs. Seward's dining room. I'm getting a tip from Mrs. Seward! Now that I have read *Team of Rivals*, I am even more admiring of Secretary Seward."—H.R.C.

Bottom: **FIRST LADY HILLARY CLINTON** in Minsk, Belarus, January 15, 1994. Mrs. Clinton was delivering Red Cross supplies for the children of Chernobyl.

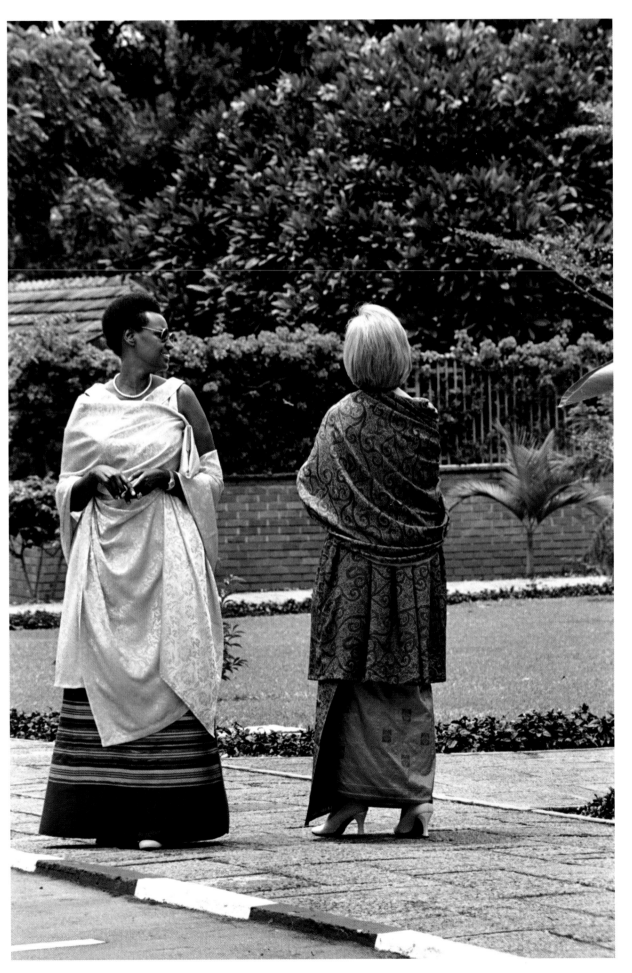

HILLARY CLINTON AND JANET MUSEVENI, wife of the president of Uganda, Kampala, Uganda, March 24, 1998. "In the garden of the presidential palace with Mrs. Museveni, I am wearing a native dress she had given me, to show our respect for the Ugandan culture. There's something about Africa that I find really reinforcing to the human spirit. There's a joy still in their lives and in their hearts that communicates itself, and though the conditions are horrible in many cases, there's a graciousness and a hospitality and a warmth. I find Africa very redemptive." —H.R.C

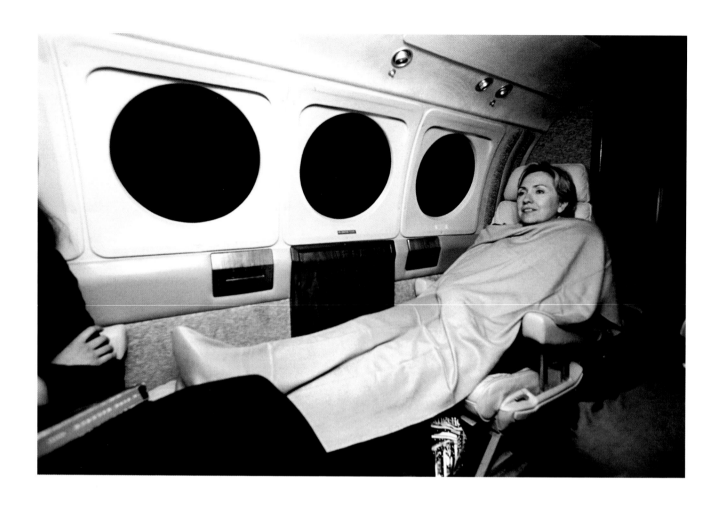

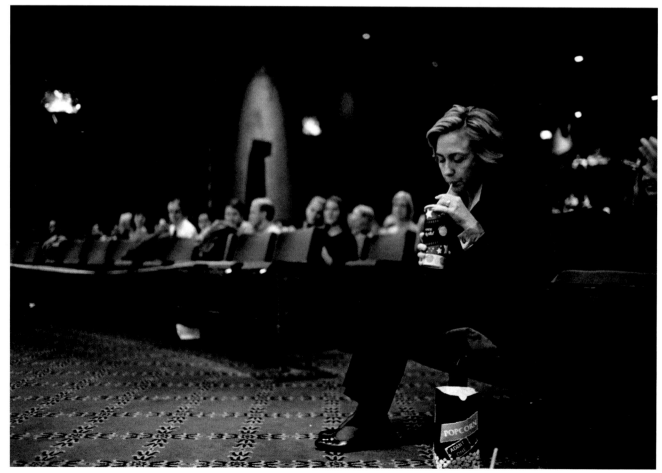

Top: **SENATOR HILLARY CLINTON** (D-NY) on her way back to Westchester from upstate New York, July 28, 2001. "Here I am on another cold airplane, heading off somewhere."—H.R.C

Bottom: **FIRST LADY HILLARY CLINTON** at a movie screening in New York City, December 3, 1998 "I was supposed to just drop in, make a short speech, and head on out. I got so captivated by the movie, *Shakespeare in Love*, that I stayed for the whole thing. And I saw it twice, I liked it so much."—H.R.C

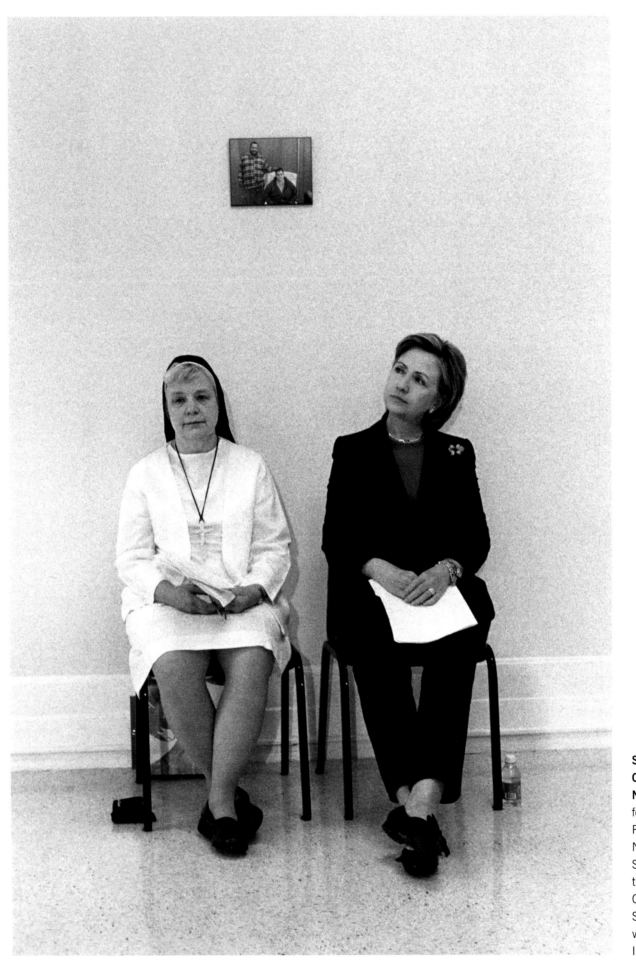

SENATOR HILLARY CLINTON WITH FELICIAN NUN SISTER JOHNICE, founder and director of the Response to Love Center, Buffalo, New York, June 2, 2006. "Oh, Sister Johnice, I love her! She is truly one of the great spirits of Christian love and charity I know. She is doing really significant work among the poor in Buffalo. I adore her."—H.R.C.

SENATOR HILLARY CLINTON walking up the steps to the U.S. Capitol, May 16, 2006. "I love going up these stairs; it's great exercise."—H.R.C.

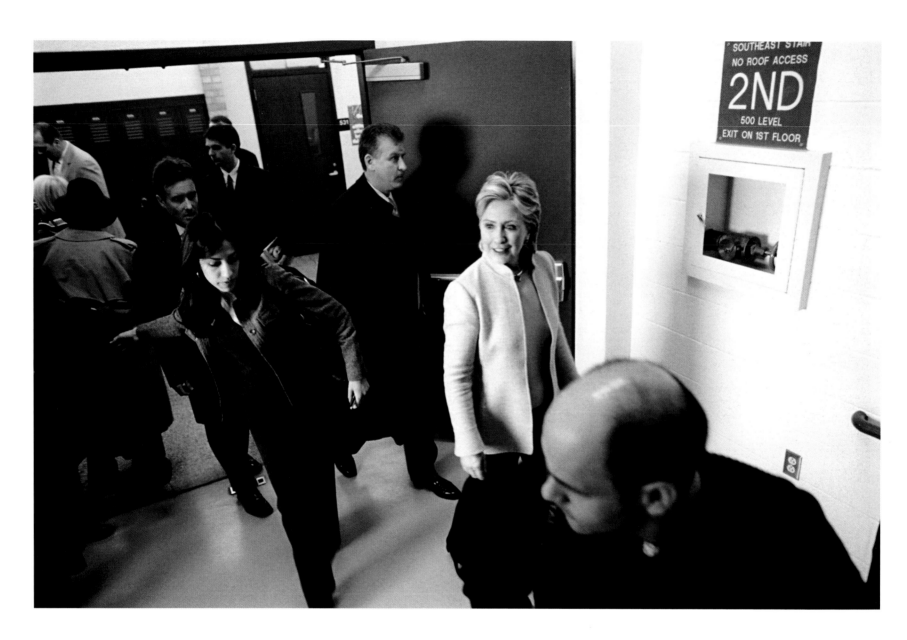

SENATOR HILLARY CLINTON walking through Central High School in Davenport, Iowa,
after a press conference, January 28, 2007

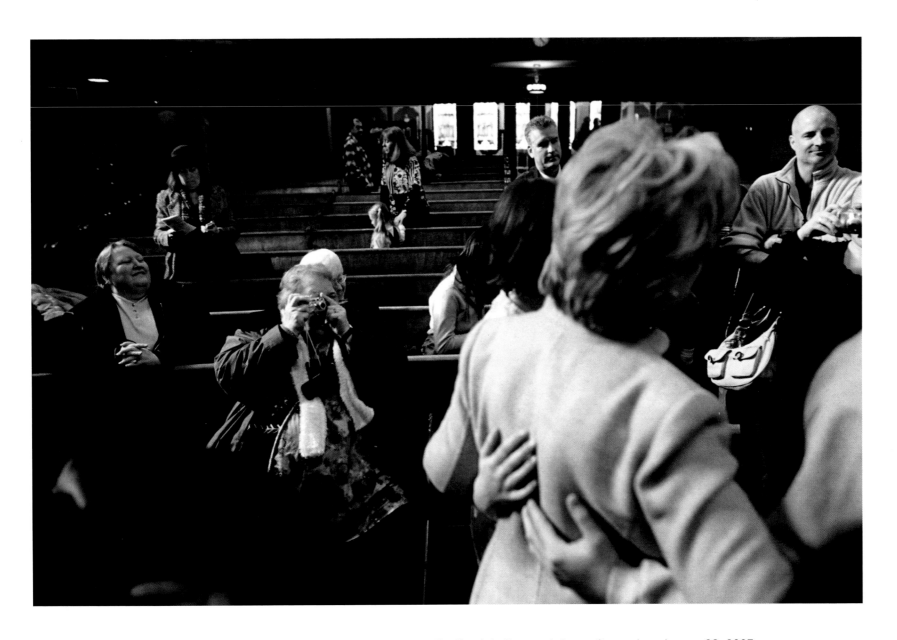

MEETING PARISHIONERS at St. John's United Methodist Church in Davenport, Iowa, after services, January 28, 2007
"Having started going to Iowa with candidates for President in 1979, I am still happy to see those remarkably open and
friendly Iowans enjoy the political process."—D.W.

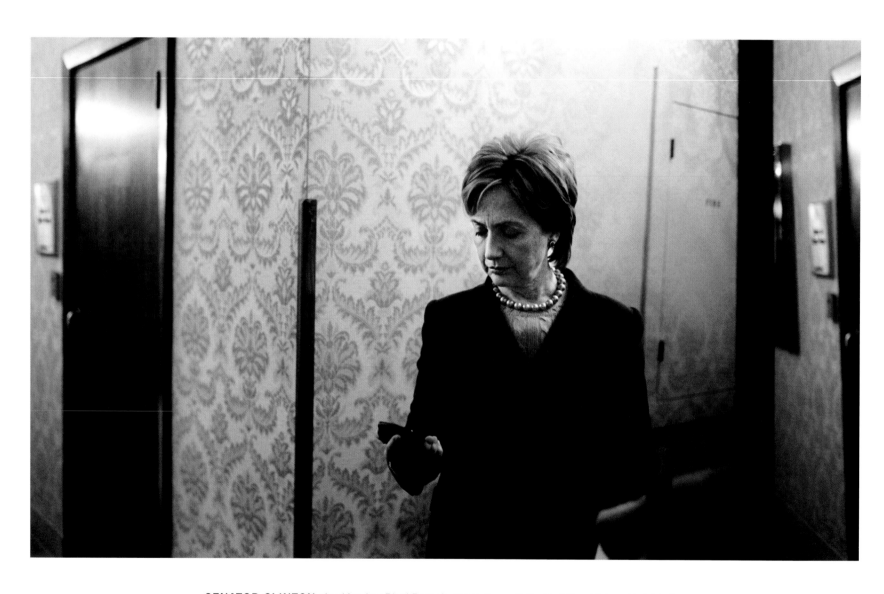

SENATOR CLINTON checking her BlackBerry in the hallway of the Fort Des Moines Hotel before speaking to labor leaders, Des Moines, Iowa, January 27, 2007

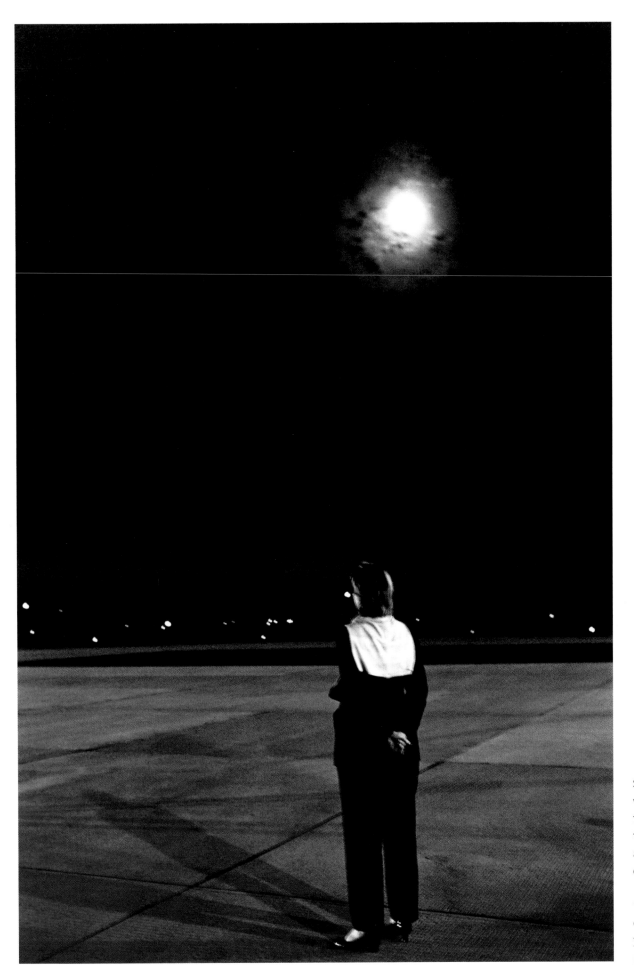

SENATOR CLINTON
waiting to be picked up at
the Westchester County Airport
to go home to Chappaqua
after a day of meeting
constituents around her state
of New York, July 28, 2001
"Sometimes, after a full day
of shooting, you find that
your last picture is the best
picture."—D.W.

AFTERWORD

After 30 years photographing presidents and politicians, I jumped at the invitation of the brilliant actor Anna Deavere Smith to travel to three countries in Africa photographing the people who told Anna their stories for possible inclusion in her next play, *Let Me Down Easy*. I'd always hoped, particularly with my White House work, that my photographs could shed light on the character of those I'd photographed. I was always looking to get underneath the surface, under the skin, by capturing the gesture, the look, the touch that could tell us something. I thought understanding our leaders was important, but now it was time for me to move on, to expand, to use what I had learned over the years to make pictures about life in a more universal context.

To see the continent of Africa with its glaring problems, its deeply human tragedies, its vibrant culture, and its everlasting hope through Anna's eyes, was a trip of a lifetime. How to describe row upon row of open graves next to those just covered over the day before? My answer is a camera. I could hardly focus for the tears. How do you express your sympathy to a man who can hardly speak remembering the slaughter of his entire family while he was trapped up to his neck in a sewer for days as the genocide raged above him?

Anna's answer is to bring that man to you on the stage. She says, "The play is about human resilience and mortality. I am hoping that audience members will come to the theater with their own feelings and ideas about resilience and mortality. If all goes well, some of the powerful stories that I have collected will cause members of the audience to enrich their own personal mythology about their lives, and what they value about life. I say 'life,' because once we look at mortality, we are bound to see life. After all, as humans, that's all we are built to see."

My experience was only a single trip, never mind how amazing, how revealing. For me it's just a start, but it gives me hope that I can somehow portray the dignity and the humanity of these extraordinary people, that I can illustrate their courage in the midst of an AIDS pandemic in South Africa; in the throes of learning to forgive the Hutus in Rwanda; in the grips of fear over Ugandan rebel abductions and atrocities where children lose their childhood, lose their feelings. What Anna brings to the stage is totally, inescapably real, and if my images can help illustrate that reality, I would be proud. We all should know these people and their stories; then may we never, ever, forget them.

There is hope in Africa. Where does it come from, against such odds? It's there, and it washes over you with every kind gesture, every head thrown back in a laugh. So many people are trying to make life better, and in many places, they are.

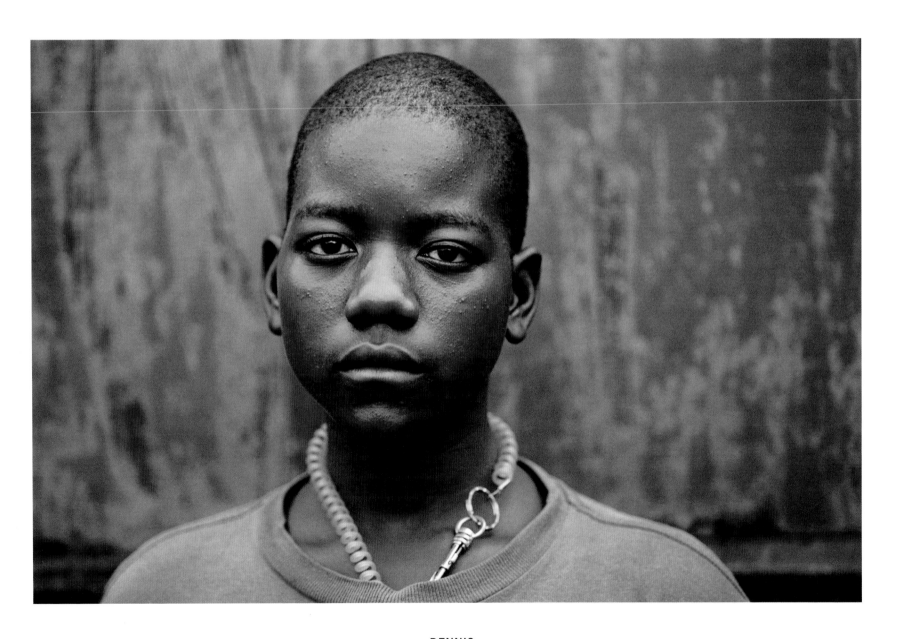

DENNIS

Formerly held by rebels in the north of Uganda, Dennis was photogrpahed at a rehabilitation center near Lira, Uganda, August 2005.

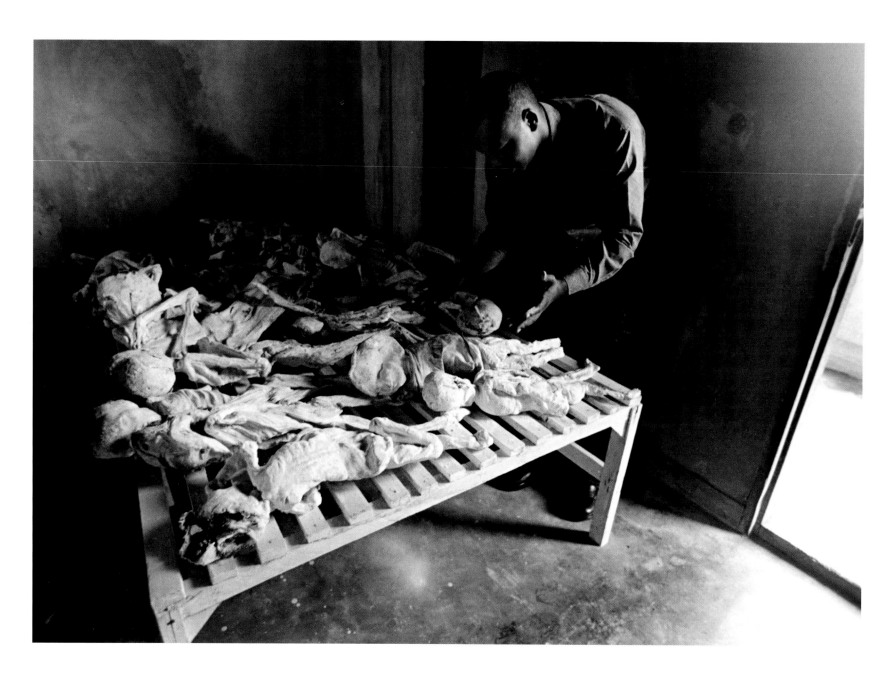

FREDDY MUTANGUHU
A guide at the Murambi Genocide Memorial shows us a display of remains from the 1994 genocide.
Freddy lost his wife and children to Hutu gangs. Gikongoro, Rwanda, August 2005

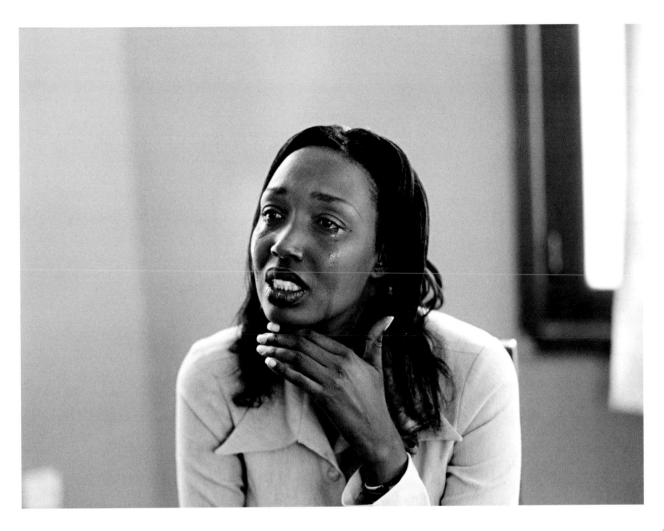

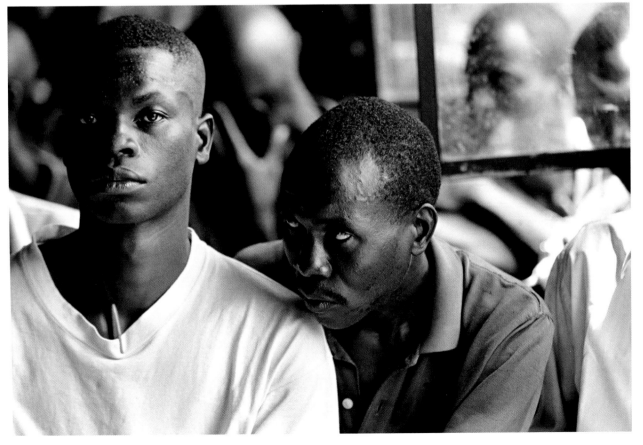

Top: **HARRIET MUTEGWAROBA**
A guide at the Gisozi Memorial Site, Kigali, Rwanda, August 2005. "Harriet, who was out of the country during the genocide, tells the horrors of losing her entire family"—D.W.

Bottom: **PRISONERS RECEIVING INSTRUCTION**
on reentering society after years in jail following the genocide of 1994, Solidarity Camp near Kigali, Rwanda, August 2005 "They were 800 strong in front of me, all prisoners, men and women, most of them Hutus imprisoned after the genocide. They danced and sang, with only a day or two to go before they were let out. The hope of the Tutsi government, now in control, is that there will be reconciliation between Hutus and Tutsis. I wondered."—D.W.

NHLANHLA SHANIGASE
A sugar plantation worker, ill with
AIDS, in his room near Durban,
South Africa, August 2005

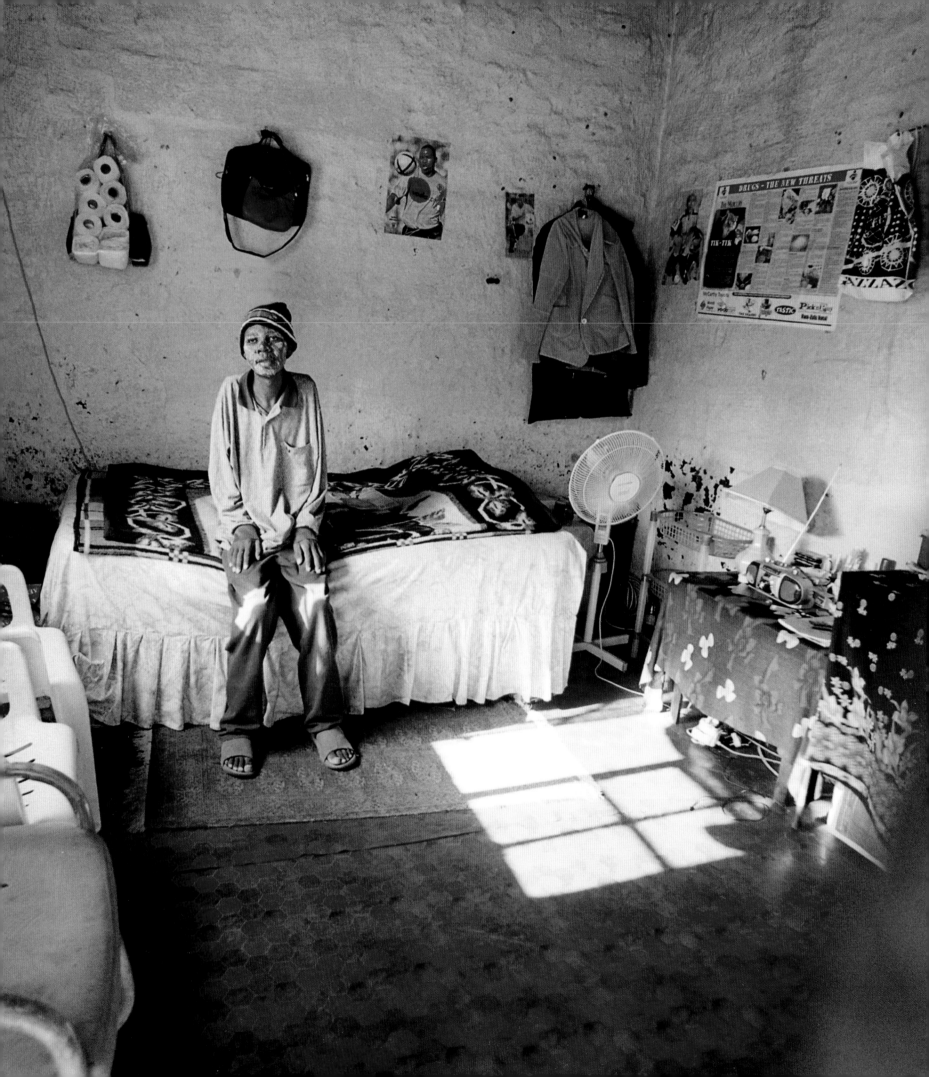

ACKNOWLEDGMENTS

I wish to thank the following people: Madeleine Albright, Hillary Clinton, Jamie Lee Curtis, Karenna Gore Schiff, and Steve Jobs for their kind cooperation in talking to me about the images in this book. In addition, I would like to thank Jamie especially for letting me publish pictures from a friendship.

For *The Bigger Picture*, there would be no book without Leah Bendavid-Val, my superb editor at National Geographic Books, and her colleague, Becky Lescaze, who helped me beyond measure put words on the page. Leah conceived of this book, and with her kindness, integrity, and encouragement kept me on track. You have no idea what a gift Leah gave me when she suggested we ask Yolanda Cuomo, the book's brilliant designer, and Kristi Norgaard, her amazing design associate, to work with us. Thank you both so much. Yo made sense of the pictures, created the spreads, and *The Bigger Picture* was born. What a wonderful team! My thanks also must go to Laurel Johnson and Lissa August, both of whom helped me tremendously finding the who, where, and when of all the book's images, and Marshall Kiker, another National Geographic Books whiz who kept track of all the images, whether on the server or in production. Also, I would particularly like to thank my friend Anne Tyler for writing the Foreword.

I am indebted to so many for helping me in my career. You know who you are, and how much I owe each of you. But I especially wish to say thank you here to the editors who sent me out to take the pictures in this book, introducing me to a world I would never have known otherwise: the late John Durniak and Anne Callahan; John Dominis; Arnold Drapkin; Mary Dunn; MaryAnn Golon; and most especially, Michele Stephenson, my editor and friend for 30 years.

I wish to thank Ann Pincus, who long ago, when she was a journalist, let me tag along on stories she was writing. Several images from her interviews in the 1970s are included in this book. And her husband, Walter Pincus, I thank for always thinking I could do it.

Finally, to my family for their enduring love, ideas, and enthusiasm, I thank Mallory, Taylor & Jane, and Willy & Sheila.

THE BIGGER PICTURE
DIANA WALKER

PUBLISHED BY THE NATIONAL GEOGRAPHIC SOCIETY

John M. Fahey, Jr., President and Chief Executive Officer

Gilbert M. Grosvenor, Chairman of the Board

Nina D. Hoffman, Executive Vice President;
 President, Book Publishing Group

PREPARED BY THE BOOK DIVISION

Kevin Mulroy, Senior Vice President and Publisher

Leah Bendavid-Val, Director of Photography
 Publishing and Illustrations

Marianne R. Koszorus, Director of Design

Barbara Brownell Grogan, Executive Editor

Elizabeth Newhouse, Director of Travel Publishing

Carl Mehler, Director of Maps

STAFF FOR THIS BOOK

Leah Bendavid-Val, Editor

Rebecca Lescaze, Text Editor

Lissa August, Caption Researcher

Laurel Johnson, Picture Researcher

Mike Horenstein, Production Project Manager

Marshall Kiker, Illustrations Specialist

Cameron Zotter, Design Assistant

Jennifer A. Thornton, Managing Editor

Gary Colbert, Production Director

BOOK DESIGN, YOLANDA CUOMO DESIGN, NYC

Kristi Norgaard, Design Associate

MANUFACTURING AND QUALITY MANAGEMENT

Christopher A. Liedel, Chief Financial Officer

Phillip L. Schlosser, Vice President

John T. Dunn, Technical Director

Chris Brown, Director

Maryclare Tracy, Manager

Nicole Elliott, Manager

Founded in 1888, the National Geographic Society is one of the largest nonprofit scientific and educational organizations in the world. It reaches more than 285 million people worldwide each month through its official journal, NATIONAL GEOGRAPHIC, and its four other magazines; the National Geographic Channel; television documentaries; radio programs; films; books; videos and DVDs; maps; and interactive media. National Geographic has funded more than 8,000 scientific research projects and supports an education program combating geographic illiteracy.

For more information, please call 1-800-NGS LINE (647-5463)

or write to the following address:
National Geographic Society
1145 17th Street N.W.
Washington, D.C. 20036-4688 U.S.A.

Visit us online at www.nationalgeographic.com/books

For information about special discounts for bulk purchases, please contact National Geographic Books Special Sales: ngspecsales@ngs.org

For rights or permissions inquiries, please contact National Geographic Books Subsidiary Rights: ngbookrights@ngs.org

Library of Congress Cataloging-in-Publication Data
Walker, Diana (Diana H.)
 The bigger picture : 30 years of portraits / by Diana Walker.
 p. cm.
 ISBN 978-1-4262-0129-5 (alk. paper)
1. Celebrities--Portraits. 2. Portrait photography. 3. Walker, Diana (Diana H.) I. Title.
TR681.F3W35 2007
779'.2092--dc22

 2007020639

ISBN: 978-1-4262-0129-5

Printed in Italy